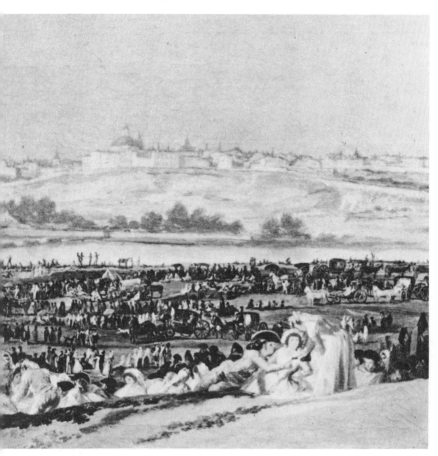

Goya's Madrid, *The Meadow of San Isidro,* 1788

The Double Lives of
Francisco de Goya

The Double Lives of Francisco de Goya

BY SAMUEL EDWARDS

GROSSET & DUNLAP
A National General Company
Publishers New York

The reproductions of Goya's art in this book were originally published
in the following works.

Margherita Abbruzzese, *Goya*, Grosset & Dunlap, 1967.
Art in America, April, 1915.
A. de Berutete y Moret, *Goya*, Blass y Cfa. San Mateo, 1, Madrid, 1916.
Albert F. Calvert, *Goya, an Account of His Life and Works*, John Lane
 Company, 1908.
Richard Oertel, *Francisco de Goya*, Bielfeld und Leipzig Derlag von
 Delhagen und Klafing, 1907.
Hugh Stokes, *Francisco Goya—A Study of the Work and Personality of
 the 18th Century Spanish Painter and Satirist*, G. P. Putnam's Sons,
 New York, 1915 and Herbert Jenkins Ltd., London, 1914.
Valerian von Loga, *Francisco de Goya*, G. Grote'sche Verlagsbuch hand
 lung, Berlin, 1903.

A list of illustrations appears on page 244.

Library of Congress Catalog Card Number: 73-6901
ISBN: 0-448-01377-0

First Printing
Printed in the United States of America

For

Elizabeth Louise Edwards

Contents

The Double Lives of
Francisco de Goya

I
Janus

In every aspect of his long, complicated life Francisco de Goya was two totally different men, one inspired by God, the other a subject of Satan. What makes this dichotomy astonishing is his constant awareness of the split in his personality. Others have gone through life similarly obsessed, but Goya was unique, in that the very nature of his genius enabled him to dwell at peace within both worlds. He arranged his existence so that he could serve the mighty and powerful and at the same time follow his own desires.

Only a Spaniard living in the late eighteenth and early nineteenth century could have accomplished such a feat. Only in a country that was a century behind the times politically and socially, where the practice of Christianity was at the same time so personal and so institutionally repressive, was it possible for a man to live in such disparate, contradictory ways.

The modern businessman who is a pillar of his family, his church and of society but lets down the barriers when he goes out of town is a familiar figure, but he at

least is consistent in most of his attitudes. This was emphatically not true of Goya, and here lies his fascination. He lived on two levels. He was two different men, and followed both lives without wavering.

As an artist, he was impeccably conventional on one side of the canvas. First Painter to the Court, head of painting at the Academy of San Fernando, he turned out hundreds of portraits as conventional as they were brilliant. Such a critical evaluation appears on the surface to be a contradiction. It isn't. He went far beyond the norms of his own day, or of any preceding age, by delving deeply into the psyches of those who sat for him. In the great days of his maturity and later life he produced portraits that were multidimensional in depicting human character. Still not satisfied, he frequently came perilously close to caricature of a subject who warranted such treatment, as his portrait of Charles III in hunting garb and those of Charles IV and his family clearly illustrate.

But Goya ranged farther than this in his painting. Whether his monsters and demons sprang from the unconscious mind of a deaf and sometimes mentally deranged genius or whether they were conscious inventions cannot be answered. No matter—Goya was a pioneer in the creation of new art forms, a painter who had the courage to experiment as he alone saw fit, never realizing—or caring—that he would be hailed by posterity as the father of the Impressionism of the late nineteenth century.

As a cartoonist he broke new ground, too, for he was the first to raise the form to the height of art. His *Caprichos* were the first social, political, moral and religious satires ever committed to paper, drawn at a time when the artist was also doing the most conventional of portraits, religious works for the decoration of churches and even still life paintings. He was far ahead of his time.

The Disasters of War, perhaps the most powerful in-

dictment of war ever conceived by any artist, was not printed until 1863, a half-century after Goya created this remarkable series of etchings.

It would be simplistic and false to say that Goya was so courageously independent that he didn't care what his contemporaries thought. He was highly sensitive to their opinions and demanded the recognition and rewards that were due him. He eagerly sought the post of First Painter of the Court of Spain. He charged exorbitant fees for his conventional work, and he delighted in living accordingly. No man boasted a finer carriage or a more comfortable home.

But in his personal habits, a strange dichotomy appeared. He served the rich meals custom demanded for his guests, but he himself was satisfied with bread, cheese, a little meat and watered wine, the rough fare of the poor.

He was consistent in his obedience to his own domestic double standard. For over four decades he was married to one woman, and poor Josefa, about whom there is little of interest, may have borne him as many as a score of children, all but one dying in infancy or childhood. At the same time his love life was notorious, and most of the scandalous stories that have been passed from one generation to the next about him are true.

He had more affairs than even the most exacting of his biographers have been able to count, with women of every class, from street girls to duchesses. He was infected with syphilis, which caused his deafness. Yet his most notable liaison was with the Duchess of Alba, and his portrait of *The Naked Maja* immortalized their relationship.

Maria Cayetana, the Duchess of Alba, may have been the one real love of Goya's life. Some of his biographers have tried to deny the significance of their affair, but the

known facts substantiate its importance. Not that anyone was capable of satisfying Goya's erotic desires—even when he was living with the Duchess of Alba he could not resist the temptation of other women.

His political attitudes forcibly demonstrate his ability to live in two worlds at the same time. He was a devoted monarchist, a loyal subject of the Spanish Crown, duly rewarded by both Charles III and Charles IV. It would not have occurred to him to rebel, and he had no use for the handful of Spanish republicans. Goya loathed the abuses of the monarchical system and finally, when he was an old man, found he could not tolerate the tyranny imposed on Spain by Ferdinand VII. Goya created an international sensation by voluntarily going into exile as a gesture of protest.

His political beliefs in the 1770s and after were closer to those of the men who created the United States of America than to the fathers of the French Revolution. But he crystalized his views independently. Because of what he himself saw and experienced, he came to believe in the rights of man, individual human dignity and justice. It is doubtful that he ever read a word of John Locke or Voltaire or had ever heard of the Bill of Rights in the United States Constitution, or that he even knew of the existence of such contemporaries as Thomas Jefferson, Samuel Adams or James Madison.

Even in social life Francisco de Goya was two men. He enjoyed the close friendship of such men as Manuel de Godoy, the powerful First Minister in the reign of Charles IV, and great nobles dined frequently at his home, as did poets and other artists. From earliest manhood, however, he spent several evenings each week in the working-class taverns of Madrid, seeking the company of artisans, simple laborers, bullfighters and the *Majos* and *Majas* who made up a special group of *Madrileños* (citizens of Ma-

drid). He needed to be accepted as a friend by both cabinet ministers and bricklayers, just as he had to go to bed with the daughters of the poor as well as the greatest ladies of the land.

The dichotomy can be seen in his religious practices, too. He was a devout, simple man who went to Mass every week and whose faith was intensely Spanish, fiercely personal. Yet no man was more aware of the weaknesses of those who administered the affairs of the Church, and his mockery of bishops and priests caused him grave problems with the Inquisition. Only because of his fame and his many powerful friends did he escape imprisonment by the Holy Office.

Simultaneously an introvert and an extrovert, a moralist and a lecher, an eighteenth-century monarch and a twentieth-century liberal, a superb conventional painter and a dazzling innovator, a conservative and a reformer, a convivial fun-seeker and a man who demanded the strictest privacy, Goya seems impossibly contradictory. Yet the two personalities merged and made one whole man.

How he achieved this remarkable feat, and why he felt compelled to drive at a headlong pace down two divergent roads at the same time, are explored in detail in the pages that follow. He was the master of his own fate, and even when he suffered inner torment, he could worship God while serving Satan. Perhaps it was the paradoxical quality of his character, the unique ability to exist simultaneously on many planes, that made him one of the greatest artists of all time.

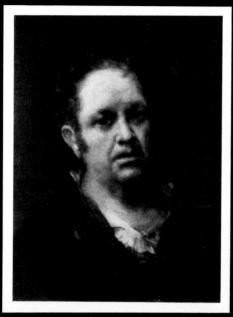

Self-portrait, 1816

A GALLERY OF THE
DOUBLE LIVES OF GOYA

Goya himself left the most comprehensive and accurate record of his double lives in his sketch books, portraits and captions. This picture section makes no attempt to represent Goya's complete development as an artist, but illustrates the many conflicting themes of his life through outstanding examples of his art. □ □ □

His Distinguished Lovers

Most art critics writing of Goya have acclaimed *The Naked Maja* as a portrait of womanly beauty and sensuality unequaled by any other painter. That Goya and the

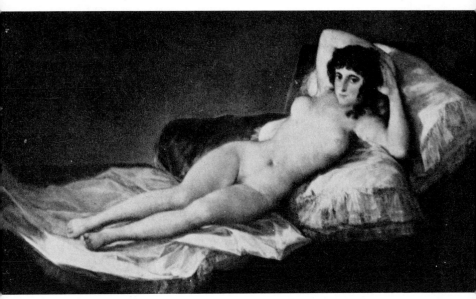

The Naked Maja

Duchess of Alba were lovers is almost unquestioned. *The Naked Maja* and its twin, *The Maja Clothed,* were painted either during Goya's long sojourn at her country estate, Sanlucar, or shortly after they returned to Madrid, and the

Duchess kept both paintings in strict secrecy. She herself was probably the model, though some critics maintain that the face is that of the girl who appears in *Majas on a Balcony,*

Rings bearing the names "Alba" and "Goya," from detail of his formal portrait of her, 1797

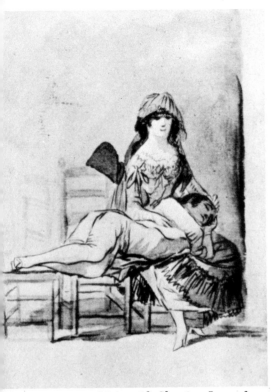

painted at a much later time. Goya's sketchbooks drawn at Sanlucar depicted the licentious life he saw at the estate, and these, like the paintings, came to light only after his death.

The Duchess of Osuna, who commissioned many works from Goya, was also his mistress for many years. And for some months he also indulged in a flagrant affair with La Tirana, the greatest actress of the day.

□ □ □

Maja with Sleeping Lover from his sketchbooks

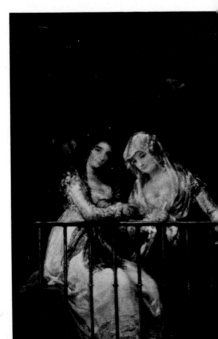

Majas on a Balcony

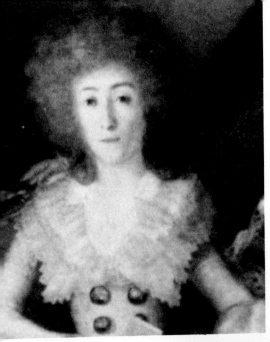

Duchess of Osuna, detail from *The Osuna Family*

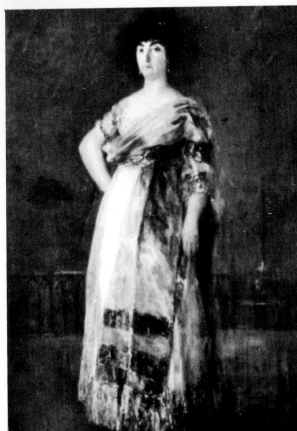

La Tirana

His Family Life

To further his career, Goya married Josefa Bayeu, sister of the court painter Francisco Bayeu, though he paid her little attention other than begetting twelve or more children. He resented Bayeu, the greatest influence of his early career, hating him for years. Goya's opinion of marriage was vio-

Josefa Bayeu de Goya, his neglected wife

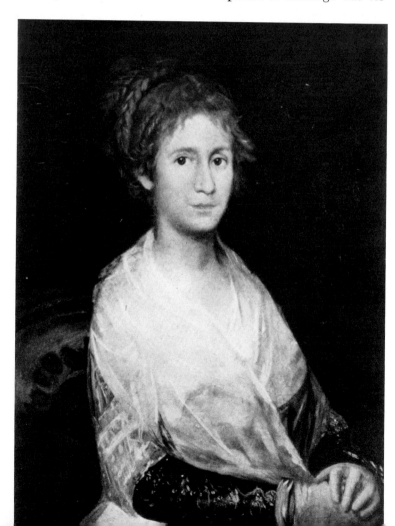

lently portrayed in *Matrimonial Folly,* an etching of husband and wife welded together back to back in lifelong agony. Goya created some of his greatest masterpieces in his portraits of children, probably because

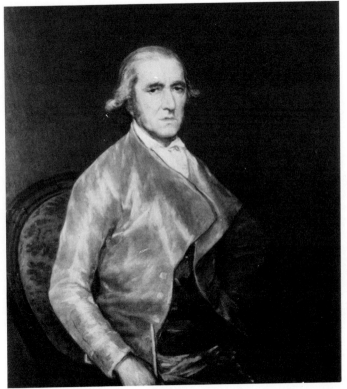

he lost so many of his own. The most famous is his portrait of Don Osorio, the Boy in Red, recognized today among American printmakers as the most popular reproduction of a classical painting.

Francisco Bayeu, his feuding brother-in-law

□ □ □

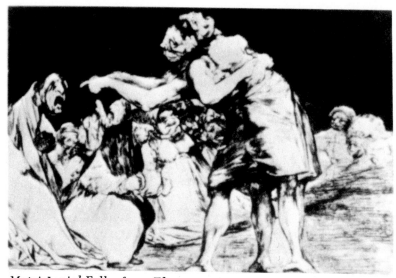

Matrimonial Folly, from *The Proverbs*

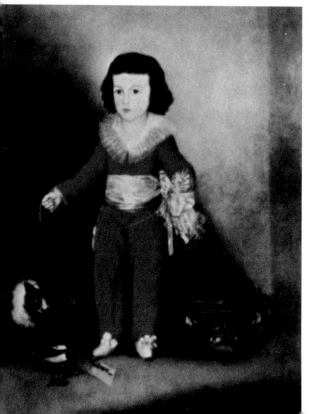

Don Osorio, the Boy in Red

His Night Life

Unknown to his family or his noble mistresses, Goya for most of his life frequented the taverns of the poor at night, brawling and fornicating, often pretending to be a housepainter.

The Forge

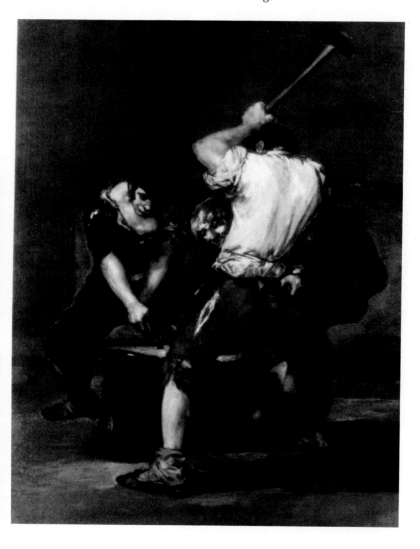

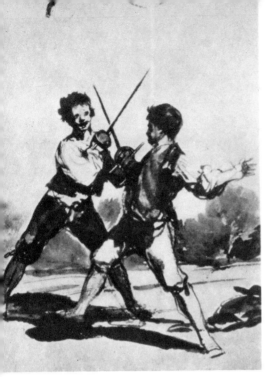

No doubt his abilities in dueling with Charles III were sharpened by his bouts with the *Majos* of Madrid. Despite his pretense of being well born, his father's family was peasant in origin, and he remained a peasant at heart. He found true relaxation only with the working class.

□ □ □

The Duel

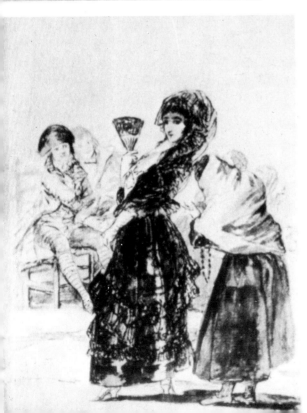

Maja with a Beggar

His Political
Double Lives

A Spaniard passionate to the core, Goya as the greatest artist of Spain walked a political tightrope. Loyal to Charles IV, to his scheming Queen Maria Luisa and to her lover Manuel de Godoy, the First Minister, he remained as First Painter to King Joseph Bonaparte in Madrid, painting many outstanding French generals and diplomats. At the same time, to make his sketch of the future Duke of Wellington he passed through

The perfidious Queen Maria Luisa, detail from *The Family of Charles IV*

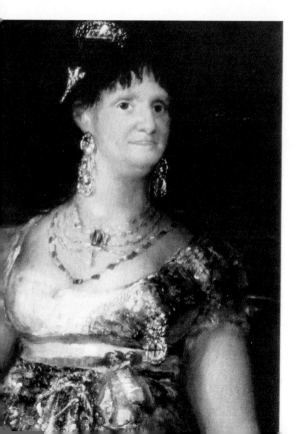

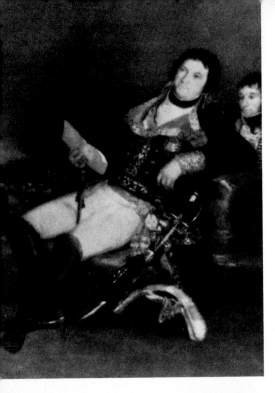

the French lines to meet the invading British general on the battlefield. When Bonaparte retreated, Goya became First Painter to Ferdinand VII, whom he despised. Even Goya's beloved guerrillas, whom he helped support in the mountains and depicted in *The Disasters of War* (kept hidden from Bonaparte as well as Ferdinand VII), did not escape his truthful brush. The cruelties of the Spanish guerrillas were as terribly revealed as the horrors committed by the French.

□ □ □

Detail from portrait of *Manuel de Godoy,* First Minister and lover of Queen Maria Luisa

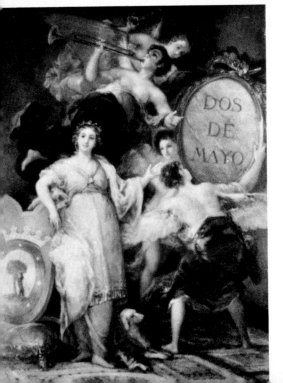

Portrait of King Joseph Bonaparte eradicated from *The Allegory of the City of Madrid.* The portrait was twice painted over and finally replaced by the words *Dos de Mayo* (the Second of May), the beginning of the Spanish revolt.

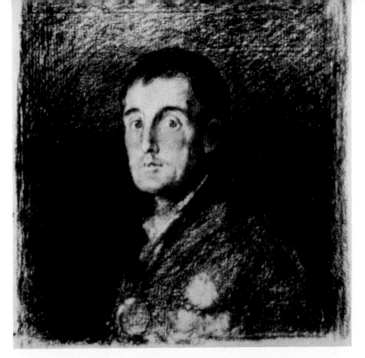

Sketch of the Duke of Wellington

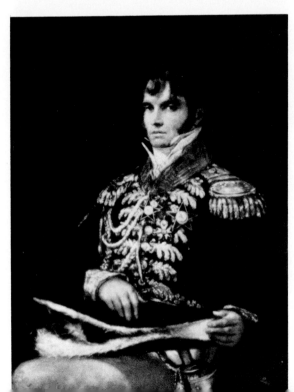

Portrait of the French General Nicholas Guye

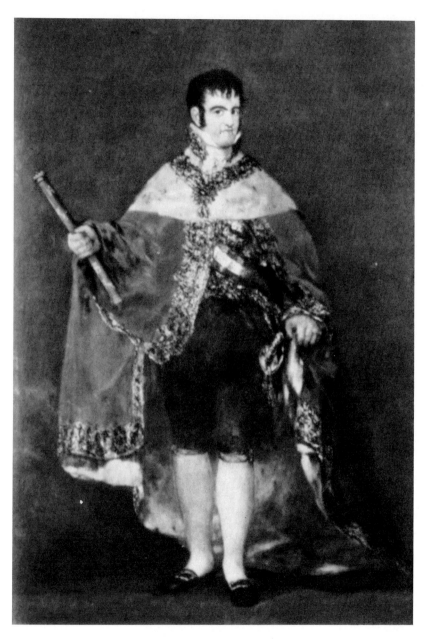

Portrait of Ferdinand VII

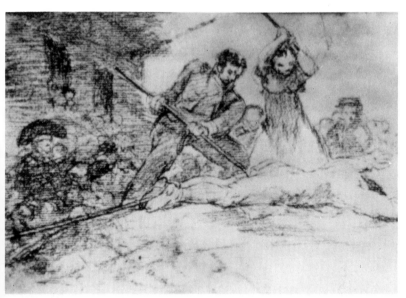

The Rabble, from *The Disasters of War,* showing Spanish guerrillas torturing a French soldier

Que valor! (What Courage!) Sketch of "the Red Carmen," the heroine who took the place of her fallen husband, from *The Disasters of War*

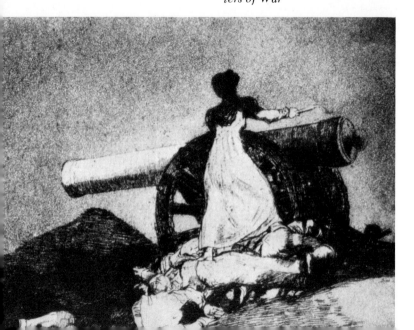

His
Defiant "Liberalism"

More than once Goya openly defied the Inquisition. From his earliest years to his last days in exile, he depicted the victims called before the Inquisi-

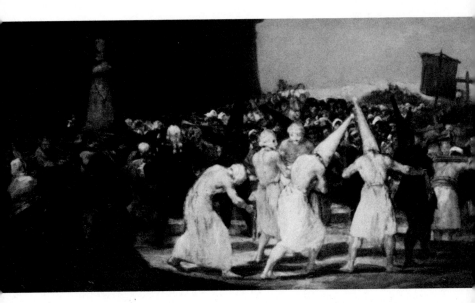

Procession of the Flagellants

tors. He mimicked the Church in *Procession of the Flagellants* and attacked it savagely in his series the *Caprichos.*

Goya was called before the Inquisition twice himself, yet later became a close friend of the Secretary General of the Inquisition, Juan de Llorente, when the latter turned coat and wrote the revealing *History of the Inquisition.* Despite his

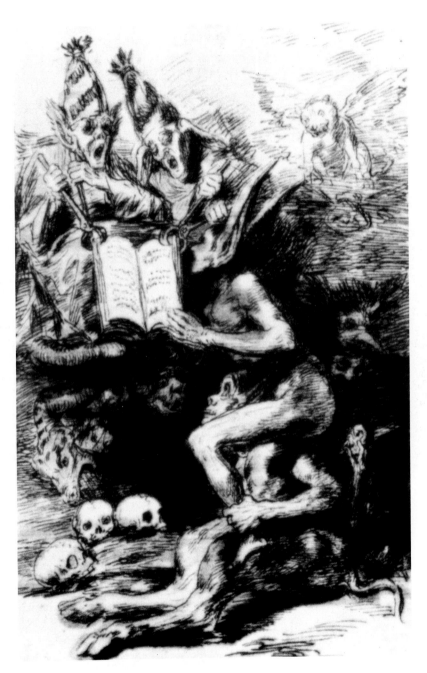

Devout Vows, preparatory
drawing for *Capricho 70*

caricatures of the Spanish priesthood, however, Goya worshiped regularly and held to the beliefs of the Spanish Church.

Goya's own social views sprang no doubt from his eyewitness observations of the shattering changes of his time.

Detail from portrait of Juan Antonio Llorente, Secretary General of the Inquisition

He also befriended the greatest liberals of Spain, the politician Gaspar Melchior de Jovellanos and the poet Leandro Moratin, whom he also painted.

Jovellanos was the first to address Goya by his self-ennobling name—de Goya—after the painter had invented a coat

Donkey tracing his ancestry, *As Far Back as His Grandfather,* preparatory drawing for *Capricho 39*

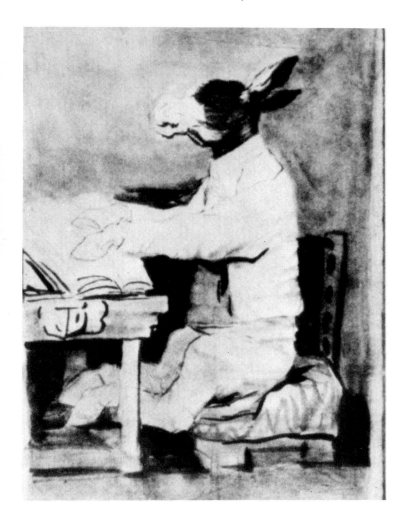

of arms for himself. Yet in the *Caprichos*, Goya satirized himself as a donkey tracing his genealogy.

□ □ □

Portrait of *Gaspar Melchior de Jovellanos*

Portrait of *Leandro de Moratin*

The Superstitions of the People and the Madness of Goya

Of the folk beliefs painted by Goya, *The Witches' Sabbath*, owned by the Duchess of Osuna, may be the most famous. It depicts Satan, in the form of the black goat, surrounded by worshipers. *The*

The Witches' Sabbath

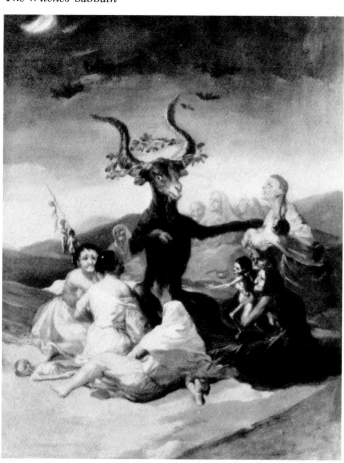

Congress of Sorcerers is another. Much has been surmised concerning Goya's tortured visions, possibly the apparitions of his two serious attacks of syphilis, possibly superstitions of his peasant childhood. *The Sleep of Reason*, with demon bats, owl and hypnotic cat, was so significant that he made it a title piece in the *Caprichos*.

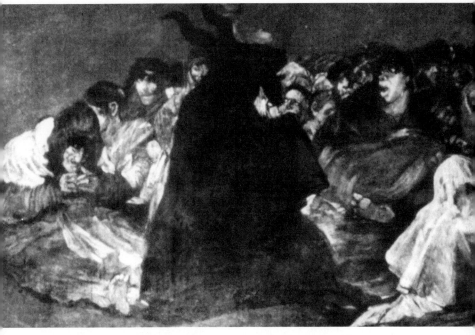

The Congress of Sorcerers

The menacing Colossus, a giant dominating the earth, appears in several paintings and many drawings. *Saturn Devouring One of His Children* is perhaps the most horrifying. And for simple human degradation,

without monsters, Goya depicted the realities of *The Madhouse* and *The Prisoners. It is* unlikely that Goya was merely symbolizing the wretchedness of his observable world. He too suffered and was terrorized by visions.

□ □ □

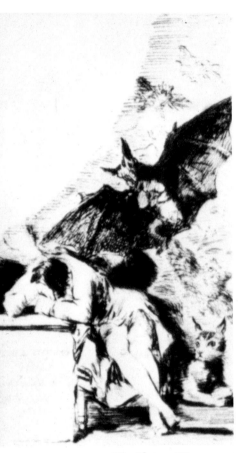

The Sleep of Reason

Goya: nightmare of things unknown—
Of human embryos brewed among witches' revels,
Of old hags in the mirror and of little girls all naked
Adjusting their stockings to tempt the demons.

Baudelaire, *Les Phares*

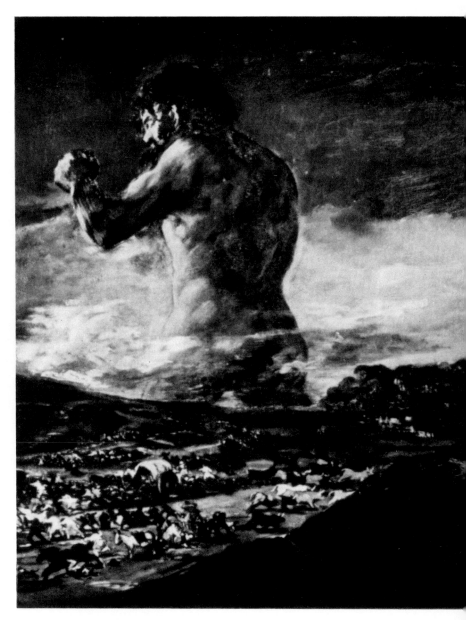

The Colossus

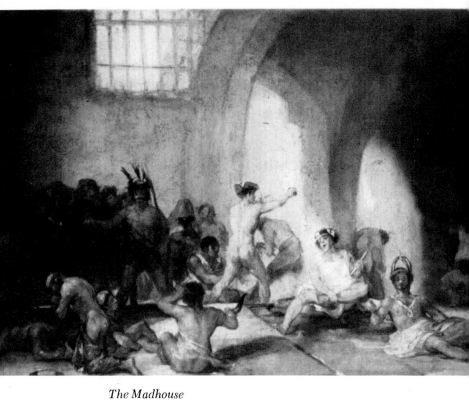

The Madhouse

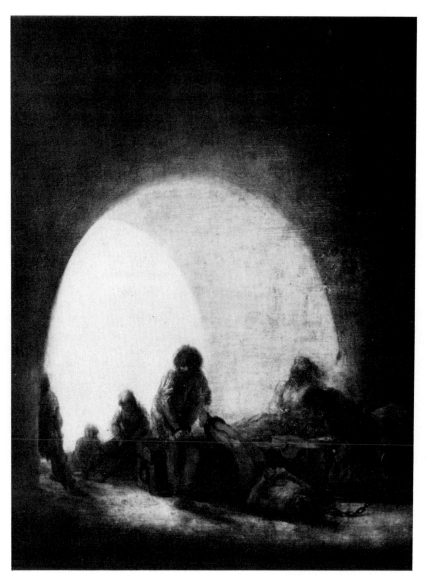

The Prisoners

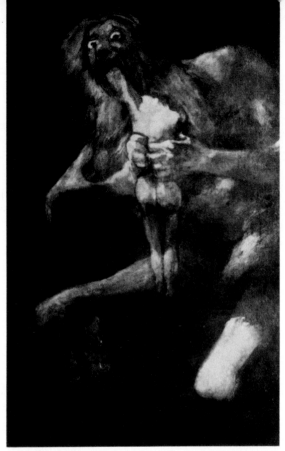

*Saturn
Devouring One
of His Children*

Faces from
*The Madrid
Sketchbook*

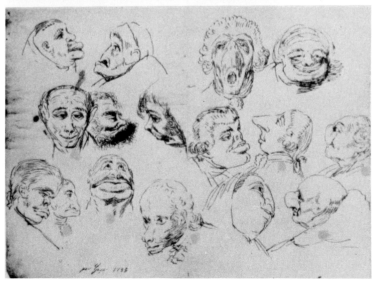

Goya
the Several Artists

Both a traditionalist and a rebel, Goya brought new realism to the toadying portraiture of the royal court. He could flatter, but he painted so realistically, with such psychological depth, that his kings might well have had no clothes. Charles III encouraged his "realism" as did Charles IV, the grandees and great ladies.

Goya would also paint unimaginatively with photographic detail. Yet he led the way to Romanticism in paintings such as the world-famous *The Third of May* and *Two Old Men Eating Soup,* and then leapt beyond into Impressionism, as in his fresco for the Chapel of San Antonio. Before

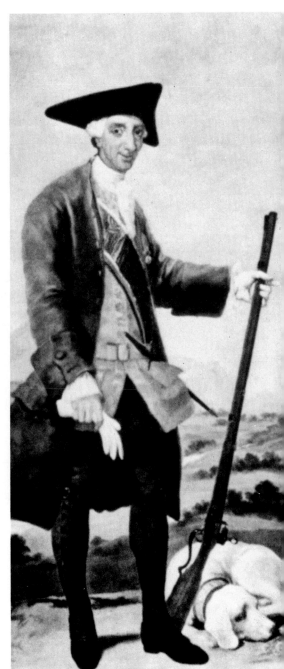

Charles III in Hunting Dress

The Third of May, detail

Two Old Men Eating Soup

his death the French Romantics were following him, and over fifty years later the Impressionists looked back to him to shatter the tradition of their day.

But it is as social commentator that Goya has become world renowned among succeeding generations. Most admirers are unaware that Goya

Chapel of San Antonio
fresco, detail

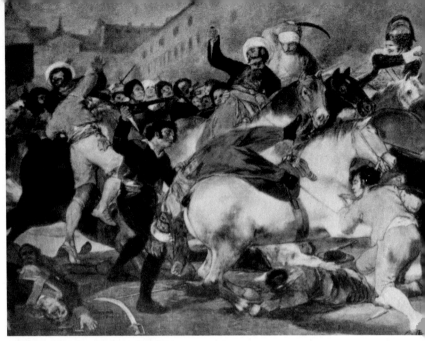

The Second of May (1808).
Goya's painting of the people of
Madrid attacking the Mamelukes,
the French mercenaries occupy-
ing the city. Neither this nor *The
Third of May* was painted until
the expulsion of the French.

dared not exhibit his most dev-
astating social works during his
life, just as he kept his intimate
paintings and sketches out of
sight.

□ □ □

I Saw This, from *The Disasters of
War,* depicting the Spanish peo-
ple fleeing the Napoleonic invad-
ers. Goya dared not exhibit the
series during the French occupa-
tion.

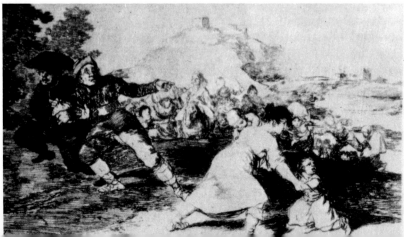

II
The Very Land Was Tortured

The very land was tortured. Physically a part of western Europe, Spain was nevertheless isolated, sealed off from the outside world by the Pyrenees and Cantabrian Mountains on the north, by the Sierra Nevada that faced the Mediterranean on the south. A brooding, sullen nation, she knew little of events occurring elsewhere and remained untouched by the political and intellectual ferment of the Age of Enlightenment.

Life was as hard as the scarred, brown earth that spread across her valleys, and although the earth yielded citrus fruits and almonds, olives and vegetables when irrigated by the swift-flowing rivers, farming remained primitive. More often than not, men rather than horses or donkeys were the beasts of burden.

The problems confronting the backward nation were so complicated they defied solution. By the middle of the eighteenth century the population had soared to ten million, almost doubling in a scant fifty years. The poor were everywhere. Food was scarce because millions of acres of land owned by the Crown and a handful of grandees re-

mained untilled, and great tracts belonging to the Church lay in a similar state. So ten million people subsisted on land that had barely supported half that number.

Industry was almost non-existent, although the Spanish craftsman had proven a superb worker. In spite of a great demand throughout Europe for Spanish swords and leather goods, little was produced for foreign consumption.

In the late summer of 1746 the long reign of the French-born Philip V came to an end, neither the monarch nor his ministers ever realizing that their attempts to enter more actively into the affairs of Europe had led to disaster. Philip had tried in vain to pursue a vigorous foreign policy. His nation, unprepared for modern warfare, had suffered a long series of crushing defeats that forced her deeper into isolation.

The grandees and the Church, both responsible for Spain's backwardness, retained their extraordinary powers. The monarchy appeared to be absolute, but its authority was actually shared with twelve great families, each of which could make its own laws. When Ferdinand VI, the least effectual of Spanish monarchs, succeeded his father, more than twelve thousand towns and villages, the personal property of various grandees, remained outside the jurisdiction of the Crown.

The power of the cardinals and bishops, themselves members of the great ruling families, was immense. They paid lip service to the Vatican, and the Popes tried to extend their own authority over the Spanish clerical hierarchy, but the liberalizing influences felt by Rome never reached Spain. Blithely ignoring the Pope and his Curia, the Spanish cardinals and bishops went their own way. They were fortified in this by their possession of rights enjoyed by the clergy in no other land: Spanish bishops

were nominated for their posts by the Crown, not by the Vatican, and the Pope merely confirmed these appointments.

In other ways the situation of the Church in Spain differed from the rest of Europe. First and foremost, medieval Spain was Europe's only totally Roman Catholic nation. The Moors and the Jews had been expelled in the fifteenth century, and the practice of Protestantism in any form was a capital offense, even in private among foreign diplomats accredited to the Court. The Reformation was unknown south of the Pyrenees.

The Church maintained its hold through an institution that had originated in Spain and had long been abolished elsewhere—the Inquisition. Certainly the spirit of the first Grand Inquisitor, Torquemada, still ruled the land. An individual could be summoned in secret by the Inquisition, jailed without trial and held indefinitely, tortured until he offered whatever confession was demanded of him, and then subjected to a variety of punishments, one of the more merciful of which was burning at the stake.

It is impossible to understand eighteenth-century Spain without some knowledge of the brand of Catholicism practiced there at the time—a mixed brew of Christianity and paganism. Superstition was a major facet of the Spanish religion, and the worship of God was accompanied by a show of barbarity and cruelty found nowhere else. In the religious processions that were a part of life in every major city, the figure of Christ on the Cross was carried through the streets dripping blood drawn from an animal for the purpose.

The bleak land had formed the religion, and together they had molded the people. Surely it was not incidental that the bullfight was the nation's most popular sport. The Spaniard was inward looking, proud, insolent, withdrawn.

He was generous to his friends, implacable in his hatred of his enemies and, above all, poor almost beyond belief.

Although the Renaissance had come to Spain, only a few men of genius had flourished in the arts. Cervantes was a national literary hero, but few authors had dared to follow in his footsteps. Velasquez and El Greco, the latter foreign born, were both revered, yet native Spanish painters were men of mediocre talents. The arts could not thrive in an atmosphere darkened by the Inquisition.

Despite all, the royal court maintained its pretentions. Monarchs and grandees, all tremendously wealthy, went to great pains to imitate their peers in other lands. Artistic competitions were sponsored, and the man who held the post of First Painter was a personage of consequence. But if an artist wished to avoid a summons by the Inquisition, he engaged in no experimentation.

One of the more backward cities of Spain was Saragossa, located in the northeastern portion of the country. This ancient capital of Aragon was noted for the fierce, belligerent pride of its citizens and for its extreme poverty. The nearby village of Fuendetodos was one of the most miserable in the province, and its inhabitants, who numbered scarcely more than one hundred, could look forward to little or no improvement in their lives. Most of them attempted a meager living by farming, but the brown, dry soil resisted their efforts. There was little water, the sun that shone down from a cloudless sky was scorching, huge rocks were scattered through the fields, and the mountains formed a somber, depressing background.

One of the poorest men in Fuendetodos was José Goya, who had known better days. The son of a Saragossa notary, he had been born into the tiny middle class but had shown no aptitude for his father's profession. On the

contrary, he moved lower on the social scale by becoming a mere artisan. Some flicker of artistic talent burned within him, and he had become a gilder, earning his living mainly by painting gold leaf on picture frames. His choice of such a vocation was itself remarkable, as the Spanish antipathy to labor of any kind was a national disease in the eighteenth century. Great nobles lived in complete idleness, the few members of the bourgeoisie imitated them, and those who worked for a living were shunned.

José Goya's wife may have been responsible for his ambition. Gracia Lucientes was no ordinary woman. Strong, handsome and resilient, she was by birth a member of the petty nobility. Her own father had been a *hidalgo*, or property owner, and she was therefore qualified to regard herself as an aristocrat. But the honor was an empty one. Approximately five hundred thousand Spaniards, or one in twenty, were entitled to call themselves *hidalgos*, even though their property in Fuendetodos consisted of no more than a few acres of land, a house, a pigpen and a chicken coop.

José and Gracia Goya, married in 1736, took up residence there from time to time, when they were not in Saragossa, and tried to scratch a living from the soil, though they were totally ignorant of farming. Their home more nearly resembled a hut than a house, although it was made of local stone. According to a description written by Francisco many years later when he was in one of his less fanciful moods, it consisted of a tiny living room and three bedchambers. The windows, irregular in shape, were tiny. A kitchen, separate but attached by a covered walk, was the largest room in the dwelling. Water was drawn from a well in the yard.

Of six children, two died. Struggling to make a living, the parents may not have been overly pleased with their growing family when a son was born on March 30, 1746,

only five months before the death of King Philip V. The baby was named in honor of St. Francis, and from birth he was intended for the priesthood, the only stepping-stone for the poor. He was spared that fate, however, because his brother Camillo decided at an early age to become a priest.

Although José Goya lived the live of a peasant in Fuendetodos, he was still a master gilder, so he and his wife probably regarded themselves as somewhat higher on the social ladder than their neighbors. At no time did they consider themselves nobility, however, and it was Francisco who later added the "de" to their family name, ennobling himself after he had already achieved a reputation as a painter. At that same time, Francisco commissioned a notary in Saragossa to trace the lineage of the Lucientes family. Since no family crest of any kind was ever found, he obligingly created his own coat-of-arms.

In spite of the family's poverty Señora Goya entertained ambitions for her sons, and Francisco, Tomas and Camillo were sent to a school in Saragossa owned and operated by the priests of the Order of Scolopes. The headmaster was a Father Joaquin, later described by his most famous pupil as "a man of great ignorance and even greater convictions." Since the Goya family was desperately short of funds, it must be presumed that the three boys were accepted as charity students, a feat that could have been accomplished only through the influence of some member of the Lucientes clan. Students attended school for approximately six months each year and were taught the rudiments of reading and writing. Most classroom hours were devoted to prayer and study of religious subjects.

Very little is known about Francisco's boyhood, although numerous stories were later invented to explain, or at least justify, his genius. According to one of the most

14

popular of these tales, the little boy was drawing on a smooth rock with a piece of charcoal one day when one of the most powerful noblemen of the area, the Count de Fuentes, happened to ride past. Struck by the child's talent, the Count arranged for him to be trained as an artist. A later, more widespread version of the same story had it that the passerby was a wise old monk. No evidence for either story has ever been discovered.

Posterity has never solved many mysteries about Francisco's youth. Where did he learn to handle a sword with the grace and finesse of a general's son? Where did he acquire such vast knowledge of the plant life of Spain? It could not have been from the good fathers of Scolopes.

The education Francisco acquired in his formal schooling was less than all-encompassing. Throughout his life his spelling was abominable and at no time did he give evidence that he read more than was required of him. But he accepted the discipline of the fathers without question: until the end of his days he always made the Sign of the Cross at the beginning of a letter, and rarely closed a communication without invoking the name of the patron saint of Saragossa, the Virgin of the Pillar, whose cathedral achieved world renown because of frescoes he painted on its walls.

All that can be said with certainty is that even as a very small boy, Francisco displayed an exceptional zest for living. He ate more than any other member of the family, although he remained slender throughout his boyhood and early adult years. When he went mountain climbing with his friends, he showed limitless energy. When he and other boys played, he was the natural leader. His brothers took orders from him.

Astonishingly, as far as is known, the young Francisco Goya showed no particular aptitude for drawing or painting. The pages of his school records merely indicate that

he was an average student and required more discipline than most. The rebellion against a stagnant and corrupt society that would be revealed in some of his greatest works took the form of mischievous insurrection in his boyhood. Many years later his lifelong friend, Martin Zapater, wrote that his strongest recollection of early years was that Francisco had always been in trouble with the authorities, that he always delighted in playing tricks on the good fathers of Scolopes, that he was always discovered and punished.

Posterity is deeply in the debt of Zapater, Francisco's classmate, who became of one Saragossa's wealthiest and most successful real estate owners and businessmen. The two friends saw each other frequently as adults, and their correspondence, which continued until Zapater's death in middle age, is the largest single record of Goya's inner feelings and the working of his mind. As boys the pair were inseparable, sharing every secret, and they were no less candid with each other as men. Goya regarded Zapater as his "other self" and withheld nothing from him, and it is likely that no one else, either his wife or the lovers so essential to him, ever knew what he thought or felt.

Spain drifted aimlessly for the first thirteen years of Goya's life under the rule of the mild-mannered King Ferdinand, who hated war and may have been intelligent enough to know that Spain might be dismembered if she continued to quarrel with the nations that had succeeded her as the major powers of western Europe.

In 1759 Ferdinand's half-brother, Charles III, mounted the throne. In the middle of the nineteenth century it was fashionable to portray Charles as a champion of progress and liberalism, perhaps because his grandson, Ferdinand VII, was a tyrant. Such claims were absurd. At best Charles can be described as a semi-enlightened despot

16

who showed a modicum of sense in selecting as his ministers such intelligent and aggressive men as the Count de Floridablanca. During Charles' reign, Spain crept toward enlightenment, but her people still lived as they had two hundred years earlier, abused and neglected by the wealthy grandees, always in terror of the omnipotent Inquisition, from which no one could escape.

In 1760 José Goya gave up his marginal existence in Fuendetodos and remained in Saragossa, where he resumed his trade as a gilder. He was no more successful than he had been before, however, and when he died years later a note was attached to his death certificate stating he had written no will because he had no property of any kind to leave.

Francisco, at fourteen, apparently gave up country life without regret and entered wholeheartedly into the more complex and relatively sophisticated existence of Saragossa. He was already familiar with the city, having spent about half of each year there since the age of seven or eight. From now on he would be a city dweller, ultimately feeling more at home in Madrid than anywhere else. But the mountains outside Fuendetodos haunted him as long as he lived, and their familiar shapes appear in scores of his paintings and drawings.

At the age of fourteen or thereabouts his formal schooling with the fathers of Scopoles ended and he became a student-apprentice in the studio of José Lujan y Martinez. There was no Spanish school of painting worthy of the name at the time, and Lujan, who had studied in Naples, copied freely from the current Italian and French modes, neither of which was particularly inspired. He took his coloring from the flamboyant Tiepolo. Perhaps the best that could be said for him was that his technique was orthodox and his designs accurate and well executed. He

had been appointed a painter to the royal court in Madrid, and the stature of this appointment enabled him to open a successful art studio in his native Saragossa.

Lujan was an honest, devout man, sincerely devoted to the principle of helping others less fortunate, so he offered two apprenticeships free of charge to boys whose families could not afford to pay his fees. One of these positions was awarded to young Goya, who must have displayed some talent to win his place, even though his early biographers insisted that at this time he had developed no deep or abiding interest in art. Lujan was highly regarded by the bishops of Aragon, and through their influence was appointed chief censor of art by the Inquisition. It is ironic that Goya, who later would cause so much trouble for the Inquisition, learned the rudiments of his profession from a civilian official of that dreaded organization.

Lujan's piety did not prevent him from knowing that no artist could function without a knowledge of the human figure. The unwritten Inquisition laws strictly prohibited any painter or sculptor from studying nudes or, as was done elsewhere, buying cadavers and dissecting them. So Lujan, at great expense, imported plaster casts of Greek and Roman statues that had acquired respectability because they were masterpieces. Goya's first detailed knowledge of the human body came from them.

The young Goya is believed to have painted crude "curtains" over the altar of the parish church in Fuendetodos with three figures beneath them. He was ashamed to look at them in later life, as they hardly indicated any trace of artistic talent. His subsequent correspondence with Martin Zapater hints at the intriguing possibility that he selected a career as a painter solely because, being ambitious, it was the only vocation that offered him an opportunity to rise in the world, other than the priesthood.

When he was fifteen and sixteen the boy also developed

his own, more accurate method of studying anatomy. He discovered girls and soon was bedding the young women of Saragossa with enthusiasm and growing expertise. Although he was short and had a stocky build, he was still slender, endowed with a strong animal magnetism that compensated for an ordinary, square face and features that lacked distinction. His dark eyes glowed, and in conversation he spoke with a zest that made him attractive to the opposite sex. He quickly developed an insatiable appetite for sex, and it was fortunate for him that women of all ages found him irresistible throughout his long life. At no time did he suffer a lack of eager mistresses. By his own admission he cultivated young ladies with the same fervor he showed in his pursuit of lower-class girls, but he never lacked discrimination, choosing only those who were pretty and lively.

Goya may or may not have been familiar with the Italian tradition that permitted art students to be wilder than other young men, but brawling was dangerous in Spain, where the Inquisition and the civil authorities alike frowned on street fighting. In repressive Spain, however, there was a streak of violence in the youth that even the danger of arrest could not subdue, and the young Goya loved a good brawl for its own sake. Although documentary proof is lacking, most of his biographers believe he was the leader of a gang from the parish of the Virgen del Pilar, a tough slum district. These boys traditionally engaged in hand-to-hand combat with a gang from the neighboring parish of San Luis, and the apprentice painter began to carry a double-edged sword, which he wielded with deadly effect.

According to one probably apocryphal story, at the age of sixteen he was cornered one evening near a notorious Saragossa brothel by three sword-bearing youths from the San Luis district. He was already expert in handling a

19

blade, and his enemies were no match for him. Supposedly he killed one and severely wounded the others without himself suffering a scratch. According to this story, he was forced to flee to Madrid for several months until the furor over the incident died down. No record of any such battle has been found in the archives of the city of Saragossa, nor did it appear in the later dossier on Goya compiled by the Inquisition, but the absence of written reports does not necessarily mean that the story is untrue. Certainly Goya was a master swordsman who never shrank from a fight.

His family's situation was anything but promising in 1763, when Francisco was seventeen. José Goya had recently died, and the best that could be said for Señora Goya's situation was that she owned the house in which she lived and enjoyed a tiny income from her property in Fuendetodos, so she would never be destitute. Camillo was to enter the priesthood, but had no powerful patron under whose influence he could find advancement. Tomas had entered his father's trade and would become a gilder. Somewhat cleverer with his hands than his father, he could earn a living for himself and give his widowed mother a small sum every month, but he would never become wealthy. Their sister Rita's future was clouded by the lack of a dowry that would enable her to marry a man of standing and substance.

Neither fame nor fortune awaited Francisco in Saragossa, for a Spanish painter could achieve renown and wealth only at the royal court. That, in all probability, is the reason Goya went to the capital to continue his studies, although another explanation has become legendary. According to this colorfully romantic story, he had an affair with a beautiful, raven-haired niece of the Count de Fuentes. The girl's brother, demanding that her honor be satisfied, fought a duel with Goya and was wounded. As

dueling was forbidden, under Spain's barbaric code of justice Goya could have been sentenced to the loss of his right hand. Such punishment would have reduced him to the status of a beggar, so he fled to Madrid in disguise, wearing clothes supplied by his young mistress. The story has persisted, even though grounds for it have never been found.

Madrid in late 1763 was in a state of constant uproar, owing in large part to the misguided attempts of Charles III to force his capital to abandon medieval customs. A royal decree that forbade throwing garbage out of windows was ignored by indignant citizens of every class. The capital's first street lamps, installed by royal decree, were smashed by heretofore respectable citizens who insisted that such illumination was a crime against nature. And the *Majos* of the city were in a wild uproar of their own.

The *Majos* of Madrid constituted a group unique in all of Europe. They formed a separate class, regardless of vocation, including in their ranks doctors and notaries as well as day laborers. Regarding themselves as the only true *Madrileños*, they refused to obey any laws they disliked and clung to their own distinct customs. Among these was the wearing of broad-brimmed slouch hats, pulled low over the eyes, and long capes that covered a man from his shoulders to his ankles. During a crime wave that disturbed the peace of Madrid, it had been impossible for the constables or even royal troops to identify culprits wearing the *Majo* hat and cape.

King Charles, who habitually failed to realize that his poverty-stricken subjects were sustained principally by their great pride, issued an edict forbidding the wearing of the *Majo* cape and hat. Any man who disobeyed could be imprisoned for as long as six months and exiled from Spain for as long as four years.

The *Majos* angrily defied the law, and the King's First Minister, Esquilache, was equally determined to enforce it. The battle raged for more than two years, until in 1766 Charles III and his eldest son, the Prince of the Asturias, later to become Charles IV, returned to the city from a day of hunting and suddenly came face to face with an angry mob. The lives of the monarch and his heir were saved by a battalion of household troops, but the people rioted for a day and a night, burning and looting, and forced Charles to rescind the unpopular law.

The impressionable seventeen-year-old Francisco Goya had arrived in Madrid in late 1763 at a time when the city was beginning to seethe. Himself in rebellion against all authority—the prerogative of a spirited art student in other lands—he must have been stunned by the realization that his attitudes were not unique. In Saragossa he had been something of a pariah, frowned upon by his elders because of his lack of desire to conform, but in Madrid thousands felt as he did.

He promptly took up residence in a *Majo* quarter, where he felt at home. Madrid, with a population of almost four hundred thousand, was filled with pretty girls who flirted with the dashing young newcomer. There were cheap taverns everywhere, places where one could find good, rough food and strong brandy, and, above all, the companionship of kindred spirits.

Francisco fell in love with Madrid, and the romance lasted for the rest of his life.

III
Wild One

Francisco Goya spent the next three years in the great city, remaining there until 1766, when he was twenty years old. Relatively little is known about his activities during this period. Hints in his correspondence with Martin Zapater and later comments and allusions help piece together the major incidents of his life during these years. Presumably he wrote to his mother, to whom he remained close throughout her long life, but those letters have been lost.

The identity of his first teacher or teachers is unknown, but it is certain that he became an apprentice in the studio of one of the capital's painters. He had no funds and could not have supported himself unaided. He would have defied all the traditions of his chosen profession, furthermore, had he tried to study alone. No one, not even an unsung genius, could have gone that far.

Eventually, perhaps late in 1764, he entered the studio of Francisco Bayeu, regarded by posterity as a minor figure but considered in his own time to be the most important Spanish painter of the age. He later held the title of

First Painter to the Court of Charles III, and in that capacity did portraits of various members of the royal family. His position won him major commissions from wealthy grandees, too, and he also painted frescoes in several churches. Portraits and sketches of Bayeu done by Goya in later years reveal him as a prim, rather prissy man with compressed lips and humorless eyes. He was intellectually myopic and his talents were limited, but he stressed technique, so his new apprentice received a sound education in the basics of painting.

In any event, Bayeu was wealthy and famous and therefore had his choice of apprentices, so it was something of a small triumph for Goya to have been taken into his studio. If Bayeu is to be commended for little else, at least he recognized the potential of the young man from his own native city of Saragossa, who had done nothing to warrant such optimism regarding his future.

Goya was enjoying the time of his life during these years, and in this period one first sees the separate, distinct aspects of his character. Goya the artist was a grimly serious young man with soaring ambition. He yearned for financial success and respectability. More than anything else, as he confided repeatedly to Zapater, he wanted to become the finest Spanish painter of his time.

The other Goya was a rakehell, a lowlife, a wild and untamed spirit. The complete hedonist, he sought pleasure wherever he could find it, principally in working-class taverns, since he could not afford more expensive places, and in the beds of various young women, including several attractive *Majas*. His own background was humble, and he felt at home with artisans and laborers. In later years, when he associated with royalty and members of the powerful twelve families, he still went regularly to the workers' districts for his relaxation.

As an adult Goya acquired a deserved reputation for his

ability to consume large quantities of liquor without becoming intoxicated, but in his late adolescence he frequently became involved in drunken tavern brawls. It is significant, however, that there are no records of his arrest by the constabulary during this time, so it must be assumed that he enjoyed a measure of license because he worked in the studio of Francisco Bayeu.

According to one of the more fascinating Goya legends, he learned the art of bullfighting during his adolescence, and in Madrid he actually fought a number of bulls in the ring. These rumors circulated widely during his own lifetime after he had won general recognition as the country's greatest artist, and he told his friend the poet Moratín that they were true. He never admitted this to others but he did not deny it either. He was fond of bullfighting in his younger years, and the many sketches, cartoons and etchings he made on the subject indicate a vast technical knowledge of the matador's profession. He later wrote Zapater in a fit of despondency that he could find release only at a bullfight, and painted *Bullfight in a Small Town* at that time.

Apparently Goya was already endowed with the boundless energy that ultimately enabled him to pour out such a remarkable body of work. He could spend a night at a tavern, take a girl to bed and, after little or no sleep, put in a full day hard at work in Bayeu's studio. Others suffered because of their excesses, but Goya blithely burned the candle at both ends—and got away with it.

When the young painter was twenty years old he entered a competition sponsored by the Academy of San Fernando, a sort of combined artists' guild, private club and semi-official government body. Membership was obligatory for all those who wanted to earn their living as painters or sculptors, and it was the custom to grant provisional membership to the winners of the first three

places in the contest. The same subject was assigned to all of the students entering the competition, and in late January, 1766, contestants were informed of the subject they were to paint: "Martha, Empress of Constantinople, presents herself to King Alfonso the Wise at Burgos and requests of him one third of the sum that the Sultan of the Egyptians had set as the ransom for the Emperor Baldwin, her husband. The great Spanish King orders that she be given the entire sum."

Nine members of the Academy comprised the board of judges, with Bayeu as chairman. Others, among them men regarded by their contemporaries as leading artists of the day, included Alexander Gonzalez Velasquez, Antonio Velasquez, Felipe de Castro, Ventura Rodriguez and Mariano Salvador Maella. The paintings were submitted to the jurors on July 20.

Two days later the candidates were summoned by the board and were given a second assignment, which they were required to complete within two hours. They were asked to paint: "Within sight of the Spanish army in Italy, Juan de Urbina and Diego de Paredes discuss which of them should be given the arms of the dead Marquis de Pescara."

In later years Goya achieved world renown for the speed with which he could complete a painting, but at the age of twenty he was apparently less sure of himself. The first prize, a gold medal, was given to Bayeu's brother, Ramon, who was also twenty years old. Second place was given to a youth who, as far as is known, never again painted anything, and third prize went to Gregorio Ferro, who struggled in vain for many years to gain distinction. Francisco Goya failed to win even an honorable mention.

Undaunted by his failure, he was determined to continue his studies in Italy, considered obligatory for every man who wanted to become a professional artist. During his

years in Madrid, Goya had seen the works of two Italians who had worked in Spain. Giovanni Battista Tiepolo was the more distinguished of the pair. In a series of prints, the *Scherzi de Fantasia*, he abandoned the formalism that was the bane of current Spanish painting and recorded his dreams in an unexpectedly simple style. In view of Goya's own sharp break with tradition in later years, he must have seen these unique prints.

Anton Raphael Mengs, the other Italian artist, became the favorite painter of Charles III during his stay in Spain from 1761 to 1769. He painted many portraits, all of them smooth, fairly realistic and mildly flattering to his subjects. Goya absorbed what the work of Mengs had to offer, but he was now planning on a larger scale: Italy, the magnet of all artists, the home of the Renaissance, was beckoning.

How Goya financed his Italian sojourn soon after is unknown, for he had neither a wealthy patron nor money of his own. It is likely that he obtained commissions from various grandees to make copies for their galleries of various masterpieces on exhibition in Italy. This was a common practice of the time, and in almost no other way could he have supported himself.

According to a story that has persisted for almost two hundred years, Goya was forced to flee to Italy because he killed the son of a prominent grandee in a duel over a girl. Supposedly she was a *Maja* and Goya's mistress, and he took up arms on her behalf when the young nobleman pressed his unwanted attentions on her.

Many of Goya's escapades have been authenticated, but no verification for this tale has been found. The identity of a *Maja* would have meant nothing at the time, but the death of a grandee's son in a duel would have been a serious matter, and the event would have been recorded. The truth was probably less romantic: Goya went off to

Italy to prepare himself for a life as a painter and was not a refugee.

In later life Goya took pride in the fact that he traveled to Italy at his own expense and supported himself there by his own efforts. He never denied the story that he worked his way across Spain to Barcelona as a member of a small troup of traveling bullfighters and that he earned enough to pay his passage to Naples. In fact, he later signed one of his letters to Zapater, "Francisco de los Toros."

However he managed it, he spent a short time in Naples, where he is believed to have indulged in waterfront brawls, and then went on to Rome. Rome! The art riches of the city stunned him, and he reveled in the works of Raphael and Rubens, Michelangelo's Sistine Chapel and the paintings of a score of other great artists. A decade later he commented simply, "I was overwhelmed by all that I saw."

Goya was impressed by more than the masterpieces. Rome was the first great metropolitan center that the youth from the foothills outside Saragossa had ever seen. Madrid, in spite of its size, was a sleepy, provincial town, but Rome was the wonder of the western world, attracting men who spoke many languages and observed different customs.

The young man demonstrated his own provincialism. He tried Roman food, English food, French food, and finally decided that none was as kind to his palate as Spanish fare, so he ate most of his meals at a small inn whose clientele was almost exclusively Spanish. Proud, reserved and shy, in spite of his bravado, he made few friends in Rome, although he was inevitably drawn to the taverns of the Trasteveri, the famous working-class district on the banks of the Tiber. He made few attempts to adapt himself to the old adage about Rome, and remained Spanish

in every way. He mastered Italian but spoke the language only when necessary and was happiest when conversing in his own tongue. He wore the boots, cape and broad-brimmed hat of the *Majo*, and though his attire made him conspicuous, he refused to dress as did the Romans.

According to one of the more fascinating legends about this period of Goya's life, he supposedly met Jacques Louis David, two years his junior, who was destined to become the greatest French painter of the age, and the pair were supposed to have held many conversations on their concepts of the directions modern art should take. Excerpts from these talks have actually been included in the early biographies of both men, revealing rare insights as well as the ability to think in long-range terms. These conversations, however, were simply inventions of a biographer, for Goya returned to Spain in 1771 and David did not arrive in Italy until 1775.

Another, equally romantic tale might well be true, and about ten years later Goya tacitly admitted it, although he took care not to offend the Spanish Crown. The ambassador of the ambitious Catherine the Great of Russia, who was trying to further Peter the Great's task of transforming St. Petersburg into a cultural center, was charged with the mission of luring promising young artists to Russia. The ambassador approached Goya with a flattering offer, but emphasized that one condition was attached. If Catherine's largesse was accepted, the artist would be expected to remain in St. Petersburg for life. Goya, who had won no competitions, established no reputation for himself and was living precariously, refused. His roots were in Spain: he loved the land, her people and her way of life. His future was in his homeland, and he could not move to alien soil.

The most shocking incident of Goya's stay in Italy, according to some authorities, occurred late in his sojourn,

probably in 1770, when he was twenty-four years of age. Whether he was devout or merely attended Mass regularly out of habit is an unanswerable question, but he did go to church every Sunday and on holy days. On one occasion, while sitting in the pew of a church whose identity has never been discovered, he caught the eye of a young nun, known to posterity only as Sister Martha, a member of the choir. She also took note of him.

How the young couple managed to meet regularly is something of a mystery, but Sister Martha found a way to sneak out of her convent late at night. According to legend, they fell in love. A crisis quickly developed when the mother superior of the convent learned that Martha was pregnant.

Goya was equal to the occasion, however, and before the girl could be discharged from her order in disgrace and subjected to severe punishment, he managed to rescue her from the convent. Presumably she went back to the small Italian town from which she had come. Whether she had her baby is unknown, for she vanished from history.

The incident caused a tremendous furor, and Goya was saved from a trial and certain imprisonment only by the intervention of the Spanish ambassador. After due consideration of the matter the embarrassed Church authorities decided it was best to avoid a scandal that would be relished by anti-Catholics throughout Europe, and the charges were quietly dropped.

If this episode did occur, the culprit was no longer welcome in Rome. At this time Goya went off—suddenly—to the Duchy of Parma, the most curious of the Italian states. Its ruling house had long been related to the Bourbons, who sat on the throne of Spain and also had close ties with France. Consequently those two languages were

spoken exclusively there, and Italian was rarely heard. Spanish was predominant, so it was not difficult for the visitor who walked down the streets of Parma to imagine himself in Madrid or Seville. The dress, food and customs as well were Spanish.

Painters at the court of Don Philippe, the Grand Duke, slavishly copied the neoclassical approach that Mengs had popularized in Spain itself. The Grand Duchess, Louise Elizabeth of France, was determined to transform her court into a "little Versailles," and in January, 1771, a short time after Goya's arrival, an artists' competition was announced. Its theme was "The conqueror Hannibal, from the summit of the Alps, for the first time sees the Italian countryside below him."

Goya entered the contest, and the results indicated that he had learned a great deal since leaving Spain. Members of the Academy of Parma acted as judges, rendering their findings on June 27. Second place was awarded to Goya, his citation stating, "the Academy has remarked with great pleasure a beautiful handling of the brush, a warmth of expression in Hannibal's eyes, and a quality of grandeur in the attitude of this general." The Academy also subjected the artist to criticism: "If M. Goya in his composition had wandered less from the subject as outlined, and if he had been more truthful in his coloring, he would have acquired the votes for the first prize."

The competition was a milestone in Goya's career, the first time he had won recognition of any kind. But his failure to win first prize was a severe blow, and his entire future was in jeopardy. He was twenty-five years old, and after more than three years of intensive study in Italy had received only one minor citation.

Goya knew he had to make a major decision, and his first step was to put Italy behind him. He wrote a brief,

31

downcast letter to Zapater, indicating that he was coming home and hinting that he might give up his profession. "I am unsure of my intentions," he said, "and will discuss them with you when we meet."

Retracing his steps, he traveled to Naples, obtained passage to Barcelona and then, in order to save money, walked all the way to Saragossa. Footsore and discouraged, he was almost penniless when he reached his mother's house.

Saragossa seemed even smaller and more provincial than he had remembered. The streets were as narrow, dark and twisting as an Arab town in North Africa, and the stench was offensive, even in an age when sanitation was unknown in Spain. The people's horizons did not extend beyond the boundaries of Aragon; they knew nothing of affairs in the outside world. Life was simple, and most people thought only of their need to earn money for food.

Francisco Goya could not decide whether to continue his career or find another. History is filled with such crises in the lives of great men, most of whom decided to press forward at all costs. Goya, however, was a supreme realist, and he reasoned that if he could not earn a living as a painter he would find something else to do. The trouble was that he was trained for no other kind of work, and at twenty-five, an age when others were well launched on their careers, it was too late to begin again.

Sheer good luck intervened on his behalf, tipping the scales and ultimately making his decision for him. Construction work had just been completed on the magnificent Catedral del Pilar, the cornerstone of which had been laid almost a hundred years earlier, and the bishop and his priests were eager to have the small Chapel of the Virgin decorated without delay. They had discovered in

dismay that established artists charged outrageous prices. Antonio Gonzalez Velasquez had come from Madrid to do a single dome in the cathedral, and they had been forced to pay him twenty-five thousand reales in gold.

Father Camillo Goya took credit for suggesting to the bishop and his staff that they summon his brother and offer him the job. In fact, Camillo used this alleged favor to extract money from Francisco for many years thereafter. Some biographers have said that Martin Zapater, already a man of consequence in the city, dropped a word to the good fathers. But in reality Francisco Goya was not as badly lacking in reputation as he himself imagined. He was called to the cathedral on the initiative of the priests themselves.

The bishop, Don Mathias Allué, opened negotiations with the young artist, and liking his ideas for the decoration, offered him fifteen thousand reales. The sum was far smaller than any established artist would accept for a major work, but Goya was in no position to bargain. Besides, if he became a day laborer, the only other work for which he was suited, it would take him years to earn that amount of money. He not only agreed to the figure, but also accepted the conditions imposed by Don Mathias— proof he could paint a fresco, and submission of a fully detailed sketch to the Academy of San Fernando for approval.

The contract was signed on October 21, 1771, and that date marks the start of Goya's career as a professional artist. He worked with concentrated fury, for the first time showing the speed that later dazzled everyone who had any familiarity with art. In two weeks he submitted a fresco sample. He was authorized to proceed to the next step, and early in January, 1772, after working a scant two months, he produced a detailed sketch. Don Mathias and

his subordinates liked it so much they decided there was no need to submit it to the Academy, and Goya was paid five thousand reales, the first portion of his fee.

He painted the frescoes in less than six months. Knowing Saragossa's conservatism, he showed no hint of the neoclassicism so popular in Madrid, none of the sardonic realism that was later to become his hallmark. The frescoes resembled those found in scores of other provincial cathedrals and churches throughout Spain, and laymen joined the clergy in praising the young artist when the work was exhibited in July, 1772. Goya's reputation was made, at least in Aragon, and he was able to forget all thoughts of working as a laborer.

Only a few days after the public was permitted to see his work, Goya was approached by Don Tomas Lopez, the head of a mammoth monastery, the Cartuja Aula Dei, located on the outskirts of Saragossa. The walls of the monastery were bare, and Don Tomas offered Goya a staggering challenge: in return for the payment of one hundred thousand reales, he would be required to fill all of the walls with paintings. Some walls were as wide as thirty feet, and Goya quickly estimated that he would need to do eleven major paintings in order to fulfill the assignment.

How could he reject a fee of one hundred thousand reales, far more money than any member of the family, including his delighted mother, had ever seen. So he accepted, plunging into the task without delay. Most authorities believe he spent the better part of two years on the project. Instead of working in fresco he painted in oils directly on the bare plaster walls, which speeded the process.

The monastery has now fallen into disrepair due to the ravages of time, wars and the weather, and the greater part of his work has been destroyed. What remains,

however, indicates a growing self-confidence. His touch was sure, his technique unfaltering, his use of color masterful. His themes were religious and banal—which was precisely what the monks wanted, indicating that he had already acquired a chameleonlike ability to satisfy his customers. He was in no way innovative, refusing to experiment at the expense of simple, devout and conservative men who were paying him a large sum of money to produce paintings that would please them.

Between 1772 and 1774 the wall paintings at the Cartuja Aula Dei were not Goya's only commission. He was proudly regarded as Saragossa's painter-in-residence, and local churchmen and nobles made more offers than he could accept. He worked on several large paintings in the parish church of Remolinos, and these figures of saints evoke a strong hint of the Goya to come. His contrasts in lighting were abrupt, and the features of some of his saints, St. Gregory in particular, were a trifle exaggerated. Perhaps he did not yet realize it, but he was approaching the sharp, realistic style that would make him immortal.

He also painted a number of conventional religious pictures that were exhibited in the Sobradiel Palace in Saragossa. Here and there were touches of ugly, somewhat heightened realism, but he was feeling his way, and apparently he was still reluctant to experiment.

By the time Goya reached his late twenties he had good reason to feel satisfied with his progress. He was still unknown in Madrid, and no one outside of Spain had ever heard his name mentioned, though he was the most prominent painter of Aragon. By the modest standards of Saragossa, he was earning an exceptionally comfortable living.

He bought new furniture and a small diamond ring for his mother, made gifts of cash to Camillo and Tomas, neither of whom was bashful in asking for "loans," and started a dowry fund for his sister, Rita. His own style of

living changed little. He continued to dress modestly, usually in the style of the *Majos* of Madrid. He drank moderately, finding it difficult to indulge himself when he was working so hard, and he continued to eat simple foods, although his appetite was large. He still lived with his mother, sleeping in the same room he had used during the latter part of his boyhood.

Two or three nights each week he failed to come home, and Señora Goya was wise enough not to ask too many questions. A great many of Saragossa's eligible young ladies would have been delighted to marry him, but he avoided them, preferring the company of the less virtuous, whom he found in the working-class taverns. As Goya matured, his sexual appetites remained insatiable.

Having proven to himself that he could succeed as an artist, Goya grew increasingly restless in Saragossa. He had accepted commissions that kept him busy for several months after he completed his work for the Carthusian monastery, but he had no intention of making himself dependent upon the provincial nobles of Aragon. Madrid beckoned, and he still regarded the capital as his real home.

So he plotted his course carefully, his sense of realism as ever-present in his personal relationships as it was in his later work. Taking stock of himself in his late twenties, he knew he could paint and that he needed clients who were available only in Madrid. He was still slender, although his chest had thickened, and he scorned a wig, preferring to show off his own thick hair. One of his greatest assets was his bachelor status, which he was willing to trade if he could make a deal to his advantage.

On many occasions throughout his adult life Goya was accused of being opportunistic, and he cheerfully admitted to the charge. It was impossible to interpret his subsequent actions in any other way.

IV
Domesticity and Danger

On a visit to Madrid in 1773, Goya made a bid for the hand of the sister of his former master, Francisco Bayeu, now a Painter to the Court of Spain. After a whirlwind courtship he persuaded her to marry him. The wedding took place on July 25, and the couple returned to Saragossa.

Early biographers who knew Goya's love of beauty found it difficult to understand why he married the plain Josefa Bayeu. The remarkably similar portraits her husband and her brother painted of her reveal an austere woman whose mouth and eyes carry a touch of arrogance. Her features were ordinary, her dress drab, and only her long, dark red hair was attractive.

Goya must have married Josefa for the help her brother could give him in his career. His letters or actions never indicated that he was in love with her, nor she with him. Their arrangement was hardly shocking according to the middle-class Spanish standards of their time. A man was expected to marry a good woman who could bring him a substantial dowry that would further his career. Instead

of a dowry Josefa could offer Goya her brother's assistance. A husband's duty was to provide a living for his wife, protect her from the outside world and sire her children, while a wife's was to make a home for her husband and rear their children. If she was unfaithful to him he could put her aside, although the Church did not permit divorce. If he was unfaithful she was expected to shrug, look the other way and ignore the matter.

Marrying for love was the prerogative of the very poor, who had nothing else to offer, and of the very wealthy and powerful, who had the leisure in which to behave frivolously. In all probability it did not occur to Goya and Josefa to love each other. They had made an arrangement that both found satisfactory, which also pleased Francisco Bayeu, the head of his family. He could see in Goya a man of great promise, an artist who had already demonstrated his ability to earn a living, and although the Painter to the Court might have preferred a brother-in-law of greater reputation and solidity, he knew that under his sponsorship Goya would prosper. Josefa, after all, was neither a great beauty nor an heiress. She was so plain that few men had been attracted to her, and although she could sew, cook, play the lute and knew enough arithmetic to do household sums, she had almost no formal education. She could have done far worse, her family well may have reasoned, than marrying Francisco Goya.

By the time Goya returned to Madrid late in 1774, after an absence of some five years, his pockets were filled with silver, his mind was seething and his ambitions were limitless. Francisco and Josefa rented a flat at number 66, Carrera San Geronimo, in a middle-class district.

Certainly Bayeu came to Goya's aid almost immediately, and in the process helped himself, too. The royal tapestry factory of Santa Barbara—Spain's attempt to reply to the tapestry industries of France and the Low-

lands—had been in disrepair for many years. Charles III was eager to bring new industries to Spain so she could compete as an equal with the other nations of western Europe. But his many plans fell through, in part because they were conceived poorly, but even more because of the lethargy and indifference of his subjects.

So the King was ripe for Bayeu's suggestion that the factory begin to operate again (whether this was originally Bayeu's or Goya's idea we do not know). There were still some elderly weavers in Madrid who knew their business, and others could be imported with little difficulty from France, where there was an overabundance of the trade. Two, perhaps three, accomplished artists would be needed to draw cartoons from which the weavers would work. It may have been unnecessary for Bayeu to remind his Catholic Majesty that the profits of the enterprise would go into the royal purse; all Bourbons were avaricious, and Charles, who sometimes spent money faster than it came in, was always looking for new sources of revenue.

The King approved. Mengs, who had returned from Italy, was placed in charge of the enterprise and immediately summoned Bayeu to a conference. They agreed that the new tapestries should depict popular, pastoral scenes. A sum of twenty-six thousand reales was set aside for cartoons each year, and Bayeu himself would receive ten thousand. He promptly obtained commissions for his brother, Ramon, and for Francisco, and later for other artists; each was to be paid eight thousand reales per year. The precise number of cartoons that each would provide was not determined. The individual artist would produce whatever was necessary.

The factory first needed to be restored by experts brought from Paris and Lyons for the purpose. Then workmen had to be hired to make the tapestries, and as

affairs in Spain always moved at a stately, maddeningly slow pace, months passed until operations began in the spring of 1776.

Goya, who had never drawn a cartoon in his life, spent hours practicing the new art. He showed his work to the new factory foreman, who quickly informed him that his painting technique was unsuitable for tapestries. The many details would clog a tapestry, making it difficult for a workman to execute, and intricacies and shadings would be lost. The ideal tapestry, Goya discovered, portrayed a simple scene in clear colors.

In June, 1776, he was commissioned to make one of a series of tapestries for the palace of the Prince of the Asturias, later to become Charles IV. Goya needed no one to tell him that this opportunity could in the long run be worth far more than eight thousand reales a year. If he made a good impression on the royal family, particularly on the Crown Prince, his fortune would be made.

He worked exclusively on the cartoon for nearly four months, destroying one effort after another until he was satisfied. Finally, late in October, he delivered his drawing to the factory. Entitled *Picnic on the Banks of the Manzanares*, it closely resembled the designs of the world-renowned Gobelin factory in France. The dark central figures were grouped against a light background, with large areas of a pleasant blue sky.

The painting was a complete success, although the factory workers complained that his drawing was still too complicated. Prince Charles sent word via an equerry that His Royal Highness was pleased, and Goya immediately knew he had found an opening to the royal palace.

He worked furiously on a series of cartoons in 1777, simplifying and refining his work even more. Some of these have become classics, the first works to demonstrate the arrival of a new master on the scene. *The Parasol,*

depicting a typically Spanish girl with a proud, erect bearing, black hair and pale skin, achieved overnight fame. *Dance at San Antonio de la Florida*, the airiest and most light-hearted of the cartoons, delighted Prince Charles. *Promenade in Andalusia* was taken to France a quarter of a century later by Joseph Bonaparte, and having been done tongue-in-cheek in the French style, it enhanced Goya's reputation in that country. The thirty-one-year-old artist was showing off his facile versatility, and viewers were dazzled, *Rixe à la Venta Nueva* was done in the style of a Flemish tapestry, and there were some who swore he had copied it from a cartoon done by an unknown Antwerp artist.

What did more for Goya's reputation than all else, however, were the tapestries that were hung at the Prado. In these he specialized in pictures of children, and the results were so simple, so indicative of the mood of childhood that even Bayeu, who rarely liked his brother-in-law's work, complimented him.

Financial success came slowly, although Goya wrote to Martin Zapater with a show of bravado, "I have some twelve to thirteen thousand reales a year; with that I live just as contentedly as the most prosperous of men." Either Goya knew no better, which is unlikely, or he lied.

Zapater visited Goya and his wife in 1777, and his account to his own family, together with what is known of the middle-class style of living of the time, make it possible to create a mosaic of the way Goya lived. His apartment, for which he paid a rent of no more than two thousand reales a year, was small and cramped. The living room contained only a few chairs and tables. All the walls were bare, as was customary, but this so annoyed Goya that in later years he decorated the walls by painting scenes on them in oils. Goya and Josefa slept in one tiny bedchamber, and their first son, Vicente Anastasio, born in

January, 1777, occupied the other. There was a small studio with the obligatory north light but this room, too, contained only essential furniture. The largest room was the kitchen, the warmest in winter, as it was the only one that boasted a fireplace. The floors were tiled, the middle class faithfully copying the aristocracy, and in winter they were covered with mats of woven reeds, which became threadbare and began to fall apart by spring.

Goya's manner of living changed drastically later in life when he became wealthy, but his food tastes remained simple. His breakfast usually consisted of sausages and bread, and on rare occasions he ate fish. The only beverage was watered wine, sometimes flavored with lemon as he didn't care for sweets. Bread, which was cheap, was a staple at all meals, and lamb, beef and pork were also inexpensive. At noon and again at night he usually ate a heavy stew of meat, potatoes and vegetables from a pot that simmered throughout the day. Some middle-class families occasionally enjoyed delicacies that only the aristocrats ate regularly, among them rich cakes and French soups, but Goya had no desire to emulate the wealthy and was content with fare slightly better than that of peasants. He had been reared on plain, inexpensive food, and his tastes never changed.

Now that he was in his thirties, his years of heavy drinking appeared to be behind him, at least when he ate at home. Josefa did not care for spirits, which were considered a luxury, and the wine served at the Goya table was always watered. This, however, did not prevent the artist from occasionally gulping down large quantities of raw, cheap brandy in the taverns he frequented at night. But he never forgot that he was a responsible family man now, and his drinking was controlled.

Life must have been lonely for the young couple. Josefa

had few friends, as she had been reared in isolation, in accordance with the custom of her class, which was careful not to expose its daughters to temptations. Goya, still a stranger in Madrid, was not yet pursued by the nobles who later clamored for his company. As he was never known to take the roisterers and harlots from the tavern back home to his bourgeois wife, Josefa enjoyed no company other than her relatives. She and Goya shared little if any social life together.

His biographers have dwelt on Goya's neglect of his family, but in all probability he was no different from other men of his time. He faithfully provided for his family and was genuinely fond of his children—Goya more than most, as he loved all children. His grief was deep and genuine in the many tragedies he and Josefa suffered through the years. They brought twelve children into the world, but only one survived to adulthood and outlived his parents.

Goya may have been less faithful to his wife than most of his contemporaries. His sexual appetite in no way diminished through the years, and he bedded scores of women, more than he could count or remember. Prostitutes were fair game, and he knew many of them; he also had affairs with *Majas*, shop girls, female street vendors and anyone else who flirted with him. These women meant nothing to him individually, though his notebooks were filled with sketches of them. Josefa was the rock on whom he built his domestic life, but he needed his affairs. He may have been something of the classic Don Juan who required continual proof of his manhood.

Josefa shared few of his interests, and even though she had two brothers who were artists, one of them the most successful in Spain, she cared little about painting. Almost totally without formal education, she devoted herself ex-

clusively to her home and children. Goya, on the other hand, displayed the typical restlessness of the creative man who was fascinated by every aspect of life.

Unable to communicate with his wife, he spent most of his nonworking hours roaming through the streets of the city. The people of Madrid were his real love, and he watched them in every mood, selling their wares from carts, leaving the Confessional proud and unrepentant, brawling and making love, enjoying picnics in the open, eating, and sleeping and dying. They made an indelible impression on him, and his memory appears to have been phenomenal. In due time he would record their activities and leave a magnificent monument to Spanish life in the late eighteenth and early nineteenth centuries.

Over a period of three years he delivered thirty tapestry cartoons to the Santa Barbara factory, more by far than either of the Bayeus or the other artists who were asked to contribute. Almost all of them depicted aspects of Madrid life.

In 1777 Goya received his first warning of what was to come. He had a strong, supple body, and had never been sick for a single day. Suddenly and without warning he fell ill and was forced to take to his bed. No details of his malady or its symptoms are known, and all that posterity has been able to learn is that Goya was alarmed. Josefa summoned a physician, but most eighteenth-century Spanish medical practitioners were charlatans, though their colleagues in France, England, the Low Countries and the German states were by now making rapid strides in scientific diagnosis and cure. In any event, Goya recovered quickly, and made the mistake of dismissing his illness.

In view of the physical calamities he suffered in later years it has long been suspected that he had contracted syphilis, perhaps in his early to mid-twenties. If so, his

sickness in 1777 was its first serious manifestation. It would not be surprising if he had contracted syphilis in one of his innumerable affairs. Venereal disease was rampant in Spain, and for a quarter of a century or more it had reached pandemic proportions, affecting all classes. Eveyone, including bishops and grandees, erroneously believed the disease had come to Spain from the New World. Almost nothing was known about syphilis or its cure. Its victims suffered, some went mad and many died, but no one was ever cured.

His illness obviously had no effect on his way of life. He continued to sleep with women several times each week, and the long-suffering Josefa had to pretend she knew nothing of his activities.

His ambition was in no way diminished by his illness. In the past he had experimented with etchings but his efforts had been crude, conventional and mediocre, though his stroke was firm. Now, while recovering from his illness, he formed a grand resolve. Velasquez was the greatest artist in Spanish history, but the people at large knew nothing of his work, principally because most of his paintings were not on general exhibition. So Goya proposed to make etchings of them, and in that way enable the public to buy inexpensive reproductions they could mount in their own homes.

It is difficult to determine when Goya first became infatuated with the work of Diego Rodriguez de Silva Velasquez, who had died in 1660. No aspiring painter in Madrid could fail to see scores of Velasquez' paintings and to recognize the genius of their creator. His naturalistic style, his lifelike portraits, his attention to detail made an indelible impression on the young Goya, who studied his paintings in the Prado and in the galleries of Madrid palaces, which could be visited by professional artists.

Until Goya, no Spanish artist had been deeply influ-

enced by the great master. Every painter paid lip service to him, but no one tried to walk in his footsteps. Velasquez' later works tended toward the Impressionist, and naturalism was not fashionable; neoclassicism vied with the baroque for supremacy.

Goya looked far beyond the Spanish imitators of the current French and Italian schools, steeping himself in the works of Velasquez. In 1778 he made eighteen etchings of Velasquez' work as part of a campaign organized by Mengs to bring the great master's work to the attention of the general public. The etchings were crude, however, in part because Goya could not completely suppress his own individuality. As a commercial enterprise his venture was a failure.

But as Goya himself later said, he learned more about painting in that one year, at the age of thirty-two, than he had in his long apprenticeship. Velasquez and Rembrandt, the two greatest masters of portraiture, had a quality in common: both realized that every human being was unique, and both brought out the individuality of their subjects. Goya was also beginning to study engravings of Rembrandt's paintings at this time. For the first time, perhaps, he could sense his own destiny. Until now he had been living a hand-to-mouth existence, accepting small commissions and earning his living drawing cartoons for tapestries, but at last he began to throw off the artificiality and the binding rules of his teachers.

This new sense of freedom showed in the cartoons depicting rural Spanish life made at the request of the Prince of the Asturias in 1778. The future Charles IV, although a simple man who was bored by the intricacies of governing a recalcitrant people, was nevertheless a patriot who felt a kinship with his future subjects. The subject matter appealed greatly to Goya, who looked back fondly on his boyhood in Fuentodos.

The artist's style became freer than ever before. In an easy, lively manner, he depicted the Aragon of his boyhood in works such as *The Game of Pelote*. In *Novillada*, in which a young bull is being led into the ring, he achieved a natural and realistic effect rarely seen in a tapestry cartoon.

In spite of his obvious love for Aragon, Goya showed a strange reluctance to return to Saragossa. A new commission awaited him at the Catedral del Pilar, and the bishop made it plain in several letters that he wanted Goya to complete the decoration of the church. But the artist procrastinated, inventing excuse after excuse: he could not leave Madrid at present because of the pressure of work; his wife was pregnant; he had been commissioned by the Crown Prince.

Various complicated explanations have been offered for Goya's desire to remain in Madrid when a lucrative offer awaited him in Saragossa. But the truth is simple. His future would be determined in Madrid; every month he now spent in a remote provincial capital would delay his advancement. He would not go to Saragossa until his reputation in Madrid was assured.

Only through the favor of the royal family could great success be achieved, and Goya well knew it. Every door in Madrid would remain closed to him until the door of the Royal Palace opened. He made up his mind to force it open, and in 1779 he began a new project. He would paint a *Crucifixion* for the palace, first preparing a sketch of it for the King's approval.

Charles III was no art expert, but he was jealous of his fellow monarchs; refusing to be outdone by them, he posed as an outstanding patron of the arts. Spain was so backward and the influence of the Inquisition so repressive that foreign artists were reluctant to take up residence in Madrid. Mengs had been the last to come—in

1761. Others had refused Charles' blandishments, so the King was forced to rely on native artists.

Goya knew this, and prevailed on his brother-in-law to obtain an interview for him at court. Bayeu, secure in his post as Painter to the Court, had no discernible reason to fear competition from Goya, and promised to do what he could. Bayeu helped in the preparation of Goya's sketch, according to Goya's letter to Zapater written after the event, but the younger man painted the work himself.

The great day came early in 1779, when Goya was summoned to the palace. There, in the "informal" reception room, where there were chairs only for members of the royal family, Charles III awaited him, flanked by the overweight Prince of the Asturias and his shrewd, birdlike wife, Princess Maria Luisa of Parma, both of whom, after they ascended the throne, would be immortalized in one of Goya's most famous paintings.

Determined to make the most of his opportunity, the artist carried not only the sketch for his *Crucifixion*, but a number of other paintings, some of which he had painted for the occasion. He was received cordially and was requested to proceed with his major work. Returning home, he wrote a euphoric letter to Martin Zapater:

> If I were less pressed for time I would tell you in detail about the honors which, by the Grace of God, I have received from the King, and from the Prince of the Asturias, and from his Princess, because of the pictures I showed them. I have kissed their hands—never have I experienced such happiness. Never, believe me, dear friend, could I have desired more, in the matter of my paintings. I should like to recount to you all the pleasure that the King, and most of all Their Highnesses, showed in them. Thanks be rendered unto God, I was not deserving of so much honor, or my paintings, either.

Goya felt that he was dreaming as he went to work on his large painting. He, the son of a gilder and peasant, had been received at the palace. Life was sweet, and the future was assured.

Other work delayed his completion of the painting, but Goya was in no rush. The picture that would open the doors of the Royal Palace had to be perfect. It was finished in December, 1779, and he sent it to Charles III, together with a petition requesting an appointment as a court painter. Attached to the petition were a number of testimonials to his talents written by colleagues, Bayeu among them.

Time passed, and Goya's expectations gave way to nervous anxiety. He heard no word from the palace in January, in February or in March. He asked Bayeu to find out what was happening, but the First Painter, long familiar with the ways of the court, told him that royalty, like nature, had to be allowed to take its own course.

Finally, in late April, Goya received a reply, and was stunned. His petition had been rejected on the grounds that there were already enough court painters. And, in spite of his conviction that the King had agreed to buy his *Crucifixion*, it too was returned to him. He was crushed at first, but as his natural ebullience reasserted itself he became convinced that his "enemies," whoever they might have been, had persuaded the King to change his mind.

In all justice to Charles and his son, they may have promised nothing. Goya, in his exhilarated state of mind, may have mistaken casual, polite praise for great promise. One lasting result of this experience was a new wariness when he dealt with royalty. Never again did he take royal support for granted, never again did he accept any other man's word. It might be too farfetched to say that the experience made him a cynic. More likely, his natural

peasant suspicion came to the fore again, and he forced himself to temper his optimism.

The *Crucifixion* was not one of his greatest works. Without the realism and power of his original sketch, the finished painting is a rather formal, almost elegant presentation of a subject that had been utilized by countless painters over the centuries.

But the painting could be put to good use, even if Charles III didn't want it. Knowing that it was in keeping with artistic trends prevalent in Spain, Goya submitted it on July 5, 1780, when he was thirty-four years of age, to the Academy of San Fernando, together with a petition requesting admission.

Goya won the unanimous approval of his peers and was admitted to full membership, which entitled him to call himself a master, one of thirty in Spain. He had taken a major step forward.

The following month, after Josefa had given birth to another son, he was at last ready to make his long-delayed journey to Saragossa to complete the decoration of the Catedral del Pilar.

V
The Honor of an Artist

Francisco Bayeu was in charge of the decoration of the Catedral del Pilar. He had done some of the work himself, and had assigned portions to his brother-in-law and others to his own brother, Ramon. Until this time Goya had always accepted Bayeu's advice, but his election to the Academy changed his position, at least in his own mind. He himself was now a master, and he had no need of direction from anyone.

Immediately before his election he had made a number of sketches for the cathedral fresco, which he called *The Virgin, Queen of the Martyrs*. Bayeu had approved these sketches. Now everything was changed, and Goya felt no need to please anyone but himself.

Francisco, Josefa and their two baby sons took up residence in Saragossa in a small, unpretentious house that Zapater had rented for them, arriving late in August. Before leaving Madrid Goya had written to his friend that his needs were few: "a print of Our Lady of the Pillar, a table, five chairs, a stove, a cask, a spit, a lamp, and a guitar; all else would be superfluous." The new member of

the Academy, was obviously not putting on personal airs, and it did not occur to him to mention that he, his wife and the two tiny children would need beds.

Old Señora Goya met her daughter-in-law for the first time and saw her grandchildren. The two women established an immediate rapport, as both were sensible, hardworking and well aware of the inferior position of the Spanish woman, which both necessarily accepted. Father Camillo Goya made it his business to get along with Josefa, as well as with Francisco and Ramon Bayeu, who arrived in Saragossa about a week later. Camillo seems to have been the first member of the family to recognize that his brother would become wealthy and famous, and he intended to take every possible advantage of the future for his own advancement.

Tomas Goya must have met his sister-in-law and her relatives, too, though there is no record of his part in family councils. As a gilder, he was accustomed to dealing with painters, and his relations with the Bayeu brothers were probably harmonious. Nothing is known about Josefa's relations with Goya's sister, Rita.

Trouble broke out almost immediately between Goya and Francisco Bayeu, and Bayeu must have been astonished when his former pupil brusquely rejected his advice. For years Goya had done whatever he had been told, but now, Bayeu wrote, he was "vain, arrogant and unmanageable." His attitude was all the more startling because, in the older man's firm opinion, Bayeu alone was responsible for what little success Goya had enjoyed to date.

An intense family quarrel erupted, disturbing the peace of Saragossa and delaying the work in the cathedral. Ramon sided with his brother, but Josefa, to her eternal credit, loyally supported her husband, even though the technical arguments were over her head. Father Camillo

Goya tried to act as peacemaker but was abused by both sides. Goya's mother, who had learned over a lifetime not to rebel against those in authority, tried to persuade her son to submit to Bayeu and was told, firmly but gently, to mind her own business.

In October Goya announced that he would start work, and he made his position clear by putting it on paper: "I took my precautions. I had it verified by the director [Bayeu] that the part of the work assigned to me is to be done by myself alone—and this in the presence of several persons in this city."

Bayeu thought otherwise, and the dispute raged on. Not until the next month did Goya actually begin painting and he still refused to pay attention to any directions that Bayeu gave him.

The modern student examining *The Virgin, Queen of the Martyrs* cannot help wondering why the two artists quarreled. It is technically proficient, to be sure, far superior to the work Goya had done in the same cathedral a decade earlier; remarkably, he completed the task in only ninety days of frenzied labor. But the fresco was banal, filled with saints, angels, bishops, children and cherubs, no different from the conventional work being done by many lesser artists of the day. It has a special value today only because it was painted by Goya.

The dispute was far from ended, even though Goya had actually done everything required of him. Bayeu was insulted because of his former pupil's "lack of respect," to use his phrase, and he decided to teach his brother-in-law a lesson by withdrawing all aid from him. Did he think he could stand alone, without the help of the renowned Painter to the Count? Then let him try!

The results were immediate. The bishop and priests of the cathedral, knowing very little about art, decided to

take no risks and sided with Bayeu. They even refused to permit Goya to paint the bottom corners of the dome until his sketches for the project received Bayeu's approval, in writing. The public at large—at least the articulate and wealthy, whose opinion mattered—also took up the cudgels on behalf of Bayeu.

Goya was humiliated. Not only was he subjected to a barrage of unfair criticism, but he was also denigrated in his home town of Saragossa.

Angry beyond measure, Goya retaliated by writing a long memorandum to the priests of the cathedral, a document that, in a sense, constituted his declaration of independence. After first offering to bring an impartial judge to Saragossa at his own expense, perhaps Antonio Velasquez or Mariano Maella, he declared that he would no longer be placed in the position of a dependent mercenary and that he refused to be subjected to further humiliation. His defense, far more lucid and fluent than anything else he ever wrote in his life, may have been written with the help of the wise and judicious Zapater, who had a way with words that Goya lacked:

> The honor of an artist is a most delicate thing, for his reputation and his means of earning his living depend upon it. From the day when it is obscured by a small shadow, all of his fortune vanishes. In an affair that injures or offends him, natural law makes it incumbent upon him to defend himself as well and as thoroughly as circumstances permit. To fail to defend himself, however meager his personal circumstances might be, would be, for an artist, to abandon the most precious treasure with which his Creator has entrusted him. . . .
>
> The work in question should be examined by some person who is a true expert in art, who has enjoyed both authority and reputation in this profession, and whose judgment could not be accused of partiality.

Goya's appeal fell on deaf ears. Bayeu said nothing, and his silence further damned Goya. The priests were adamant, and a rumor spread that Goya would not be paid for the work he had already done. When he heard the report he completely lost his temper and announced that if he did not receive the sum owed to him he would remove his entire painting from the dome. This display of bad grace did him even more damage.

Goya appeared to be powerless, and he made plans to return to Madrid, prepared to forget the fresco in the cathedral and remain forever on bad terms with Bayeu. At this juncture he received a remarkable letter from an old friend, Brother Felix Salcedo, who lived at the Carthusian monastery. After urging the painter to turn to God for solace, comfort and calm, the monk also offered him some worldly advice. He was not yet in a position, counseled Brother Felix, to offend Francisco Bayeu, who could do his career permanent damage. Regardless of his personal feelings or the justice of his cause he should submit to the will of Bayeu, for in the long run he would not have cause to regret it.

Goya took the advice and made the effort. He announced publicly that he would submit his designs for the corners of the dome to his brother-in-law and would do anything that was required of him. This act of submission would have been difficult for any Spaniard, but was even more so for Goya, who never forgot or forgave an injury. For years to come he nurtured a blazing hatred for Bayeu.

Bayeu made matters no easier by being picayune. He rejected the sketches, forcing Goya to draw a second set, then a third. Finally, he refused to praise the finished paintings, calling them "barely satisfactory."

On the day Goya completed the work he could contain his anger no longer. He demanded immediate payment from the bishop, calling the money "the silver of my

shame," and was so abusive that, although he received his payment, he also incurred the further ill will of the priests.

The cathedral staff had the last word. Gold medals were given to Francisco and Ramon Bayeu for their contributions to the beauty of the Catedral del Pilar, and another was presented to Josefa Goya—because she was the sister of the Bayeu brothers and had "inspired" them. Goya, of course, received nothing.

Josefa made what may have been the greatest mistake of her life by accepting the medal. Her marriage survived the gross insult to Goya, but the relations of husband and wife were never the same. Goya continued to sire Josefa's children, as required of him by the Church and by custom; he also supported her unstintingly, so she could make no complaint. But despite all her previous loyalty he withdrew from her emotionally. He never again confided in her and thereafter conversed with her only on matters concerning their children. No middle-class couple in Catholic Spain could even contemplate separation, much less divorce, but Goya and Josefa now lived as strangers under the same roof.

The strain must have proved far greater for Josefa, who had no independence, no life of her own outside the home. As for Goya, he soon began to search for more than an evening's diversion with a harlot. He began to take mistresses of high station, sought companionship and understanding from them, sometimes imagining himself in love with one of them.

The priests' slight had an explosive effect on Goya. As he departed for Madrid, accompanied by his abashed wife and small sons, he announced that he was disgusted with the world of art and would never paint again. When Goya reached Madrid, however, he found a letter awaiting him from Martin Zapater. In the name of their old and dear

friendship, Zapater wanted a picture painted especially for him. Goya was emotionally incapable of refusing the request and replied:

> The picture—I will do it. For you to ask for it is enough for that. But, believe me, only your friendship would make me do it. For when I think of those nightmare days I spent in Saragossa, my painting burns me alive, and my shame, which is like the itch, never leaves me.

Goya soon became involved in another project that enabled him to consign his contempt for Francisco Bayeu and his strained relationships with Josefa to the back of his mind. Work was nearing completion on one of the largest and most grandiose architectural efforts ever made in Madrid, the building of San Francisco el Grande, a mammoth Franciscan monastery. Several painters were to be commissioned by King Charles to decorate the interior of the place, but Goya, thanks to Bayeu's enmity, naturally expected to be excluded. It had already been announced that Bayeu and Maella would contribute paintings to the decoration.

Within days of Goya's return to Madrid, however, he was called the home of Ventura Rodriguez, the principal architect for the monastery. Some years later Goya painted his portrait, perhaps as a gesture of thanks, portraying Rodriguez as a handsome man with deep-set eyes, a firm chin and a sensitive mouth. The architect was also a native of Saragossa and had supervised the final phase of the building of the Catedral del Pilar, so the two men may have met in Aragon a decade or more earlier. However they had become acquainted, they were by this time on good terms. Rodriguez undoubtedly knew of the feud between Goya and Bayeu, which was the talk of the Academy and other art circles.

The angry young painter must have been astonished when his friend offered him a glittering commission: he was asked to paint a major picture for one of the monastery's altars. He was also informed that the Crown was conducting a contest and that the best painting would win a special prize.

Goya set about his commission immediately, and the pain caused by his experience in Saragossa promptly subsided. "I was very much crushed," he wrote to Zapater, "but it has pleased God to comfort me." His only chief concern in that matter was the rehabilitation of his reputation in the city he still called his home, so he asked Zapater to pass along the news of his new commission "in order to confound those vile slanderers who have so little confidence in my worth." That task having been performed to his satisfaction, he reduced the quarrel to the level of a tempest in a paint-pot, although he continued to despise Bayeu.

Whether Goya selected his own subject for his Franciscan painting or whether it was assigned to him is not known. The subject was "San Bernardino of Siena preaching before the King of Sicily, René d'Anjou," and the thirty-five-year-old painter met the challenge.

His composition was particularly clever. The saint, attired in the simple robe of a monk, stands high on a hill against a bright background, delivering his sermon. King René is consigned to the valley in the foreground, and looks drab in spite of his gorgeous clothes. Both rather stiff figures are representative of the Spanish art of the period. There are baroque touches in the work, too, that Goya soon would abandon. What makes the work truly memorable, however, are the faces in the crowd listening to the saint preach. Real flesh and blood people, they rivet the attention of the viewer. The mature Goya was beginning to emerge.

The painting of the huge picture took three years, far longer than Goya usually spent on any single effort. But so much depended on its reception that he worked meticulously. He also continued to produce cartoons for the factory of Santa Barbara, although in reduced numbers. And in 1782 he painted his first masterpiece, a portrait of the factory director, Cornelius van der Goten.

It was the second portrait he is known to have painted. The first, that of Don Pedro Alcantara de Zuniga, done in 1777, had been so drab, so ordinary that no other commissions had followed. But van der Goten seemed to come alive. Goya now understood suffering, and his study of Velasquez and Rembrandt had not been in vain. Everyone who viewed the van der Goten portrait realized that a new, great master of portraiture had arrived on the Spanish scene.

This was not a completely happy time in Goya's life, however. Rita Goya had finally found a man worthy of her and was betrothed to a prosperous merchant in Saragossa, but suddenly she died of a mysterious ailment after a very brief illness. Francisco was duly pious and added a self-deprecatory touch when he wrote to Zapater, "The death of my sister has brought me much grief. But I console myself by thinking that she will find her share of recompense above. We others, we have been such good-for-nothings that we should mend our ways in the time that is still left to us."

After Rita's death Goya decided to bring his mother to Madrid to live with him and Josefa. Señora Goya arrived in due time after traveling by donkey instead of using the funds Francisco had sent her to take a coach. She had saved thirty reales, she said, and was pleased with herself, although her son raged.

The old lady made an attempt to reconcile Goya and Josefa, but their rift was too deep. And she found Madrid

too large and too bewildering for a woman who had never before been in any community larger than Saragossa; on a number of occasions she lost her way in the streets and had to be guided home. After spending several months with her son and daughter-in-law—the exact dates are not known—she went back to Saragossa, where she remained for the rest of her life. Goya respected her decision and settled a pension on her so she would never be in want.

He was good to his brothers too. He loaned money to Camillo frequently, and through his growing circle of influential acquaintances made his first efforts to have Camillo promoted to the rank of monsignor, an honor for which the priest in no way qualified. It was far easier to help Tomas: a number of Goya's friends in the Academy followed the example of the painter himself and sent some of their works to Saragossa to be framed by an artisan who was no more competent than a dozen or more who lived and worked in Madrid. A true member of the Spanish middle class, Goya helped his relatives without complaint. It may not have occurred to him as yet that they were taking advantage of him. He was the most successful member of the family, so it was his duty to come to their aid.

Early in 1783 he received word that Don José Monino, Count of Floridablanca, wanted a new portrait painted, and had selected the relatively unknown Francisco Goya for the task. His hopes soaring, Goya wrote confidentially to Zapater, predicting that it would not be long before everyone of consequence in Madrid would be clamoring for his services.

But the powerful Floridablanca, First Minister to King Charles, was an exceptionally hard-working man and could set aside no time for a mere portrait painter. He postponed session after session until Goya was in despair.

The painter resorted to a strategem that would prove

useful to him again and again in the years to come. He managed to obtain an introduction to the Countess of Floridablanca and, always at his best when dealing with a woman, charmed the lady and obtained her sympathetic promise of help. The Count soon found time for a sitting, and Goya saw him frequently.

After the finished portrait, which was conventional and mildly flattering, was delivered, Goya expected to be summoned to the First Minister's palace, paid for his efforts and offered praise. But he waited in vain. He never received payment for the portrait, and the busy Floridablanca apparently forgot his existence. Prime ministers, Goya learned, were as unreliable as kings.

A few months later, however, Goya's fortunes took a turn for the better, thanks to another intervention on his behalf by his friend Ventura Rodriguez. This time the royal family was directly involved.

The Infante Don Luis, the younger brother of Charles III, was a man with a curious background. As a child he had been made Cardinal Bishop of Toledo and Archbishop of Seville, posts that not only brought him vast revenues but made him Primate of Spain, the head of the Spanish Church. As he grew to manhood, however, Don Luis discovered he had no desire to live the celibate life of a priest, and as he was endowed with a quality rare in his class and station—honesty—he refused to have surreptitious affairs. Instead he left the Church.

Ultimately, after refusing union with one or another princess who would have strengthened Spain's foreign alliances, he married the lady of his own choice, Maria Teresa de Vallabriga, whose ancestors, hundreds of years earlier, had been the kings of Aragon. The couple, charming and enormously wealthy, actively disliked court life and had no interest in politics. So they retired with their five children to a huge estate in central Castile, Los Arenas

de San Pedro. Don Luis, who dabbled in botanical studies and loved hunting, was a genuine patron of the arts. He understood painting and tried to encourage purely Spanish trends in art. Many artists had painted portraits of the Infante and his family, but none had satisfied him, so Ventura Rodriguez, who may have been the first to recognize Goya's potential, suggested the temperamental painter from Aragon.

Goya was summoned to Los Arenas de San Pedro, arriving there in mid-June, 1783. He was given a private suite in the palace. Achieving an immediate rapport with the Infante, he remained for six weeks. In all, during that summer and the next, when he returned for a second visit, he painted fifteen portraits of Don Luis, Doña Maria Teresa and their children, including a notable family portrait that was his first effort of this sort.

Encouraged by a patron who understood him and admired his work, Goya grew in the friendly atmosphere. His portraits, realistic beyond anything he had as yet accomplished, yet lacking the satiric bite that eventually crept into his work, were his best to date. He made no attempt to flatter the Prince and his family, but presented them honestly. The finished portraits were a far cry from the paintings turned out by other members of the Academy.

Goya entered completely into the life of the palace and was stunned by its opulence. The food and wines were too rich for him, so he ate simply, but the experience of sleeping on sheets of pure silk made him giddy. He loved the inlaid furniture, the expensive clothes, the service provided by superbly trained butlers and maids. This, he wrote to Zapater, was the way he wanted to live!

Soon establishing a routine, he worked for about five or six hours each day, beginning early in the morning and painting rapidly. Then, after eating a light meal, some-

times sitting with the royal family, he and Don Luis went hunting together. The Infante was astonished to discover that the painter was not only an expert horseman but a superb marksman who shared his own passion for the chase. And Goya could not get over the fact that he had become an intimate of a member of the Bourbon family.

Before leaving Los Arenas de San Pedro he spoke to the Infante on behalf of Camillo, who promptly received a splendid appointment as Chaplain of Chinchon. And when the artist departed he received double payment for his paintings, along with many valuable gifts for himself and his family, including a gown of silver and gold cloth for Josefa. Goya's head spun when, in response to his question, an equerry told him it was worth twenty thousand reales. Since Josefa never went anywhere, however, it is doubtful that she ever had occasion to wear it.

The patronage of the Infante Don Luis made Goya a success overnight, and he soon became the most popular portrait painter in Spain. Powerful grandees, generals and great ladies demanded to be painted, and his schedule was so full that he had to make his appointments three to four months in advance. His income leaped from twelve or thirteen thousand reales a year to thirty-five or forty thousand. Money was no longer a problem.

Some of his colleagues were jealous, of course, and Francisco Bayeu fumed. Never had he enjoyed such a success himself, but he was forced to admit that Goya's portraits were remarkably lifelike. What confused Bayeu and other members of the Academy was that Goya did not flatter his subjects, who were not offended and instead clamored for still more portraits.

Subtle changes appeared in Goya's personal life. He was so well known now that he could no longer go to those taverns he had long frequented, but he had formed habits that were difficult for him to break. So on two or

three evenings each week, he donned the hat, cape and boots of a *Majo* and went to another working-class district where he was not known. There he told his companions of the evening, male and female alike, that he was a house painter, and they had no reason to doubt his story.

According to one of the more amusing anecdotes of this period, a ferocious brawl erupted in a tavern one evening, and the constabulary, arriving in force, arrested everyone in the place. Goya had no desire to spend several days in a Madrid prison, reputedly the most primitive and barbarous in Europe, and he knew his budding reputation would be damaged. So he told the constables he was a close friend of the distinguished Francisco Goya, official household painter to the Infante Don Luis, and as proof showed them a signet ring bearing the Infante's royal seal. Whether they believed the glib story or suspected he was Goya himself is unknown, but he was released without delay.

During the early 1780s Goya became friendly with one of the most remarkable Spaniards of his age, Gaspar Melchior de Jovellanos, a poet and dramatist who had embarked on a one-man campaign to liberalize Spain, draw the intellectuals out of their lethargy and establish a greater measure of individual freedom in Europe's most reactionary country. It is possible they first met in the summer of 1781, when Jovellanos had delivered an inflammatory address to the Academy that had caused both the Crown and the Inquisition to regard him with suspicion.

Goya painted Jovellanos' portrait and gradually was drawn into the poet's elite circle. Until this time the artist had displayed no interest in politics, and like millions of his countrymen, had accepted the repressive measures of both state and Church without question. The extent of Jovellanos' influence on Goya is difficult to determine, although some of the artist's biographers, without citing

specifics, credit the poet with introducing Goya to the concept of the dignity of man.

There can be little doubt that Goya, who had read nothing of consequence, was now exposed to ideas and principles that had been prevalent in the more advanced nations of Europe since the early part of the century. For the first time, perhaps, he heard of John Locke and Voltaire and learned something of their beliefs, which had contributed so much to the movement known as the Enlightenment. But the claim that Goya read the works of Locke and Voltaire is absurd, since neither had been translated into Spanish. He was totally unfamiliar with the English language, and although he eventually could converse rather haltingly in French, he was never able to read a word of Voltaire's writings.

Goya was not alone in what appears today to have been abysmal ignorance. The isolation of Spain from the European mainstream was so complete that, for example, not one Spaniard in one hundred thousand knew that a War of Independence had been fought on the other side of the Atlantic and that the people there had formed a democracy called the United States of America. Floridablanca, who had offered a limited measure of help to the Americans because it was Spanish policy to oppose Great Britain, knew the true situation, of course, but the Prince of the Asturias, soon to become Charles IV, still believed, rather vaguely, that the British had put down the insurrection and had retained their North American colonies. Church and state worked together, the borders of Spain were sealed, and the liberalizing forces of the outside world were excluded.

In spite of his later contributions to the spirit of human freedom, Goya was no intellectual. His principles grew out of his own experiences and those of the Spanish people. He was a man of the people, and his indignation on

behalf of fellow humans was a natural development in the heart and mind of an independent son of Aragon, where rebellion against authority was a way of life. While Jovellanos and his friends may have influenced Goya in the direction of liberalism, it would be a mistake to emphasize too strongly the role that Jovellanos played in Goya's development as a thinking man.

On a far different level, Jovellanos, in a note written in 1783, may have been the first to address the artist as Francisco *de* Goya. Late that year Goya wrote to Zapater, asking him to investigate the family tree of the Lucientes family, and by 1784 he ennobled himself, signing his name as "Francisco de Goya y Lucientes," the name by which posterity has known him. Now that he was moving in aristocratic circles, he wanted to be regarded as an aristocrat, too.

In spite of these pretensions, Goya never lost touch with reality. His earthy sense of humor, his ability to laugh at himself, were mainsprings of his genius. Probably no one but his relatives and his oldest friends ever realized that he was making fun of himself in his famous etching, *Asta su Abuelo*, in which a donkey attempts to learn the identity of his ancestors. To the outside world he became Don Francisco de Goya, but *he* knew he was the son of a gilder and farmer who had never been able to earn more than the barest living for himself and his family.

It might even be argued that by ennobling himself, Goya was laughing at the whole human race. Ultimately his sense of satire became so intense that he saw all of life in sardonic terms; he might have become a mere recorder of foibles and weaknesses had he not also developed the saving grace of deep compassion for the weaknesses of mankind.

He must have hesitated the first time he signed a letter

to Martin Zapater as Francisco de Goya, but as he increasingly assumed his new role he gained confidence. His original signature was cramped, the letters small, but it did not take him long to develop a bold, flourishing style. At no time did he use his new signature on his work. When he bothered to identify himself at all he signed his paintings and etchings with a single word, Goya. On occasion he merely used the initial G, and at other times he did not sign his work in any way. By then he was so renowned throughout Europe that he may have felt his work spoke for itself and needed no additional identification.

The suspicion persists that Goya was not trying to put on airs by changing his name but simply thought it was good business for his wealthy and noble clients to believe he was one of them. The timing of the change substantiates that view, for it came just after his stay with the Infante Don Luis, who treated him with great respect.

VI
Painter to the King

Francisco and Josefa de Goya probably had twelve children, but this is at best an educated guess. Some sources say that they were the parents of as many as eighteen or twenty-two babies. The uncertainty is caused by a situation that reveals much about Spain at the turn of the nineteenth century. The infant mortality rate was so exceptionally high that the only birth records kept were those of children who were baptized. Five of the Goya children lived long enough to have their names entered on baptismal records, and by piecing together Goya's letters to Zapater we can determine that seven others died at birth. Those who were baptized were: Vicente Anastasio, born in 1777; Francisco de Paula, born in 1779; Maria del Pilar Dionisia, born in 1780; Hermenegilda, born in 1782; and Francisco Javier Pedro, born in 1784.

When a new Goya came into the world, the proud father wrote exuberantly to his old friend: the new baby was lovely, graceful, sweet and healthy, God had been good, and the undeserving Goya had been blessed. When a baby died he said very little, usually alluding to the tragedy in oblique terms, if he mentioned it at all. Something of his state of mind was revealed when he told Zapater of the birth of Javier: "I trust to God that this

time all will go well." In that one instance there were no complications or problems, and Javier was the only one of the Goya children who grew to manhood, outlived both of his parents and reared a family of his own.

The loss of so many of his own children accounted for Goya's great tenderness and affection for all the children he encountered. Many critics have noted the sympathetic warmth he poured into his portraits of children, a trait he never lost. In his maturity and old age he treated adults with blazing contempt, ridiculing them and emphasizing their frailties, but he was unfailingly gentle and understanding with children.

One of his greatest masterpieces, his portrait of the little Don Manuel Osorio de Zuniga, was probably painted in 1784 or 1785. Uncounted thousands of reproductions have been made of this tender portrait of a child who was about two years of age.

Goya, it appeared, now could do no wrong. The frequently delayed opening of the Church of San Francisco el Grande took place on December 8, 1784 and was the great social event of the season. King Charles III attended with his entire court, and the Infante Don Luis came to Madrid from his country palace. A contemporary scribe noted in the large crowd the presence of seventeen cardinals and bishops. The entire diplomatic corps was in attendance, as was First Minister Floridablanca. Francisco Bayeu, who had been working on a commission in Toledo, returned to Madrid for the occasion and openly snubbed his brother-in-law.

But Goya had the last laugh. His *San Bernardino* was acclaimed to be the finest painting on exhibition by the King, the Infante Don Luis and two cardinals who regarded themselves as art experts. The crowd agreed, and scores stood admiringly in front of the Goya work all afternoon.

The Crown's memory was short, however, for Charles

III had forgotten his promise of three years earlier that a prize would be awarded to the painter of the best picture. Even worse, Goya and several of his colleagues were not paid for their efforts, the King having forgotten that not all of those who had done work for the new church were on the royal payroll.

Goya and two of his colleagues, Gregorio Ferro and José del Castillo, submitted petitions reminding the monarch of the oversight. Goya, who no longer fawned on royalty, was firm, almost indignant, and made it plain that after spending three years at work on the *San Bernardino*, he found the praise he had received for the painting insufficient to sustain him and his family.

Floridablanca immediately authorized the treasury to pay the three artists, and commented that although he didn't think any of them were worthy of the fees that were asked, their work wasn't as bad as those of the other artists on exhibit.

Few in Spain agreed with the First Minister's sour estimate of Goya's talents. More orders than ever poured in from grandees and prelates. Even his brother Camillo managed to return a favor and obtained a commission for Goya to paint a picture for his new church. Among the many other admirers of the *San Bernardino* was one of the most prominent noblewomen in Spain, a woman who had so many titles that her rank as a member of one of the twelve royal families of Spain was of almost no consequence. Doña Maria Josefa Pimentel Tellez Giron y Borja, Countess-Duchess of Benavente and Duchess of Osuna, was twice a princess, nine times a duchess and a direct descendant of the notorious Italian Borgias.

She was slender, almost boyishly thin, and her face reflected sensuality and intellect as well as the patrician arrogance of her class. A passionate devotee of bullfighting, she was one of the most accomplished horsewomen in

Spain. She was also a patroness of poets and fancied herself an expert in finance to the extent that the royal treasurers not only listened to her lectures but frequently took her advice. Said to be the best-dressed woman in the country, her wardrobe was supposedly more expensive than those of the Infanta Maria Luisa, the future Queen, and of the Duchess' great rival, the famous Duchess of Alba.

Doña Maria Josefa was a connoisseur of men as well as of painting, and it was rumored—softly, because she could make or break enemies with a flick of her fan—that her lovers had been legion. No one knows where she met Goya, but, according to legend, he was pointed out to her in the Church of San Francisco, and she congratulated him on his painting. It may be that she also took note of his broad shoulders, slim hips and sturdy legs. If she saw that he was beginning to grow bald and that his face was thickening, she paid no attention to such trivialities.

Early in 1785 Goya was requested to make an immediate appearance at the so-called summer palace of the Duke of Osuna in central Castile and report to the Duchess. Such a call was tantamount to a royal summons, and he hastened to obey. The vast complex of buildings known as Alameda was even larger than the palace of the Infante Don Luis, the furnishings costlier and more servants were in attendance. If Goya was impressed, however, he was sufficiently familiar with great nobles not to show it. He did become increasingly annoyed when he was allowed to cool his heels for seventy-two hours without catching even a glimpse of his hostess. Only when he notified her major domo that he could wait no longer and intended to return to Madrid the following morning was he admitted to her presence. Doña Maria Josefa, it is unnecessary to add, was using her own means and knew precisely what she was doing.

No one knows what was said behind the closed door of her audience chamber, but the financial details of her arrangement with Goya were no secret. She wanted him to make seven sketches and would pay him one thousand reales for each sketch. She would select one, from which he would paint a portrait, and for that she would pay him an additional twelve thousand reales. Not even a highly successful artist could reject such princely generosity.

His portrait of the Duchess, recognized even in his own day as a masterpiece, took up only a portion of his time. He also accompanied the Duchess on long rides into the foothills of the mountains, and his horsemanship delighted her. She discovered he could play the guitar, and fancying herself as something of a singer, she insisted that he accompany her when she sang peasants' songs, most of which he knew.

It did not take long for Doña Maria Josefa and Goya to become lovers, and if precedent was any guide, it was she who was the aggressor. A man in Goya's position would have taken his life in his hands had he made unwanted advances to a woman of her status.

Goya made only one cautious reference to the affair in a letter to Zapater, saying plaintively that her desires were "inexhaustible."

So was her energy. In a single day, she posed for her portrait, dictated letters, wrote a treatise on economics, entertained a large company at an informal picnic, played the leading role in an amateur theatrical on a stage built for the purpose at the palace, and after acting as the hostess at a large, formal dinner, insisted that Goya make love to her far into the night.

If Goya was not genuinely attracted to Doña Maria Josefa he hid his real feelings from her. He was her lover because she gave him no choice, like other painters, actors and even common *Majos* before him. He made several

paintings of the Duchess, one—because the idea pleased her—in the costume of a *Maja*.

The portly Duke of Osuna, who ranked as the fourth grandee of Spain, happened to be in residence while Goya was there. Ordinarily he and his wife, who was also his cousin, went their separate ways, but he observed one of the portraits of the Duchess, and was so impressed that, some time later, he wanted his portrait painted, too. Only slightly less generous than his wife, he paid five thousand reales for five sketches and another ten thousand for the finished portrait. He must have known of Goya's affair with his wife, but chose to ignore it. After all, Maria Josefa took many lovers.

Before Goya returned to Madrid he was prevailed upon to paint a family portrait of the Osunas, the Duke having seen the similar work in the palace of the Infante Don Luis. Such paintings were becoming Goya's specialty, and he was paid an additional fifteen thousand reales for it. So he was wealthier by more than fifty thousand reales by the time he reached Madrid after a month's sojourn at the Alameda.

He could not escape the Duchess even in the capital. Interrupting his work schedule with an imperiousness that tolerated no refusal, she summoned him to her Madrid palace at will, insisted that he escort her to bullfights, and clung to him so passionately in public that she created a scandal. It was fortunate, nobles said, that Charles III was a widower. No reigning Queen would have tolerated the spectacle.

Escape was impossible for Goya; the Duchess of Osuna would have been too terrible an enemy. An equally sound reason for dancing attendance on her in Madrid was her generosity. She gave him one commission after another and paid him lavishly.

Goya also had other concerns on his mind. The post of

secretary of the Academy of San Fernando was open, and he applied to the Crown for it. Instead he was made Assistant Director of the Division of Painting. This paid a salary of twelve thousand reales a year, which would have delighted him only a short time earlier. Now money was pouring in so rapidly that the post meant little, though in a letter to Zapater, he managed to sound grateful.

Of far greater importance was an opening on the staff of painters to the King, and Goya, who had always sought the honor, was eager for the position. To his astonishment he received a warm endorsement from Francisco Bayeu, the most respected of the court painters, who also recommended that he be given an increase in annual salary for the cartoons he made for the Santa Barbara tapestry factory. Bayeu had not achieved and held his own high place at the Royal Palace by accident, and was an expert in judging the direction and velocity of various winds. As Goya was rising swiftly in the favor of grandees and clergymen, Bayeu's opposition to his brother-in-law well might be regarded as petty jealousy.

So he deliberately made his peace with Goya. It might be remembered, too, that Bayeu was growing older. His health was beginning to fail and he had no appetite for continuing feuds. Goya was happy to accept a truce, but although the quarrel was ended, he always remained wary in his dealings with Bayeu. Josefa, at least, must have felt relieved.

Goya's new prosperity enabled him to move his family, which now included five lively children, to a larger apartment. The family's new dwelling was, like its predecessor, located in a working-class district, even though the painter could well have afforded to move into luxurious quarters. Goya never gave any reason for his insistence on maintaining a humble address, but chose the only means he could of remaining close to the people. In spite of new

associations and an aristocratic name, he still regarded himself as an ordinary man, and his affection for the peasants, artisans and *Majos* remained firm. He was consistent in still frequenting the taverns of ordinary men.

He could finally afford a few luxuries, however, and after doubling his mother's pension he finally hired a serving maid to help Josefa with the cooking and housework. In addition he bought himself a handsome two-wheeled carriage and a fine horse to draw it. The very first time he went out for a drive the carriage overturned, and Goya broke his leg. He walked with a decided limp for more than a year, but stubbornly insisted on using his carriage daily. After all, he had spent too much on the vehicle to abandon it, and there was still enough of the peasant in him to insist on getting his money's worth.

In July, 1786, thanks in part to Bayeu's intervention on his behalf, Goya's fondest wish was realized. He wrote in triumph to Zapater that he had been appointed a painter to King Charles III, with a salary of fifteen thousand reales per year. He also received an increase in pay from the Santa Barbara tapestry factory, which now would pay him thirteen thousand reales annually. The increase was long overdue, as the factory was flourishing, thanks in large part to the demand for Goya's work.

Soon after receiving his royal appointment Goya painted his first portrait of the King, *Charles III as a Huntsman*, one of the most celebrated of his paintings. A large work, Goya may have intended to handle it conventionally, but the spirit of Velasquez and his own growing individuality overcame him. The portrait is shockingly realistic, showing Charles as an old, painfully thin man with bowed shoulders who looks slightly ludicrous in his hunter's attire. He is grinning quietly, ready to explode with laughter as he shares a private joke with the painter.

No one had ever dared to paint him so realistically. The

portrait is saved from satire by Goya's obvious respect for a man who had worn himself out in the service of his country. The artist's compassion was greater than his sense of ridicule.

The portrait created a storm of criticism; many at court believed the artist should be dismissed for subjecting the monarch to contempt. But Charles III did not agree with his angry subjects and was elated to find a painter who had finally shown the good sense to paint him as he was. Goya, by being honest, inadvertently made the old King his staunch friend and admirer. As the future Charles IV thought his father could do no wrong, Goya's relationship with the Prince of the Asturias was solidified, too.

One day in late November, 1786, Charles III made his opinion of his new painter clear by dining alone with him, an unprecedented honor. What was said at the table was not important—Goya's future was assured. Every high-ranking nobleman, every Churchman of consequence in Spain wanted his portrait painted by this startling realist who was the old King's new favorite.

Goya's reconciliation with his brother-in-law was now complete, and he painted his famous portrait of Bayeu, a realistic representation of a prim, dyspeptic man suffering from obvious ill health. It was at about this same time that Goya painted his only known major portrait of his wife. Josefa is shown much as she must have been, a drab housewife exhausted by childbearing, dispirited because of her isolation from the world.

Goya was enormously popular now. The forty-year-old artist had spent his entire professional career in training for a time of great success, and his output was prodigious. He worked furiously, his energy seemingly inexhaustible. He turned out so much work that some of his contemporaries falsely believed he had secretly hired a number of

lesser artists who actually did most of his paintings. Such a practice had been common two hundred years earlier, but that era had passed; Goya alone was responsible for everything that appeared under his name.

He moved his family again, this time buying a small but charming house on the bank of the Manzanares River, with a garden overlooking the water. The move was notable because it marked the first time that Goya had lived where there were no laboring poor. Most of his neighbors were well-to-do shop owners or senior civil servants, all of them fellow members of the tiny upper middle class. But he did not desert the common life with which he felt such an affinity. No longer working at home, he rented a small two-story building with a skylight on the second floor for his studio. Among workmen's houses, it was far away from his important new neighbors.

Daylight, the major concern of most artists, was of little importance to Goya. He accepted so many commissions he could not crowd in all of his work by day, so he developed the habit of also working at night by candlelight, a practice he observed for the rest of his life.

Portraits occupied only a portion of his time. He drew his cartoon tapestries, usually of Spanish rural or village life, including a series for one of the King's younger sons, the Infante Gabriel, called *The Four Seasons*. For the first time he did paintings on similar themes, many of them commissioned by the Duchess of Osuna, with whom he continued to maintain a close relationship.

Some of Goya's biographers have attempted to play a guessing game, as to when his affair with the Duchess ended. The truth is that only the two people involved knew the precise nature of the relationship. Ultimately they terminated the affair and thereafter remained good friends, but the date of the change is not important. At no

time was Goya either romantically or emotionally involved, so it was inconsequential when they ceased being lovers.

The Duchess, Goya's first important patroness, remained loyal to him, recognized his genius as an artist and continued to offer him more commissions than he could comfortably handle. At least fifty of his magnificent paintings of Spanish life, some of them realistic, others tending toward what would later be called Impressionism, graced the walls of various Osuna palaces. No one has ever been able to determine how many such paintings Goya made for the Duchess, in part because he was so prolific, in part because many paintings have been stolen or destroyed in the many wars that plagued Spain in the years since Goya's death.

Everything he saw was a potential subject for his canvas—a pretty girl sitting on a swing in a country house, a *Majo* lounging on a Madrid street corner, a family enjoying a picnic beside a river bank, a group of children playing hide-and-seek in a park. All came to life again in his paintings, which were light and playful. When he dealt with the poor, however, his mood changed. A painting depicting a religious procession through the streets of a city or town emphasized the toil-worn faces of the poor, seeking a brief respite from their cares. Similarly, in his landscapes he tried to achieve a sense of realism that was unique in his time. A grove of fruit trees, a valley, a meadow had to be instantly recognizable as a grove of trees, a valley or a meadow. "Just now I am painting a meadow of San Isidro," he wrote to Zapater. "Because of the thousand details to be seen in it, it is the most fatiguing and meticulous task I have ever undertaken in my life. I shall not sleep, I shall not rest until I come to the end of this piece."

Goya was now at home in exalted circles, in a position

to refuse more commissions than he accepted. Only the great and the wealthy could come to him unbidden and be accepted; all others had to be recommended before he would consent even to interview them. Other artists, jealous of his success, complained that he was becoming arrogant, but Goya denied the charge in his correspondence with Zapater. He no longer had time to open his door to anyone who might wander in off the street and want a painting. He was so cruelly pressed for time, in fact, that he hired an assistant whose principal duty was to screen visitors.

There can be no doubt, however, that his way of life changed drastically. When he was hired to paint the directors of the Bank of San Carlos, probably the wealthiest and most powerful men in Spain, he dressed like a banker. When he appeared at the palace he looked like a wealthy courtier, and when he went to the estate of a grandee he resembled a well-dressed nobleman. His wardrobe, he told Zapater, was a never-ending drain that cost him a fortune, but he was reconciled to the expense. After all, he was accepted by the great and was expected to play an appropriate role.

He spent almost eight thousand reales for an elegant carriage to replace the rickety phaeton and painted its doors with a splendid coat of arms that he invented himself. He hired a coachman and added a man-of-all-work to the cook and serving maid on the household payroll. In 1789 Zapater invested one hundred thousand reales in real estate for him. Goya's first great success was more financial than artistic. Although he painted some of his masterpieces during this relatively early stage of his career, the bulk of his more important work was executed later.

Don Francisco de Goya y Lucientes accepted these comforts as his due and established a new way of life, but he never abandoned his earlier habits, continuing to ob-

serve them in private. After completing his day's work around nine or ten o'clock at night, he quietly changed into the boots, cape and sombrero of the *Majo*, and went out on the town. He had become the friend of princes and the lover of at least one very high-ranking noblewoman, but he relaxed in the company of those with whom he felt most at home. He called himself Paco—which was actually Zapater's private nickname for him—and could prove that he was a house painter to his companions of the night by showing them flecks of paint beneath his fingernails.

Although he could afford to buy the finest French cognac, he still drank raw Spanish brandy in cheap taverns, where he exchanged rough, friendly insults with laborers and flirted with the cheapest women in the country. He genuinely enjoyed these nocturnal adventures, which invigorated him and gave him relief from the pressures of his soaring career. There was no need for him to put up a false front when he cheered himself hoarse at a Sunday afternoon bullfight, no need to assume airs when he made love to a street girl in a tawdry tavern bedchamber.

"The ordinary Spaniard," he wrote Zapater, "is my blood brother." That refrain runs through many years of his correspondence. In it is the key to the real Goya, the artist who depicted every phase, every aspect, every nuance of Spanish life. It is insufficient to say that he did not forget his origins. His roots were too deeply entrenched in the bleak, dry soil of his native land for him to escape, even had he tried. He embodied the essence of all that was Spain.

Zapater wrote to his own family about a meal he ate at Goya's house during a visit to Madrid. Food was served on the finest chinaware and was carried to the dining table in containers of gleaming silver. But the main dish was a coarse stew of beef and vegetables, and the steam that curled into the air above the container was redolent

of garlic. Goya lived like other members of his new-found world and assumed some of the habits of the nobility, but at heart he remained a peasant.

During his later, celebrated affair with the Duchess of Alba, Goya amused his mistress by rejecting the dishes prepared for her table by her French chef, reputedly the finest cook in Spain. Instead he sent for the plain, rough fare that the servants ate in the kitchen.

In his own home he served the best wines to guests, but would himself not touch anything but *tinto*, the cheapest red wine. Only when entertaining people of high station did he serve the delicate dishes of the aristocracy. Even on these occasions he himself preferred ordinary food with garlic, spices and herbs.

Eventually there were three carriages in his coach house and two teams of matched horses in his stables. His earnings were a thousand times those of a laborer now. But he elected to walk when he went anywhere except on official business as a painter, and he continued to roam through every quarter of Madrid, observing scenes he subsequently painted. His wardrobe was extensive, but he kept a *Majo* costume at hand—and wore it regularly.

In June, 1787, King Charles III personally commissioned him to do a set of altar paintings for the Church of Santa Ana in Valladolid, and at about the same time the Duchess of Osuna gave him an order for a series of paintings on the life of St. Francis Borgia, which were to decorate the Osuna family chapel in Valencia.

These powerful works transcended realism, and in the deathbed painting of St. Francis Borgia we can see for the first time the creatures of the Inferno, vile monsters that were to appear in so important a way in the *Caprichos*. Goya was himself beginning to struggle with these dreadful apparitions, and in the painting of St. Francis Borgia the greatest painter of his age begins to emerge.

VII
The Renowned Iconoclast

Late in 1788 King Charles III died and was succeeded by his eldest son. Charles IV came to the throne shortly before the outbreak of the French Revolution yet was scarcely aware of that upheaval and its effect on monarchy throughout Europe. A heavyset glutton, he was a simple man whose tastes were surprisingly refined, as he loved not only good food but also fine paintings and hunting, although not necessarily in that order. He thoroughly disliked his grasping, crafty queen but he seemed not to know about her notorious affair of many years with Don Manuel de Godoy, the man who, with her connivance, soon became First Minister. Europe snickered at the cuckold, but Charles was not as stupid as he seemed. He recognized an exceptionally able statesman in Godoy, whose loyalty he did not question, and his faith was justified.

Charles himself was far more complex than Queen Maria Luisa or anyone else realized, and he was sincerely devoted to his country. Through no fault of his own he totally lacked any understanding of the ordinary Span-

iard, but his desire for the improvement in the lot of the common man was genuine. That he himself did little to help his subjects seems almost irrelevant; the forces of reaction in Spain were too powerful. The King, who lacked forcefulness and who was no administrator, would never have been able to counter these influences.

Perhaps his greatest claim to enduring fame was his recognition of Francisco de Goya's genius. European painters no longer needed powerful and wealthy patrons in order to flourish, except in Spain. Perhaps Goya might have fulfilled his genius had a different sort of monarch sat on the twin thrones of Castile and Aragon, but it is somewhat doubtful. Charles IV became Goya's most enthusiastic patron, giving him a free hand to paint what he pleased and intervening on his behalf when the Inquisition was about to bring the artist's career to an abrupt end.

A new era for Goya now began. He was given numerous commissions for the coronation celebration, more than even he could undertake. The Duchess of Osuna ordered portraits of the new King and Queen, as did three government ministries and a number of grandees. Goya could not restrain his humor in writing to Zapater that he was thinking of opening a factory for the sole purpose of reproducing such portraits. Charles and Maria Luisa posed for him daily, and the new King took a lively interest in the artist's other work.

He studied each of the portraits as it progressed, offering benign words of advice on a subject about which he knew nothing, and was pleased when Goya, displaying the artfulness of an experienced courtier, went through the motions of pretending to accept his suggestions. Tiring of art, the new monarch sometimes invited the painter to join him in one of his favorite pastimes, wrestling. The King was proud of his physical strength and loved to test

it, so Goya sometimes found himself thrashing on the floor in the grip of a man twice his size. His own prowess was unimpaired, but he knew better than to beat the King in a match, and ultimately, after putting up a struggle, he would always allow Charles to win. This cemented their friendship.

Everyone at the Court knew that Charles and Goya discussed many subjects while the King sat for his portrait, and attempts were made to persuade Goya to bring up causes that would advance certain grandees, diplomats, bankers and politicians. But the painter was wise enough to realize he could exert influence only if he refrained from taking advantage of the relationship. Charles knew it, too, and appreciated his friend's restraint.

It was said that Goya knew of many royal decisions long before they were announced, but he made it a cardinal rule never to discuss anything the King said to him. Even after Charles died he remained faithful to his trust. As a confidant of Charles IV, in all probability not even Queen Maria Luisa or First Minister Don Manuel de Godoy could worm anything of substance from him.

His loyalty was rewarded early in their relationship. In April, 1789, it pleased His Catholic Majesty to appoint Don Francisco de Goya y Lucientes to the post of Painter to the Chamber, with a salary of twenty-two thousand reales per year. Goya, who could now insist on being addressed as Your Excellency, also enjoyed several other benefits: he could dine at the palace whenever he pleased, he could stable his horse at the Crown's expense and he could attend all royal audiences. On state occasions he could wear the yellow and black plumes that would gain him immediate passage through the lines of household troops guarding the King and Queen, and he was entitled to draw one liter of red wine from the royal cellars each

month. Grandees who had been unaware of his existence now went out of their way to speak to him.

Goya's portraits of Charles IV were so realistic and un-flattering that it is a miracle their friendship flourished. Even Queen Maria Luisa had to bite her lower lip on one occasion, when invited to inspect a new portrait of her husband. But it appears not to have occurred to Charles himself that Goya's work came so perilously close to cari-cature. The fleshy face with its exaggerated Bourbon chin and nose that looked at him on canvas was precisely the same as that which returned his stare in a mirror. On many occasions he announced in public that the new Painter to the Chamber was the only man who could re-produce a perfect likeness of a living person.

In 1790 Goya was forced to leave the court for a time—or it may be that he found an excuse to escape. Josefa fell ill, and when the physicians prescribed a change of air for her, he accompanied her to Valencia. Soon tiring of the provincial town, he went on to Saragossa to visit his mother, see his relatives and spend some time with Zapa-ter. His reception in Saragossa was far different from be-fore, when the priests of the Catedral del Pilar showed such disapproval of his work.

Goya was invited to attend a banquet given by the Academy of San Carlos, Aragon's elective society devoted to the arts, and when he arrived for the occasion he was informed he had won honorary membership by unani-mous vote. Every grandee and high-ranking clergyman in Saragossa wanted this now-famous native son to paint his portrait. When Goya protested that he didn't have time to execute so many paintings, he was told to name his own fee. He did, charging outrageous sums, but his price did not deter the grandees, who continued to pester him with their demands. During this period he painted one of his

finest portraits, that of Don Ramon Pignatelli, a distinguished clergyman and the younger brother of the Count de Fuentes. It too was dangerously close to caricature, now acceptable to the nobility. Another was of Don Martin de Goicoechea, a wealthy advocate of autonomy in local affairs for Aragon, who, many years later, would become the father-in-law of Goya's son, Javier.

During his stay in Saragossa Goya performed one labor of love; he painted Zapater's portrait, signing it, "To my friend, Martin Zapater," and presenting it to him as a gift. The mere fact that it was a work by Goya made it worth thousands of reales, which the artist himself knew well. He mentioned it in an accompanying letter to Zapater, and to increase its worth still more he stressed how hard and conscientiously he had worked on it. He would have charged anyone else a fee of ten thousand reales or more for such a work.

Only on rare occasions has any man been so completely rehabilitated in the eyes of those who had known him as a boy. Goya had left Saragossa in such disgrace that he had contemplated abandoning his career as a painter, but his visit now engendered an excitement that lasted throughout his entire stay. He said he was pleased solely for his mother's sake, but he enjoyed himself so thoroughly that he twice postponed his departure. His brothers were not neglected: he loaned large sums of money to both, promised to use his influence to help Camillo win a bishop's hat, and arranged to have Tomas frame all the pictures he painted while in Saragossa.

Josefa recovered sufficiently from her illness to join him in Saragossa, and she spent a week or two visiting with his mother while he attended dinners and other functions given in his honor. Then the couple returned to Madrid, riding in their own carriage, a luxury usually attained by only the wealthiest of nobles. It was said in Saragossa that

Goya now earned more than two hundred thousand reales a year, and his old friends did not exaggerate. He was already the highest-paid painter in the history of Spanish art.

Soon after his return to Madrid his new prestige precipitated a quarrel with the tapestry factory of Santa Barbara. Goya had grown weary of drawing tapestry cartoons for small sums, and although the fees had been useful and necessary during his years of struggle, he no longer needed them. Since he held his place by royal appointment he could not resign, but he maintained that he was too busy to fulfill his obligations.

The factory had been profitable only because of the demand for tapestries made from Goya cartoons. Now that he was no longer active the work dropped off, and several weavers were discharged. The director of the factory, Livinio Stuiks, became so upset that in the early spring of 1791 he sent a report to Charles IV informing him of the deplorable state of affairs and blaming Goya, who, he said, had nothing else to do and was "absolutely without occupation."

Goya defended himself with spirit and cunning. He, too, wrote a report to the King, basing his stand on a so-called legal position that he invented for the occasion. According to "precedent," he declared, a Painter to the Chamber was relieved of all other obligations. Unfortunately for Goya, he underestimated the strength of his foes and placed too high a value on his prestige.

The Ministry of Finance supervised the activities of the Santa Barbara factory, and its highest-ranking officials were disturbed when they discovered that large profits had declined into substantial losses. In theory, at least, the profits belonged to the Crown, but the finance officials knew better than to appeal to Goya's royal wrestling partner. Circumventing the King, they went instead to

Queen Maria Luisa. She had been reared in relative poverty as the Princess of Parma, and when she had absorbed the facts became so angry that she decided to inflict a severe punishment on Goya. She would issue a decree that would send him into exile from Madrid for twelve months.

Such a royal order would have meant the end of Goya's career as a portrait painter of the wealthy and powerful. Fortunately,. Francisco Bayeu learned of the danger and intervened on his behalf. Hurrying to the Queen, Bayeu gave her his own promise that he would persuade the stubborn Goya to draw more tapestry cartoons.

When Goya heard the whole story he was contrite, and his gratitude to Bayeu was genuine. In an extraordinary, frightened letter to his brother-in-law, in which he depicted his own character defects, he said:

> To tell the truth, I very much regret that our relations should be disturbed, and I pray to God constantly that he may rid me of this spirit of pride which always takes possession of me on these occasions. If I succeed in keeping my feelings within bounds, and if I do not fly into a passion again, my deeds will be less evil for the rest of my days.

To prove that he meant what he said and was surrendering, Goya sent Bayeu a large tapestry cartoon with the letter. This was the first of several, and although one of them was the celebrated *Blindman's Buff*, regarded by many critics as his finest cartoon, his heart was no longer in such work. Making cartoons was boring drudgery compared to the far greater challenges that occupied him. He sent only a few cartoons to the factory in the next year or two, just enough to keep himself out of trouble. Late in 1792 Stuiks was appointed to another post. His successor was a timid man who had no desire to lock horns with the celebrated Francisco de Goya. So Goya promptly gave up

the drawing of cartoons and never again did any work for the Santa Barbara factory.

This time, the artist proved that he could be as shrewd and clever as his enemies. In the course of several private conversations with the King he managed to convince Charles that the factory was losing money because tapestries had gone out of style. When Queen Maria Luisa attempted to complain to her husband about Goya, the King terminated the matter by declaring that tapestries were no longer fashionable and that his finest painter was better employed in other ways.

Work did not occupy all of Goya's time now, any more than it had in the past. In 1792, or thereabout, he became involved in what may have been his most serious romantic dalliance to date. Long devoted to the theater, he became enamored of the leading lady of Manuel Martinez' company, the most popular actress in Madrid. Everyone was in love with Maria del Rosario Fernández, known to audiences as La Tirana, but Goya was unwilling to worship her from a distance. It did not matter to him that distinguished grandees had tried in vain to batter down the resistance of La Tirana; he intended to succeed.

He did, and commemorated their affair by painting her portrait, subsequently regarded as one of his finest. La Tirana was at the height of her powers, a breathtakingly lovely, proud, haughty woman whose very bearing was theatrical. Goya saw her with the eyes of a painter rather than those of a lover, and the painting hints that her prime is behind her, that henceforth she will only go downhill. This tragic mood is subtle and elusive, although very much present, and gives the portrait a striking depth.

For months Goya and La Tirana were inseparable and could be seen together nightly in a tavern near Martinez' theater, where they jointly held court after her evening's performance. Both were so prominent that gossip was in-

evitable, and the officials of the Inquisition, the self-appointed guardians of public morals, frowned in displeasure. Whether someone on the staff of the Inquisition dropped a word to Ramon Bayeu, the younger of Goya's brothers-in-law, or whether he acted on his own initiative is unknown. All that posterity has ever been able to learn is that Ramon Bayeu went to Goya and told him he was making a spectacle of himself.

No man was more aware of the vulnerability of his own position than Francisco de Goya, who had learned over the years how even the support of the most powerful of patrons could evaporate. In a contest with the dreaded Inquisition he could not emerge the victor, so he quietly stopped seeing La Tirana in public. There is no way of determining how much longer they continued to see each other in private; by early 1793, at the latest, their affair had come to an end.

Some years later Goya painted La Tirana's portrait again. By then she had aged and grown fat, and in her eyes we can see the expression of a once-proud woman who has been forced to accept defeat. The man who painted that portrait was no lover, but a compassionate, wise artist who could discern the soul of a woman behind her theatrical makeup and lavish costume.

Another woman caused Goya far more trouble. Queen Maria Luisa was the talk of every court in Europe, knew it and did not care. Before the death of her father-in-law, her many affairs drove Charles III to distraction, and he supposedly warned her that if her husband ever learned she was unfaithful to him, he would kill her. Maria Luisa had a healthy respect for Charles IV's violent temper, but she was confident that she could handle him, and with good reason. Over a period of almost twenty years he had never even suspected one of her affairs—unlike hundreds in Spain and thousands elsewhere.

As homely as she was arrogant, the tiny Maria Luisa may have been the cleverest woman in Spain. The youngest of her children, the Infanta Maria Isabella, was the daughter of Godoy. When Floridablanca went to the King with the truth, the Queen went into private session with her husband. How she convinced him the story was untrue has never been told, but she emerged with her strength unimpaired. The King not only dismissed Floridablanca from office, but appointed Don Manuel de Godoy to succeed him.

Ruthless in her suppression of anyone who dared to oppose her, Queen Maria Luisa was a dangerous woman. No one had better calculated her strength than Francisco de Goya, and his first portraits of her had been flattering, emphasizing her gorgeous clothes and expensive jewels. But he had grown tired of such insincere work, and late in 1791, when she told him she wanted him to paint her again, he decided to do a portrait as realistic as those he painted of others.

He must have realized that he was placing his entire future in jeopardy. Maria Luisa was as vain as she was ugly, and if his work displeased her he would be so badly disgraced that he would be unable to find any other work in Spain.

At his request the Queen did not look at the painting in progress, but agreed to wait until it was finished before she examined it. But others at the Court saw it, were shocked and reported back to Maria Luisa that it was cruel, abominable and held her up to ridicule. She kept her promise, however, and made no attempt to see the painting. The gossip increased, and one day King Charles asked Goya to show him the work, but the painter managed to put him off, too.

According to one story, Josefa took a hand in the situation, begging her husband for her sake and that of their

children not to paint an unflattering portrait of the Queen. Goya supposedly refused, saying it was his right as an artist to paint as he saw fit. There is a glibness to the story that renders it suspect, but the fact remains that Goya was always conscious of his artistic integrity, as his dispute over the paintings in Saragossa's Catedral del Pilar amply demonstrates, so it is possible he did take such a stand in conversations with his wife.

The finished portrait was truly shocking. All of the Queen's defects were there—her short stature, gaunt face and hollow cheeks, hooked nose and yellowing skin. Those who saw the work felt certain the painter would be banished from the court in permanent disgrace.

To the astonishment of everyone who knew her, Maria Luisa thought the portrait was superb. For there were qualities in it that others had failed to recognize: the intelligence of her expression, the strength in her mouth and chin, the quiet pride of her bearing. Endowed with an intellect and a shrewdness far greater than the courtiers possessed, she recognized a masterpiece that would make her live for hundreds of years. Her mirror did not lie, no matter what the sycophants told her, and Goya had not lied either.

Instead of sending him away in disgrace, the Queen rewarded Goya with an extra purse, then further astonished the entire court by ordering another portrait from him, and yet another. In all, he painted at least twenty to thirty pictures of her, all in the same candid vein.

King Charles thought the initial portrait was superb, too, and rewarded the painter in his own way—by playing the violin for him. That incident is one of the most celebrated in Goya's entire career. The artist was summoned to the King's private audience chamber in great apprehension, knowing that Charles had just seen the portrait of his wife for the first time. The two men were alone, and

equerries waiting outside the closed door half-expected the monarch to lose his hair-trigger temper. Instead they heard him playing his violin, which he was accustomed to practice for an hour or longer each day. The concert for an overwhelmed audience of one lasted for the better part of the afternoon, and Goya must somehow have expressed his gratitude for the great "honor" that had been bestowed on him.

Late in 1792 Goya spent time in Cadiz, where he painted a magnificent portrait of his good friend Sebastian Martinez, an art patron who held several high financial posts in the country. Nothing else is known about the journey, its duration or the reason for it. Possibly it was political. Charles' cousin Louis XVI of France had been imprisoned. Charles exiled Goya's liberal friend Jovellanos, and Goya himself felt threatened. He may have thought it wise to leave, as no one could forecast what might happen.

In any event, he returned to Madrid before January, 1793, and then tragedy struck. He developed "a disease of the most terrible nature," as Francisco Bayeu described it. Physicians, including the private physician to the King himself, hurried to the little house on the banks of the Manzanares, and Josefa was advised to buy her widow's weeds. No details of Goya's affliction have ever been known, but he was not expected to live, and Bayeu flatly predicted that no man so sorely tried could ever recover his health.

From all that was written by contemporary sources, and from certain delicate omissions, it is not difficult to determine the nature of Goya's illness. He was suffering from syphilis, and some of its more severe symptoms had suddenly manifested themselves. His entire left side was paralyzed, and he completely lost his hearing. But he fought hard for his health, and the ruggedness of his con-

stitution helped him achieve a partial recovery. By February, 1793 he could be propped up in an armchair. He defied his doctors by engaging in painful exercises that he devised for himself, and by late February he was strong enough to send a note in his own hand to the Academy, requesting that he be granted a leave of absence so he could travel to Andalusia. There, under a warm sun, he hoped to regain his health.

"Goya has been brought to this pass by his lack of reflection," Zapater wrote, "but one must commiserate. with him with all the pity that his sad affliction demands."

No details of Goya's convalescence are known, other than the fact that his wife did not accompany him to Andalusia, but remained in Madrid with their children. No medication for syphilis was available at the turn of the nineteenth century; Goya relied on his willpower alone. By July he was strong enough to return unaided to Madrid, and in the months that followed he gradually regained the use of his left hand and arm, then his left leg. He could not yet hold a paintbrush, and as late as February, 1794, Jovellanos recorded that Goya was unable to write to him. His recovery was a testimonial to his will and his strength, but it was far from complete. Goya remained deaf for the rest of his long life.

His struggle to overcome his handicap was long, arduous and gallant. He taught himself lipreading and practiced with members of his family. Overcoming his hesitancy, he learned to carry a pad and pencil with him at all times and asked others to jot down their more complicated thoughts for him. He also worked daily with his paintbrushes, but threw away the crude paintings he made, not wanting others to know that Francisco de Goya had been reduced to such childlike efforts.

"My state of health is always the same," he wrote to Zapater in the spring of 1794. "I am sometimes so dis-

turbed that I can no longer endure myself. Then I become calm, as at the moment when I write to you, but I am already tired."

During this long and bitter convalescence Goya began to see the visions that later peopled many of his paintings and etchings and contributed so greatly to his lasting fame. Some resembled madmen he had seen in the insane asylum of Saragossa, a place he had once visited in his youth and had never forgotten. Others were like the demons he had imagined in childhood while listening to a priest deliver a sermon on eternal damnation. Still others sprang fully formed out of nowhere, instant products of his lonely, tortured imagination.

Was Goya sane at this time, and if not, did he ever fully recover his sanity? Had syphilis permanently scarred his mind? These questions can never be answered, but one thing is certain. The visions that Goya saw at this time haunted him for the rest of his days. They were a part of him, and he learned to live with them. His deafness isolated him, often shutting out the world, and he was alone with the demons, the madmen, the monsters, the terrifying creatures. Gradually he learned to accept them and lost his fear of them. It has even been suggested that he tried to exorcise them by reducing their likenesses to paper.

A new dimension was now added to the two worlds of Francisco de Goya. No matter what he did, where he went or what he thought—in his life as a distinguished artist, as a husband and father, or in his very private life as roisterer, woman chaser and iconoclast—his demons always accompanied him. He could not know it, but these apparitions were to contribute decisively to his immortality.

VIII
The Duchess

Driven by a frenzied desire to make up for lost time, Francisco de Goya secretly returned to work. In the latter part of 1793 and the first months of 1794 he protested to everyone, even Zapater, that he was still unable to hold a brush in his hand. But that was a self-protective ruse, a shield that would enable him to retreat in some dignity if his efforts failed. He revealed the true situation in a letter he sent to the Academy in January, 1794, saying he was at work on a number of small paintings that he called "library pieces," on the general subject of *Popular Diversions*. He intended to submit them for the Academy's inspection, he declared, and he asked, rather hesitantly, for his colleagues' opinion.

According to the written report of the Academy, all eleven paintings in the collection received the enthusiastic approval and endorsement of the membership. No list of titles was made, but some of these works were subsequently identified.

Their significance in the world of art cannot be stressed too strongly. They were created out of the talents and

tortured mind of a man who had been crippled at the height of his manhood. He painted what he saw in his mind's eye; abandoning the realism that had brought him wealth and fame, he painted impressions, substituting violent clashes of color for clarity. In these paintings Goya gave birth to Impressionism.

The Madhouse was one of the most terrifying of these works. Crowded with men and women suffering various degrees of insanity, the little painting reeks of sickness. The insane men and women, many of them only partly clad, their decaying bodies more nearly resembling demonic creatures than human beings, are engaged in a variety of activities. They declaim, they sing, they dance, or they slump in despair. What gives this work its power is the isolation of the lunatics; each is alone, living in his own, private world, unable to communicate with his neighbors.

Perhaps no painting better illustrates the aloneness that Goya felt. Like his filthy, ragged madmen, he was living a nightmare existence, convinced he could neither reach out to others nor be reached. Certainly the poignancy of this work was not lost on his contemporaries.

Bullfight in a Small Town may or may not have been one of the series, as the subject is not ironically treated, like the others; experts have never been able to make a definitive judgment on the question. But it belonged to the group in the most general sense, as it evoked a feeling for its subject, depending on suggestion to achieve its effect.

Even more controversial has been the question of whether *Tribunal of the Inquisition* was one of the paintings that Goya sent to the Academy at this time. Regardless of his personal feelings, he—like all other men who valued their lives—had been careful never to attack this dreaded force. In this painting, he rips off his mask and

reveals his deep loathing for the Inquisition, attacking it with all of the skill and energy he can muster.

The setting was one familiar to many Spaniards of the period: the Church of the Dominicans in Madrid, where the victims of the Inquisition were brought before a tribunal, and in the presence of an invited audience—usually persons who were being warned in a none too subtle manner to conform—heard sentence pronounced on them.

It has been speculated that Goya himself had received such an invitation, which was tantamount to a command, and had watched the strange, spine-chilling spectacle, the combination of religious rite and pagan ceremony that could have been staged nowhere but in Spain. The *Tribunal of the Inquisition* indicates that he was no stranger to the scene. Victims sit in the foreground, wearing dunce caps and coarse robes that chafe their skin. Their judges are indifferent to their fate, a group of hideous monks sneer at them and most of the audience forms only an indistinct blur, part of a bilious background. It is the viewer's familiarity with the rites of the Inquisition that makes this painting so terrifying. Someone unfamiliar with the institution and its ways might find the picture merely confusing.

Why did Goya choose this particular critical time in his life to bait the Inquisition? He well may have felt he had nothing to lose, as his hearing was gone forever and he had barely escaped death. His contempt for the torturers who repressed the spirit of man on the pretense that they were uprooting "heresies and evils" was a conviction that sprang from his own soul. He would hardly have felt so deeply on the subject had he merely acquired through Jovellanos some secondhand sense of freedom from the philosophies of Locke and Voltaire. Other men were car-

ried into the Age of the Enlightenment by influences that surrounded them. Living in the intellectual vacuum that was Spain, Goya might have been late in discovering the Age of Reason—for the period was actually coming to an end—but he found it himself, unaided and alone.

Another of the *Popular Diversions* was probably the grotesque *Burial of the Sardine*. A strange, carnival-like procession is in progress, peopled with laughing, shouting, gesticulating adults and children. Some wear carnival masks, others have demonic faces resembling masks; it becomes difficult to distinguish one from another. Floating above is the carnival banner that is to be buried, and observing the crowd, jeering, is a disembodied, moonlike face. The scene may be interpreted in many ways, but one is obvious: the painter himself will never again hear the shouts and laughter of a carnival crowd.

Perhaps the strangest element in the life of Francisco de Goya is that at this tortured, out-of-focus period of his life, in 1794 and 1795, he became involved in his most celebrated affair, a liaison with a woman whose name is irrevocably linked with his.

Doña Maria del Pilar Teresa Cayetana was the thirteenth Duchess of Alba, a duchy she inherited from her grandfather. Her position in Spain—and in all of Europe—was unique. The house of Alba stood first in the hierarchy of Spain's twelve families, and the holder of the title was, for all intents and purposes, a sovereign, virtually independent prince. No one had ever been able to measure the Alba wealth: the real estate holdings amounted to millions of acres, and it was said that the family controlled more land than the Crown. The Duchess maintained eleven palaces and country estates and could have made her home in more than thirty others. The Alba collection of jewels, paintings and sculpture was greater and

more varied than that of most monarchs, and there were more retainers on the Alba payroll than in the employ of Charles IV.

Relations between the Crown and the house of Alba had long been cordial, at least on the surface, for the simple reason that neither side dared to attack the other. The men who bore the title of Duke of Alba made their own laws, paid token service to the reigning monarch and lived as they pleased.

Maria Cayetana, the present Duchess, had an unusual background, even for an Alba, due in large part to her mother. Doña Mariana de Silva y Sarmiento, born the Duchess of Huescar, had been married three times and had buried all three of her husbands. The first had been heir to the Duchy of Alba, and from him she had acquired a taste for literature and an intellectual curiosity lacking in most Spanish grandees. The second had been the old Count de Fuentes, the father of Don Juan Pignatelli, one of her lovers. The young Don Juan created an international scandal by deserting her to become the lover of Maria Louisa, the future Queen of Spain. The third husband of Maria's mother had been the romantic Duke of Arcou, whose father had threatened to disinherit him if he pursued a career as a bullfighter. The old Duchess was Honorary Director of the Academy of San Fernando; she also painted, wrote poetry and prepared adaptations of English and French plays for the Spanish stage.

Her daughter inherited her intellectual curiosity and quick-witted approach to life. She was imperiously arrogant, shockingly selfish and totally indifferent to convention. She did precisely as she pleased, paying no attention to custom or the rights or opinions of others. Her one talent was her enormous enjoyment of life, and she cheerfully admitted her hedonism. In England and in pre-

Revolutionary France she was regarded as the most beautiful woman in Spain.

At the age of thirteen a marriage had been arranged for her with a young man six years her senior, Don José Alvarez de Toledo, the Marquis of Villafranca. According to the original terms of the marriage contract, arranged by the grandfather of the bride-to-be, her husband would inherit the Alba title. But Maria Cayetana balked, and her grandfather, the most powerful man on the entire Iberian peninsula, was so amused that he changed his mind and allowed her to inherit the Duchy alone.

The marriage, which was childless, had been successful enough by the standards of the nobility. Villafranca had been no match for his tempestuous wife, and a few years after their marriage his health had declined, making it possible for her to go her own way without bothering to observe even the formalities of the marriage contract. When the Duchess was in Madrid she and Villafranca lived under the same roof, and occasionally she humored him by acting as hostess at one of his musical evenings. He composed music, and like Charles IV, he played the violin. He was also proficient on the harpsichord and the flute and buried himself in his music, blind to his wife's never-ending escapades.

For two decades Madrid had been relishing stories about the Duchess, and most of the tales were true. Unlike other great ladies, who mingled only with members of their own class, she was truly democratic. She collected bullfighters, artists, bricklayers and penniless members of the petty aristocracy. She sometimes sat in the pit with commoners when she attended the theater and, like Goya, she occasionally spent an evening in a working-class tavern, scarcely bothering to disguise herself. According to widespread rumors, she sometimes amused herself by

playing the role of a street girl. She could also be the haughtiest of noblewomen, and took particular delight in remaining seated, as was her hereditary right, when King Charles and Queen Maria Luisa entered a room.

Her relations with the good-natured King, who admired her beauty, were amicable, but she and the Queen usually kept each other at arm's length. It was no secret that the homely and ambitious Maria Luisa envied the great beauty who had a mind of her own and whose wealth was greater than the Crown's. According to a joke that had been told at the royal court for years, the Duchess of Osuna regarded herself as the great rival of the Duchess of Alba, but the latter, who couldn't be bothered with one so far beneath her, didn't even know it.

The Duchess had her own court, and among her intimates were a physician-surgeon-barber who was said to exercise sinister influence over her, a dwarf who acted as her jester and an elderly monk who was believed by many to be half-witted. The Duchess' confessor, a cardinal bishop, admitted he could do nothing to curb her exuberant excesses. Had she been anyone but the Duchess of Alba she would have been called to an accounting by the Inquisition, but because of her exalted rank, she was safe, untouched and untouchable.

Even the Queen could do little to punish her many impudences. When the Duchess dressed six of her maids in costumes identical to a gown of Maria Luisa's, the most severe discipline the harassed Queen could inflict on Maria Cayetana was a token slap. From time to time the Duchess was banished from Madrid for periods ranging from one to three months.

These sentences caused her no hardship. Amused and unrepentant, she went off to one of her many estates, usually accompanied by a lover and twenty or thirty other members of her ever-changing entourage. On one occa-

sion, in 1790, she more than evened the score with Maria Luisa. Learning that the Queen intended to hold a gala reception while her nemesis was in exile, Maria Cayetana invited almost everyone of importance at the Court to visit her palace at Sanlucar on the precise date that the Queen planned her reception. Only Don Manuel de Godoy and other government ministers remained behind, and they were treated to a spectacle of royal hysterics when Maria Luisa learned what had happened.

No one knows when the Duchess of Alba first entered the life of Francisco de Goya. Although many books, both nonfiction and fiction, have been written about their romance, the researcher is reduced to speculation. Did they form a relationship before Goya fell ill in 1792, or did their association more or less coincide with his recovery in 1794–95? One guess is as good as another.

It has been fashionable to search for Maria Cayetana's likeness in various of Goya's works as far back as 1787. She has been discovered in *Blindman's Buff, The Swing* and many others, but no authority has been willing to say with certainty that this or that figure is indeed the Duchess.

Compounding the mystery is an undated portrait of the Duchess—believed to be the first that Goya painted of her. And adding to the provocation of this work is her pose: in one hand she prominently displays a key, probably a key to a room, and the suggestiveness of this symbol has kept the theorists busy for decade after decade.

Goya's first signed portrait of the Duchess was painted in 1795, the same year he painted her husband, the Marquis de Villafranca. He had recovered the full use of his hand, and his eye was as keen as ever. The portrait is formal, but no realism is sacrificed, and the lovely woman on the canvas stares at the viewer with a haughty arrogance tempered by her sensuality. The intimacy in the

103

portrait makes it plain that Goya had become her lover.

The year 1795 was important in Goya's life in other ways. Using deafness as an excuse, he resigned from his post with the Santa Barbara tapestry factory, and King Charles graciously consented to relieve him of this unwanted burden. Late in the summer Francisco Bayeu died, and Goya was immediately elected to the post of Director of Painting at the Academy. He relished the honor, but his lack of hearing made it difficult for him to preside at meetings, so most of the work of the Director fell to the man he defeated for the place, Gregorio Ferro.

It has been claimed that Maria Cayetana was not in love with Goya at any time and merely added him to her long string of conquests, but this assertion seems to do her an injustice. Goya was forty-nine years old in 1795. A self-portrait he painted in that year reveals him as a gaunt-faced, balding man with thick features, heavy eyelids and a thickening frame, a middle-aged man who has known great pain and has come to terms with it. No longer dashing and in no sense distinguished looking, he was shabby, almost pathetic. The Duchess, on the other hand, was thirty-three, and never had she been more beautiful or energetic.

Did Goya arouse a dormant and hitherto unknown maternal instinct in her? Was she drawn to him out of pity? Again, one can only speculate.

It was the Duchess, not Goya, who was the aggressor in the affair. Her exalted position made it socially impossible for him to pursue her. And, more important, he had not yet completely recovered from his illness and continued to suffer from psychic wounds. Bayeu noted this diffidence shortly before his own death by commenting on Goya's unaccustomed hesitancy in his *Journal*. Even King Charles, far from the most sensitive of men, remarked that Goya was no longer his old, assertive self. Such a man

would not have made the first move with a woman so many years his junior, the most beautiful woman in Europe, a princess who ruled by caprice.

Remarkably little was written by contemporaries about the Goya-Alba affair, and the principals themselves said nothing. The artist had always boasted to Zapater and others about his conquests, yet in this remained a remarkably discreet silence. The Duchess' rank protected her from the Inquisition, but her lover would have been jailed, tortured and forced to repent publicly.

As for Maria Cayetana, she never wrote about any of her romantic liaisons. She lived in an age when letter-writing was one of the most popular arts, but only a few of her scribbled notes have survived. None refer to Goya in any way.

Goya's work is an important source of information about their affair. Several small paintings done in 1796 reveal not only their intimacy but also Maria Cayetana's influence in restoring Goya's buoyancy and sense of humor. In one of these pictures she is seen only from the rear in her dressing room, where she is having a temper tantrum. The subject of her wrath is her elderly nurse-maid, still a member of her household staff; in one hand the old woman clutches a crucifix, which she holds high in an attempt to halt the torrent.

In another work Goya shows the Duchess archly conversing with an overdressed young beau who is over-whelmed by her presence. She is flirtatious, amused and slightly contemptuous. Her pose somewhat resembles that of a dancer, and she is in complete command of the situation. Those who have claimed that this painting reveals Goya's jealousy of the Duchess have failed to understand his sense of humor. This painting was the wryly amused observation of a man who knew his own place in her life and thoroughly understood her mercurial nature.

Other works show her with pets, including the silly little dog seen in her formal portrait, and with various small children, among them a black child whom she adopted and reared and the little son of her major domo. Goya reveals that she was endowed with the maternal feelings others claimed she lacked.

The Duchess was not Goya's only subject during the first seven months of 1796; he painted a number of other portraits during this time. But in October, when he either accompanied or followed her to her favorite estate, Sanlucar, she monopolized him completely, and for the next few months, until early April of 1797, she was his constant model.

The Duchess' estate, still owned today by the Dukes of Alba, was located near the Guadalquivir River, outside of the old walled town of Sanlucar, between Cadiz and Seville. The main building had eighty rooms, and smaller "cottages" could house scores of guests; in Maria Cayetana's time the formal gardens were said to extend over more than sixty-five acres. Twenty cooks worked in the kitchen, and there were enough horses in the stable to mount a battalion of cavalry. Probably no one but the major domo knew how many servants were on the staff. Not even King Charles IV owned such a vast, handsome estate.

It was there that Goya and the Duchess "secluded" themselves, far from the scandalmongers of Madrid. Goya apparently told no one where he going when he left the capital. He just disappeared, and it is uncertain whether even Josefa knew his destination. Although neither Goya nor the Duchess, whose husband had died in June, wrote letters during their sojourn, Goya did keep his sketchbook.

He filled several volumes with hundreds of drawings and sketches of Maria Cayetana, many of them done in

pencil or crayon. Here and there a page has been torn out, another piquant mystery in the never-clarified relationship of the artist and his Duchess. Were these drawings removed by Maria Cayetana because she was particularly fond of them, or did Goya destroy them later?

Goya captured her in every mood and in every type of dress and situation, formal and informal. He drew her at her dressing table, applying cosmetics; he caught her playing with the little black girl, Maria de la Luz; he captured her during a temper tantrum; he portrayed her when she awakened from a nap, picnicking on the bank of the river and sipping tea in her garden. He showed her hugging her dog, formally entertaining visitors in a drawing room and kneeling in her chapel. He showed her laughing and storming, angry and forgiving, placid and aroused. He portrayed her with the light of love in her eyes, or displaying contempt for a lover. For his own edification and entertainment, and presumably for hers, he showed her running the scale of human emotions; he sketched every activity in which she engaged.

Above all, these sketches demonstrate that Goya was in love. The affair was anything but serene, which was not surprising in view of the tempestuous nature of both principals. Other men enter these drawings—an officer in the uniform of a colonel, a grandee in splendid attire, a very young, burly man, even a *Majo*. Occasionally he portrayed Maria Cayetana or one of the men gesturing in an intimate way, and the subtleties, the placement of a hand or a gesture, hint that he was tormented.

Goya struck back in the only way he knew, the only way open to him. Another, younger woman appears in some of his sketches. She is less willowy than the Duchess, but she is pretty in an earthy way, and it is apparent that the artist came to know her very well. He shows her in the nude, emerging from a bath; he portrays her in bed, beck-

oning; he shows her in various stages of undress. Was this girl a real person, or was she merely imagined to even the score? In all probability she was real, as the Duchess would have been aware of the identity of her guests and would have been quick to detect a ruse had he tried to perpetrate one.

It was during his stay at Sanlucar that Goya painted his most famous known portrait of the Duchess. She is dressed in the beautiful costume of a country woman, and an inscription in the sand at her feet reads *Solo Goya* (Only Goya) and the date, 1797. The Duchess wears two rings: one is inscribed with the name Alba, and the other with the name Goya. It is realistic, yet endowed with a sense of formality befitting the subject, and it is drenched in the imperious mien that proclaims Maria Cayetana for what she really was, the first noblewoman of the land. This painting Goya took with him when he left for Madrid.

Two other paintings, a matching pair, may have been painted a short time later—nobody knows the date. In one a young woman is reclining on a sofa, her hands clasped over her head. Her diaphanous costume and her figure are compellingly sensual.

The other portrait, the twin of the first, depicts the young woman in the nude. That the thirteenth Duchess of Alba could have revealed herself in such a manner is shocking, and the world has never recovered from that shock, down to the present day. We will examine later the theories that another woman posed for these paintings.

Posterity has never been able to determine which of the two portraits was painted first. The difference in expression in the two paintings has given rise to the notion that the clothed version was painted before sexual intercourse and the other after, though many experts dismiss this assertion as the work of too-lively imagination.

Stories about *The Maja Clothed* and *The Naked Maja*

are legion, limited only by the inventiveness of those who have written on the subject. One of the most persistent is that other members of the Duchess' family, including her mother, saw *The Naked Maja* and were horrified. According to this story, it was the nude that was painted first. It is doubtful that the old Duchess, who had outlived all her husbands and numerous lovers, was offended on moral grounds. Morality, in the upper reaches of the Spanish aristocracy, was nonexistent at the time. But the old lady supposedly was frightened, and knowing that there would be talk, persuaded her daughter to pose again, this time as a fully dressed *Maja*.

The painting and exhibition of any nudes was strictly forbidden in Spain, the land of the Inquisition. In the long history of that nation's art, only one nude had ever been painted. Only Velasquez had achieved such great stature that he had dared to paint a nude, and even he revealed his subject only from the rear. The Duchess of Alba herself owned this famous painting, *Venus and Cupid*, at the time. And to possess a nude by Goya was an event in the history of art.

That Goya had painted such a work at all was startling. That his subject was Doña Maria del Pilar Teresa Cayetana, Duchess of Alba, was unbelievable. The painting of *The Naked Maja* was an insult to every institution Spain held dear, a challenge to the nation's morals and mores. Had the existence of the work become known, it is certain that Goya would have been jailed by the Inquisition, tortured until he signed a confession of heresy and then burned at the stake. Even the Duchess' high rank probably could not have saved her. In a direct confrontation, with its authority at stake, the Inquisition would have been forced to take action against the owner. Goya and the Duchess knew the risks they were taking. No Spaniard could have been ignorant of them. The Duchess was reck-

less and loved to flout the authority of others, and it is possible she appealed to the iconoclast in Goya. Or it may be that the same spirit that impelled him to draw *The Tribunal of the Inquisition* was responsible for *The Naked Maja*. He must have wanted to bait the officials of the Holy Office.

Whatever their motives—and both may have been moved exclusively by eroticism—they came to their senses after *The Naked Maja* was completed. The very existence of the portrait was kept secret; it was shown to no one.

But Maria Cayetana had never before found it necessary to keep a secret in her life, and her nature was so exuberant that she failed to remain quiet now. She must have whispered about the painting of *The Naked Maja* to friends, and perhaps she showed it to a few of her intimates. Inevitably, rumors began to fly in Madrid.

Goya returned to the city in the spring of 1797 but was not summoned to the headquarters of the Holy Office until years later, in 1815, when he was questioned about the twin portraits he had painted of the Duchess of Alba. He must have protested with complete truthfulness that he had painted her in the full-dress costume of a *Maja*, but as the Inquisition seemed satisfied with this explanation, he kept his mouth shut on further details. As usual, no record was kept of the proceedings.

That ended the matter, so far as the Inquisition was concerned.

The Duchess of Alba was not Goya's only major subject during his long sojourn at Sanlucar. He was too restless an artist to confine himself to one model, no matter how much he may have loved her. He found time to travel to nearby Cadiz, and there, in the huge Church of Santa Cueva, he painted a *Last Supper* that amply demonstrates his striking progress as an artist—his daring in a new art

form that he was developing solely for his own inner satisfaction.

Breaking every tradition, he painted a *Last Supper* filled with dramatic action and almost frightening in its conception. The Apostles are not depicted in their usual pose, grouped around the Master. Instead, Christ has been betrayed, and the terrified Apostles have hurled themselves to the ground. The color contrasts are violent and clashing, the mood is electric.

The bishop of Cadiz was shocked, as were the members of his staff, but no attempt was made to force Goya to change the painting. By this time he had become so great a figure in Spain that his fame had spread to other lands, and the clergymen were compelled to accept his startling, unorthodox work.

Goya's stay at Sanlucar ultimately produced totally unexpected results. Though he took full advantage of the licentious atmosphere, continuing his affair with the Duchess of Alba and in all probability also sleeping with the young woman whose pictures appear in his sketches, he was troubled. Like all Spaniards of his class, he had been reared in a world of the strictest morality and he had always taken the teachings of the Church to heart. He had been unfaithful to Josefa for many years, but the double standard in marriage was universally accepted, and priests rarely bore down in the confessional on the man who cheated on his wife. This in no way contradicted the basic code of morality.

The high life Goya observed at Sanlucar was far different. Maria Cayetana herself had many other lovers while Goya was there, and other members of her household, guests and those attached to her court followed her example. These activities defied every precept Goya had known, and ran counter to his beliefs. The sketches made during the latter part of his sojourn concentrated with

increasing frequency on the Duchess' relations with other men, and a sense of disgust began to replace his earlier jealousy.

New ideas filtered through his mind, and he began to make rough sketches of them in his notebook. The original concepts for many of the magnificent drawings that later appeared in his *Caprichos* were conceived at Sanlucar. The artist was revealed to the world as a moralist in the *Caprichos*, but few have ever realized that he first began to crystallize his ideas for them at Sanlucar, where sexual relations were astonishingly casual and where anyone who was so inclined might freely indulge in an affair with anyone else.

Goya and Maria Cayetana did not completely terminate their relationship when he left Sanlucar in the spring of 1797. Their involvement was too deep, and they were too proud to admit they were tiring of each other. But they undoubtedly saw each other far less often thereafter, and a few years later a tragic ending separated them forever, leaving behind *The Maja Clothed, The Naked Maja*, and a legend.

IX
Dark Side of the Moon

Goya did not return to Madrid from the country estate of the Duchess of Alba, but made the long journey to Saragossa. There he visited his aged mother, again advanced money to his avaricious brothers and renewed his old friendship with Martin Zapater, whose portrait he painted again. According to Zapater's children and grandchildren, who wrote letters on the subject many years later, the straight-laced Martin heartily disapproved of Goya's relations with the Duchess of Alba and did not hesitate to make his views known. Goya was now fifty-one years of age, and in Zapater's opinion he was far too mature to throw himself at a woman whose name was synonymous with sexual license.

How Goya reacted to these lectures is not known. In spite of his loss of hearing he was still hot-tempered and impulsive, but he would have accepted such reproof from his lifelong friend more than from anyone else. The fact that he painted another portrait of Zapater indicates that he bore no grudge for the deserved reprimands.

He was in a sober frame of mind when he returned to

Madrid in the late spring. His first act was to resign his post as Director of Painting at the Academy of San Fernando. Citing his infirmities, he said with great candor that he could not perform the functions that the office required. Such a step must have taken great effort. He had yearned for the post for many years, envying Bayeu, whose work he knew to be inferior to his own. The Directorship had been a symbol of prestige and excellence to him.

His fellow members of the Academy realized he had gone through a difficult inner struggle. They replied by electing him unanimously to the new position of Honorary Director of Painting and took the unprecedented step of authorizing continued payment of his salary. According to a letter written by Gregorio Ferro, who succeeded him as Director, Goya wept when a committee called on him to tell him of his election to the newly created post. His tears took them aback. Ferro remarked that he had never before seen Goya display his emotions so freely.

With his desire for the Duchess of Alba no longer haunting him, Goya turned to a new task, mending his relations as a court painter to King Charles IV, Queen Maria Luisa and the all-powerful First Minister, Manuel de Godoy. Events had jarred Spain out of her isolation since Goya's illness, and the artist appeared to be aware of these changes for the first time.

Horrified when the leaders of the French Revolution executed Louis XVI, Spain had promptly declared war on her neighbor. That struggle had gone badly for the ill-equipped, poorly led Spanish armies, and the situation had deteriorated even more when Godoy took personal command of the troops in the field. The First Minister had a knack, almost a genius, for turning national catastrophe into personal triumph. In 1795 he had negotiated a peace with France, surrendering territory and paying repara-

tions in order to obtain a treaty. Then he had posed as the man who had brought peace to Spain, and the Crown rewarded him with a duchy, vast estates and Spain's highest decorations. The King and Queen believed he could do no wrong, and for the first and only time in his career he was also enjoying a strong wave of popular support. He was cheered as the "Prince of Peace" when he rode through the streets in his state carriage, and because his origins had been relatively humble, the common people felt genuine admiration for him.

Now, in 1797, Godoy signed a new treaty of alliance with France, and the two nations promptly went to war against Great Britain. That struggle would last until 1809 and would bring ruin to Spain, whose fleet had already been soundly defeated by the British navy. Cadiz was under naval siege, and far-seeing statesmen feared the new alliance with France, but Godoy remained high in the King's esteem.

He was lucky even in his personal relations. His predecessor, Floridablanca, had been dismissed for saying that the youngest princess was fathered by Godoy. Now the Queen's youngest son, the Infante Francisco de Paula, bore a remarkable resemblance to the First Minister, which was duly noted by everyone except the myopic Charles IV. Godoy challenged even the Queen by secretly marrying a young woman of questionable reputation, Josefa Tudo, soon to be immortalized in street ballads as "Pepa." Godoy managed to persuade Maria Luisa not only to accept his "secret marriage" but to promulgate a royal decree making his Josefa Tudo a duchess. No one ever knew how he accomplished this extraordinary feat. Goya received a commission to do a portrait of the new duchess, but though the First Minister may not have known it, Goya had already painted her portrait several years earlier, when she had been simply Pepa Tudo. That work had

115

been a study of a sensual face, leading various experts to believe she had been Goya's mistress for a time, and at least two novels and one play have been written on this theme.

Goya and Pepa said nothing of what they meant to each other before she met Godoy. She had her new, exalted position to protect, and he his role at court.

Godoy's love life became even more complicated. Whether his secret marriage to Josefa Tudo was legitimate is questionable. But with the approval of both the Queen and Pepa, he soon after married a member of the royal family, the Princess Maria Teresa de Borbon y Vallabrigida, the seventeen-year-old orphaned daughter of the Infante Don Luis. After the marriage, Maria Teresa, known as the Countess Chinchon, was brutally ignored by her husband, whose political position she had greatly enhanced. Godoy continued to live with La Tudo.

Wallowing in wealth and honors, he wanted the larger of his two Madrid palaces to resemble the Royal Palace more closely, so he decided that it should be decorated with frescoes. Only one artist, Francisco de Goya, was sufficiently distinguished to be given the commission. He actually painted three medallions, resembling frescoes, that he called *Industry*, *Study* and *Agriculture*. They were inferior works, unworthy of Goya's great talents. Many authorities believe he did the medallions in great haste, and it is obvious that his mind was elsewhere. But Godoy was delighted, and commissioned Goya to paint several portraits of him, one an equestrian figure.

Goya spent a great deal of time at Godoy's palace, and other people, because of his infirmity, were inclined to speak freely in his presence, not suspecting that he had become an expert lipreader. It was not only the rampant sexuality of the place that disgusted him. He verified what he could only have suspected before—the tremendous

corruption in high places. Men of every rank, including ministers of state, freely accepted and offered bribes. People were greedy beyond belief, Goya concluded, and man was bestial and vile.

Ideas for the *Caprichos* began to take shape in his mind, and he made extensive notes, both in drawings and in words. A caption that later reappeared on one of the *Caprichos* expressed his sentiments:

> The man who is called to live among men most assuredly will be peppered with annoyances. If he wishes to avoid them, he must go away, escaping from them, and live in the depths of the forests; and when he is there he will perceive that this kind of life also has its vexatious aspects.

The mere fact that Goya was painting a number of portraits of Godoy caused other government officials to clamor for his services. By the end of the year he also did portraits of the Minister of Justice, the Minister of Agriculture, several members of the Royal Council and two King's Magistrates, the highest-ranking members of the judiciary. The news that Goya was well again, that his illness had destroyed none of his talents, spread rapidly, and he was even more in demand than before. He also painted another portrait of Jovellanos, whom Godoy would send to prison the following year for writing seditious literature.

There was a difference between the Goya of 1797 and the artist who had been so popular six years earlier. He and his family still lived comfortably in their same house facing the river, but the flair of yesteryear was gone. Goya, who had been inclined to wear the latest fashions, now dressed soberly in suits of black, dark gray and brown. He considered wigs an affectation and refused to carry a walking stick, though he still carried a sword,

117

principally because crime was increasing in the streets of Madrid, particularly after dark, and every man had to protect himself.

The deaf artist was no longer the smiling courtier who joked with the great men and ladies who sat for him. He observed them closely, his thick brows contracted, and remained silent as he painted them. Expressing his new attitude in a letter to Zapater, he said he was not hired as a ballad singer or actor. He was a painter, and would perform no other service on behalf of those who engaged him.

The one exception to his new rule was King Charles IV. Goya returned to the palace late in 1797 to paint more portraits of the King, the Queen and their children, and he made no special effort to be sociable in Maria Luisa's presence, knowing she had the sensitivity not to demand that a deaf man strain himself trying to hear what she was saying at a time when he was attempting to concentrate on his painting.

Charles, however, may have been incapable of understanding another's affliction, so Goya continued to laugh heartily at his feeble jokes. On at least one occasion he was forced to sit through another of the monarch's private violin concerts, performed for his exclusive benefit, an incident that caused considerable mirth in court circles. Goya, it was said, was the most fortunate man in Spain, for he had not been able to hear a single note that King Charles played.

The artist's heightened perceptivity reflected itself in his work. His portraits were no longer realistic in every detail. Now they had become in-depth psychological studies, and the painter developed a rare insight that enabled him to penetrate his subjects' souls. His portraits were now unique, unlike those of any other painter, living or dead, and it was generally conceded throughout Europe

as well as in Spain itself that he was the peer of the men whose works he had admired, Velasquez and Rembrandt. His professional ego unimpaired by his physical affliction, Goya was inclined to agree with the critics.

His social life was the one aspect of his existence that remained unchanged. He had rarely entertained at home or in his studio, so it was difficult for him to invite friends to dinner. He and Josefa still had little in common other than their children, and he continued to spend evenings in the taverns of the poor.

Now, however, he no longer tried to conceal his identity. His companions knew him and apparently were willing to accept him at face value. One reason for dropping his disguise may have been his fame. The whole world had learned that he was deaf, and he could hardly pretend to be a humble artisan. There was less reason to keep up the pretense as his sex life changed. He no longer bedded street girls, his illness having sobered him somewhat, and he preferred semipermanent liaisons with women who, now that he was in his fifties, he saw less frequently.

Obviously he needed the company of ordinary men, and he was convinced that his earlier judgments had been right: as he wrote to Zapater, they were the only people in Spain worth cultivating. He had lived and dined with the great, and had seen their contempt, their disregard of the rights of the common man. He brooded about injustice, greed, corruption and folly, and he came to the conclusion that although ordinary people had their fair share of human frailties and weaknesses, they were the only members of the race worthy of salvation. Most of the wealthy and powerful were past redemption.

Goya dreamed of the day when man would be ruled by reason and justice alone. Without realizing it, he had taken up the basic principles of the Enlightenment. Con-

ditions that had sparked the Age of Reason elsewhere in Europe were now prevalent in Spain a century later, and Goya rebelled against them. The moral indignation within him was building to the explosion that would produce the *Caprichos*, that most extraordinary of all his artistic creations.

It might be argued that by the end of 1797 Goya was actively and consciously planning the *Caprichos*. He may already have drawn some of these remarkable sketches, many of which, complete with captions, were the precursors of the modern political and social cartoon. He labored on them privately in his studio day after day, locking himself in whenever his presence was not required at one or another palace for portrait sittings. No one knew what he was doing, and he did not discuss his work. So it is not surprising that when the *Caprichos* later emerged, he was able to show friends several dozen drawings at one time.

Goya did not invent caricature as an art form, but refined it and infused it with his genius. Certainly he was influenced by others. A number of revolutionary French satiric cartoons, forbidden in Spain, had found their way across the border, and Goya adapted them to his own use. Occasionally it is possible to discover precise sources for his work. One was a popular French cartoon depicting a peasant on the verge of collapse because he was carrying a nobleman and a priest on his back. In Goya's version of this work, two men are struggling in vain as they try to carry donkeys on their backs, and beneath his picture he wrote, "Thou who canst not."

In a grisly French cartoon, several expensively dressed, corpulent noblemen are playing croquet, using the heads of peasants as croquet balls. In Goya's subtler and infinitely more provocative version, a mock bullfight is taking place. Several men have tied horns to their heads, while

others, most of them very elderly, are precariously perched on the backs of their servants. His caption says, "One to another. So goes the world: they make sport of each other; the one who was the bull yesterday plays the caballero today, the picador. Chance presides over the festival, and distributes the roles according to its caprices."

His very title, *Caprichos*, or Caprices, was chosen with great care. According to a comment attributed many years later to his only surviving child, Javier, Goya considered scores of titles for the overall work, rejecting each of them in turn before finding one that fitted his subject matter to perfection.

The *Caprichos* exploded with Goya's anger. He despised the laziness of the wealthy, the pretensions of every class, the sexual excesses, the corruption and the ignorance that plagued the Spain of his day. Unlike Cervantes, who had launched similar attacks on almost identical subjects, Goya was no intellectual. He was rough, earthy, half peasant and half middle class. He expressed himself exclusively through the medium of his pictures.

But the painter was no admirer of the French Revolution. His loyalty to the Spanish monarchy was genuine, deep and sincere, and he did not hold the Crown to blame for the nation's ills. To the extent that the nobles were at fault, he wanted to reform the system and had no desire to abolish it. He enjoyed the favors bestowed on him by King Charles and Queen Maria Luisa, and he relished his close association with Don Manuel de Godoy. At heart he remained a monarchist, and undoubtedly he would have been disturbed had he known that, many years later, Spanish republicans and others would use the *Caprichos* for their own propaganda purposes.

Similarly, it is false to assume that because of his satires he became the enemy of the Church. He remained a de-

vout worshiper as long as he lived, still attending Mass faithfully on Sundays and holy days. A head of Christ he had painted remained in his bedroom until the end of his life and many of his letters were signed with a Cross. In the *Caprichos* he attacked Church corruption with a vigor unprecedented in Spain, but he was able to distinguish clearly between the teachings of the Church—with which he had no quarrel—and their miscarriage by imperfect men who administrated the affairs of the Church.

Goya fully realized, of course, what the Inquisition would think of the *Caprichos*. He was not a fool, and he knew he would be subjected to the most severe punishment the Holy Office could devise unless he took steps to protect himself. How he handled the matter will be discussed later.

The true genius of the *Caprichos* is that they were more than the expression of one man's discontent. Rather, they were an outcry on behalf of all Spaniards against institutions and customs that kept Spain in chains. Peasants in the fields of Aragon and *Majos* who lounged on the street-corners of Madrid felt precisely as Goya felt, though inarticulate in their grievances. The *Caprichos* achieved grandeur in the universality of their harsh, strident and frequently vulgar demand for justice, decency and the dignity of the common man.

It is almost impossible for people living almost two centuries after Goya's time to imagine what his world was like. Even today the Spanish peasant is suspicious, sullen and withdrawn, but at the turn of the nineteenth century he—and the townsman also—dwelt in the Dark Ages. Only sons of the aristocracy and the miniscule middle class attended school; it was regarded as dangerous for the ordinary man to read and write. Even the educated layman was forbidden to read the Bible, out of fear that people might choose to interpret Holy Writ in their own

way rather than accept the word of a cardinal bishop or a village priest as final.

Superstition ruled the mind; no belief was more widespread than the conviction that Satan and his cohorts existed as real beings. Occasionally a monk or nun who had been subjected to the ministrations of the Inquisition offered a spectacular confession before being burned at the stake, during which the victim revealed long conversations with the Devil and his kind. The faith of Spaniards was as primitive, their fear of Hell as great as in the American witch-burning colony of Salem one hundred fifty years before.

Goya had been exposed to more sophisticated ideas than most of his fellow countrymen had ever known, but his own faith remained simple. He shared the fears that caused men to shudder and cross themselves when they passed a graveyard or saw a black goat standing in a field. He believed that Satan sometimes inhabited the body of a goat, he believed in the existence of witches and demons, and the nightmares of his childhood possessed him again after he lost his hearing.

Was Goya hallucinating when he painted the *Caprichos*? Had syphilis permanently damaged his brain as well as his hearing? The questions are debatable, but the possibility that he had suffered partial derangement cannot be denied or overlooked.

The Satanic goat of the *Caprichos* had appeared earlier, however, in a painting done in 1798 for the Duchess of Osuna. Here his superstitions, fears and longing for improvement in man's lot blend in a horrifying spectacle. A male goat, obviously possessed by the devil, sits in a meadow on his hind legs, a garland of leaves on his head and an expression of frightening human lust and avarice on his face, holding out his front paws in a gesture of mock benediction. He is surrounded by women and chil-

dren, and some of the elders closely resemble witches. Others are eager voluptuaries; still others share the goat's greed. Most of the children express fear; those who do not seem already dead.

Certainly demons possessed some of these women, and Goya had no argument with the Inquisition on theological grounds. Unlike Jovellanos and some of his other intellectual friends, he was still a peasant boy from Aragon whose belief in the existence of demons had been confirmed by his own illness. Late at night, when he could not sleep, he sometimes crept from his bedroom into the living room, and there, by the light of a candle, he tried to exorcise his own demons by drawing their likenesses. Hundreds of such creatures found their way onto paper, and Goya's torment was so genuine and deep that he had good cause to believe in the powers of Satanic forces.

In a sketch that bears the date of 1797, Goya prepared a drawing intended as a preface to the *Caprichos*. The viewer sees the form of a well-dressed man slouched deep in a chair, his head hidden in his arms, collapsed over a table. His hands are crossed in a protective gesture as he tries to ward off the vision of owls and bats that are swooping down, almost suffocating him. He is alone in his world of darkness, but not quite alone. Unblinking, demonic eyes stare at him, boring into him. Beneath the picture Goya wrote a caption that he intended as the theme of his work: "The dream of reason produces monsters."

Afraid that the viewer might not grasp his meaning, he added a fuller note of explanation: "Imagination abandoned by reason begets impossible monsters: united with it, it is the mother of the arts and gives birth to marvels and wonders."

The Duchess of Alba appears in several of the early *Caprichos*, her face, figure and mannerisms unmistakably

clear. In one, which he entitled *Tantalo*, the lovely young woman has fallen in a dead faint across the lap of a man who is wringing his hands in horror. But her faint is not quite real, and the viewer can see that her eyes are open a tiny fraction of an inch so she can observe the man's despair. The caption is rough: "If he were more gallant and a little less of a bore, she would revive."

The moralist often reveals himself. In one carefully drawn picture, a young girl with an innocent face and a wise body sits in a prison cell, hopelessly bewildered by the fate that has befallen her. The harsh caption reads, "Because she was sensitive." Eager to drive home his moral, Goya felt compelled to add a longer note: "It is that this world has its ups and downs, and the life she was leading could have brought her to no other end."

All that Goya knew of the world appeared in the *Caprichos*. There were gluttonous, sensual old men and greedy girls who used their bodies to win financial security. There were drunken Churchmen and equally drunken artisans. There were old crones, highway robbers, city thieves. The honest, self-respecting and pure of heart were usually depicted en masse, faceless and supine.

He gave free rein to fantasy. Humans were shown with the bodies of birds and animals, and sometimes animals and birds were displayed with human characteristics. Demons, witches and other creatures were everywhere.

Several pictures were given identical or similar captions, perhaps deliberately, perhaps because these themes were so strongly present in Goya's mind that he could not help presenting them repeatedly. One thought was paramount: "Everything is a lie," or "Nothing in life is what it appears," or, "No man knows his own nature."

For what audience did Goya produce the *Caprichos*? It sometimes seems that he was interested only in purging his own soul. In some of the drawings he was a clergyman

delivering a sermon, not caring whether the pews he faced were empty or full. In others he was a lonely, frail waif, defying the powers of evil, daring them to inflict still more punishment on him. And at times he was a demented artist who was recreating the frightful nightmare of his own inner world. The latter part of the *Caprichos* depicts a world from which all reason has fled, a world peopled by men who have been transformed into beasts. This well may have been the world in which Goya himself lived.

Goya's contemporaries immediately began to play an identification game. The Duchess of Alba was instantly recognizable, and so, perhaps, were a few other members of the nobility. But most identifications were mistaken, and those who have played the game for so many decades miss the fundamental point Goya was trying to make. They destroy the universality of his concepts.

It is unlikely, all arguments to the contrary, that he depicted King Charles IV, Queen Maria Luisa or Don Manuel de Godoy in any of the *Caprichos*. He was proud of their patronage and friendship, proud of his belated appointment in 1798 to the post of First Painter to the Court. And he knew, too, that an attack on them would mean the abrupt termination of his career, the confiscation of the fortune he had so painstakingly acquired and his banishment from the realm.

It has been said, for example, that the cloaked woman hurrying to a rendezvous on a rainy night was Maria Luisa. According to a rumor heard prior to Godoy's marriage, the Queen sometimes went incognito to secret meetings with him late at night. But Goya, who had probably heard the story, had no reason to arouse the personal enmity of the sensitive Queen. He was lashing out against every type of immorality. Many Spanish women went off

to secret night meetings with lovers when their husbands were otherwise occupied, so it is safe to say he was attacking unfaithful wives as a breed.

At no time in his career, regardless of his personal problems, did the artist ever lampoon his patrons. Some authorities believe that he did a caricature of the mother of the Duchess of Osuna in one of the *Caprichos*, but that, too, seems unlikely. The lady was known only in a small, aristocratic circle, and she would not have been recognized by the majority of people who would see the drawings. Furthermore, the Duchess herself was still a valued patroness whose orders for paintings brought him a substantial income. She had remained loyal to him in spite of his affair with the Duchess of Alba, her enemy, and a gratuitious insult to her mother would have cut off the flow of gold from the Osuna treasury.

As Goya himself anticipated, however, when the etchings of the *Caprichos* were published and the Duchess of Osuna purchased four sets of the prints, the noble gossips of Madrid became busy. Goya, tired of denying that he was attacking any individuals, predicted just such a development. The whisperers mocked the Duchess of Osuna for failing to recognize the caricature of her own mother.

At the end of 1797 Goya let it be known that he intended to publish the *Caprichos*, which consisted of seventy-two prints. They were not published until two years later, however, when eighty plates were put on sale. Goya planned to make them available in only one Madrid bookshop, a place owned and operated by a widow of about forty with whom he was enjoying an affair.

An advertisement published in the Madrid newspapers shortly before the *Caprichos* appeared indicates that the artist was apprehensive. He either wrote the notice himself or persuaded a friend to write it for him.

The author, persuaded that the criticism of human errors and vices (however dependent it may seem upon eloquence and poetry) may also be the object of painting, has chosen, among the manifold extravagances common to all civilized society, and the prejudices and snares sanctioned by habit, ignorance, or self-interest, those themes for his work which he has deemed apt in furnishing material for ridicule and at the same time in exercising inventive imagination.

Painting (like poetry) chooses in what is universal that which it judges best suited to its ends; in one single fantastic personage it unites circumstances and peculiarities of disposition which Nature has presented as divided among several subjects, and from this ingeniously arranged combination is produced a happy imitation, thanks to which the artist, by skillful artifice, acquires the title of inventor and not that of servile copyist.

The project seemed ill-fated from the outset. Friends, not identified by posterity, who had seen Goya's etchings in the spring and summer of 1798, became frightened on his behalf, telling him candidly that the Inquisition would take action against him if the work was published. No man in Spanish history had ever held the Church up to such ridicule; many of the pictures were blasphemous.

Goya had never been reckless in regard to his livelihood, but the *Caprichos* were close to his heart. He wanted them published no matter how great the personal risk. But he soon discovered that no Madrid printer shared his view. After seeing his proofs, at least four different engravers declined to become associated with the project. They had their own fears of the Inquisition's torture chambers.

Years later, in his old age, after the *Caprichos* had vastly increased his renown, Goya admitted that he had toyed with the idea of publishing the etchings abroad. His

pride held him back; he was a Spaniard, his themes were exclusively Spanish and he had no intention of allowing a foreigner to share in either the glory or the profits.

Nevertheless, the project was at a standstill, and Goya finally turned to the powerful Don Manuel de Godoy for advice and help. The simple but ingenious plan that emerged from their conference may have been Godoy's, although it has been ascribed to Goya himself. The plan appeared simple, but was ingenious. Goya would go to King Charles IV and Queen Maria Luisa, offering them the entire earnings from the *Caprichos*. He would ask in return only for a pension for his son Javier, which would enable the boy to be educated at a good university and thereafter to travel abroad.

At a private meeting held at the Royal Palace, Goya confronted the King, the Queen and Godoy. It is difficult to imagine more dramatic circumstances. The artist was deliberately making a large financial sacrifice, though his income was great enough for him to afford the gesture. Paramount in his mind was his desire for a public. Throughout his career he had worked on commissions arranged in advance, so his etchings represented a radical departure from lifelong custom. He had hoped to publish them himself, but as this was proving impossible, there were far more important considerations than money at stake. He wanted the portfolio to be seen, absorbed, appreciated.

Under the circumstances it is absurd to think that caricatures of Charles IV, Maria Luisa or Godoy were included in the eighty pictures that the artist carried to the meeting. Even if he had succeeded in fooling them, the truth would have emerged eventually, and he would have been imprisoned—and possibly executed—for his temerity.

Both Maria Luisa and Godoy were eager to accept a new

source of revenue, for the war with Great Britain was a steady drain on the royal treasury. Money was of less concern to King Charles, who had no head for finance, but he was under the firm influence of his wife and the First Minister and was inclined to accept whatever they suggested. All three had artistic pretensions and regarded themselves as expert critics, but the *Caprichos* were so unorthodox, so unlike anything they had ever seen that they must have been somewhat bewildered. Also, neither the King nor the Queen was endowed with a keen sense of humor, and only Godoy could laugh at subtleties or appreciate ironies.

So revenue was the primary consideration, and money won the day. Their Majesties were pleased to accept Goya's handsome gift and ordered the royal engraver to take the plates. In return, although this was not specified as part of the deal, Charles IV promised to pay for the higher education and subsequent travels "in Italy and elsewhere" of Javier de Goya, "the son of our beloved First Painter."

Goya must have assumed that royal ownership of the *Caprichos* would keep him out of trouble with the Holy Office, but he miscalculated. Although he did not admit it until a year or two before his death, when he was living in exile in Bordeaux, he was summoned to the Madrid headquarters of the Inquisition soon after the publication of the portfolio in early 1799.

That dreaded institution's most potent weapon was its secrecy, and it was a standing rule that anyone under investigation was forbidden to mention that fact. The unfortunate man or woman who blurted out the truth even to a close relative was subject to immediate arrest and incarceration that could last for years.

So Goya kept his mouth shut, and only a few facts regarding his interrogation are known. He spent two days at

the headquarters of the Holy Office and was required to explain the meaning of each of the eighty drawings in the portfolio. Imprisonment, torture and severe punishment appeared almost certain, particularly as the sale of the *Caprichos* was halted abruptly on the same day that the shaken Goya returned home.

The ban on the sale of the prints remained in force for seventy-two hours, during which time there was a dramatic confrontation between the Inquisition and the Crown. Usually the two institutions worked in tandem with relatively little friction between them, but in this instance the line was sharply drawn. The Inquisition had forbidden the sale of property that belonged to the King. Ever since the kingdoms of Castile and Aragon had been united under the rule of Ferdinand and Isabella in the fifteenth century, Spain had been an absolute monarchy. Every attempt to weaken the authority of the Crown had been defeated. Now, with the very institution of monarchial rule threatened by the forces unleashed by the French Revolution, Charles IV could permit no challenge to his ultimate right to rule as he alone saw fit. Goya's future was a secondary issue in the conflict, although it was clear that if the Holy Office won, he would be subjected to the usual Inquisition treatment, in which case it would not be difficult for his interrogators to prove he was inhabited by demons and that he could be scourged only by burning at the stake.

For three days a succession of cardinals and bishops called at the Royal Palace. Charles granted them individual audiences, but refused to see more than one of the high-ranking clergymen at a time. The meetings were held behind tightly closed doors, and the equerries in the anteroom soon became accustomed to the sound of their monarch's voice being raised in anger. Although the cardinals and bishops argued that permitting the sale of the

Caprichos would undermine the Inquisition and thereby weaken the Crown too, Charles remained adamant.

After three hectic days the ban on the sale of the etchings was revoked, and long lines of customers appeared outside the modest bookshop. As rumors of what had happened spread throughout the city, interest in the prints rose sharply, and the royal printer was kept busy making new sets. It was said that the proprietress of the bookshop lived comfortably for the rest of her days on her share of the profits.

The delighted Goya was hailed by the small group of Spain's intellectuals as the only man who had inflicted a damaging defeat on the Inquisition. He had the good sense to say nothing and issued only one bland statement, saying, "Foreigners are most desirous of acquiring my plates; and for fear that they will fall into their hands after my death, I wish to make them a gift to my King, my master, for his collection of engravings."

Few people took his announcement at face value, but that did not matter. They applauded his finesse, and his victory was complete.

Not until 1803 did the plan for the gift of the *Caprichos* to the King become official, when Goya wrote a formal letter to Charles IV offering them, and the King's support for Javier's education was granted.

X
The Paintbrush Does Not Lie

Goya is believed to have completed the *Caprichos* by the summer of 1798, and he began looking around for new worlds to conquer. He did not have to search long, and by the end of the year he executed two additional masterpieces, each of them unique, each revealing his dazzling versatility as an artist.

One was a large allegorical painting that he called *Time and History*. His concept of Time was particularly fascinating—the figure was that of a tough, sinewy old Spanish peasant, a heavyset man with a thick chest and abnormally strong arms. But Goya's Time was far more: he had wings of the palest gossamer silver and gold hues that trailed off into infinity, blending with a bright sky. The work was exhibited at the Madrid palace of the Duchess of Osuna, and several distinguished French visitors predicted that the artist would go down in history as the greatest man of his age.

The other masterwork was one of his most ambitious undertakings, and the results were even more glorious. Fortunately for posterity, virtually all details of this enter-

prise have been recorded. One of Goya's closest friends was the architect Juan de Villanueva, whose portrait he had recently painted. In the summer of 1798 Villanueva finished a major task of his own, the neoclassical Church of San Antonio de la Florida. It was located in the open countryside near Madrid, and at his friend's request Goya agreed to paint the entire interior.

The artist's subject matter was the story of St. Anthony, who supposedly had brought a dead man back to life to reveal the name of his murderer and thus release an innocent man facing execution for a crime he had not committed. The parish was too poor to pay Goya's usual fee, and not even a wealthy grandee could have paid for a task of such magnitude. So the painter agreed to do the work as a labor of love, but at the same time he shrewdly made private arrangements. He would show his finished product to King Charles IV, and if the monarch liked his work Goya would be pleased to accept any commission that Charles offered him.

Goya began the task early in August and each day he drove out to San Antonio de la Florida at dawn, returning at sunset. He completed the mammoth assignment sixteen weeks later, in mid-December; only because the dates have been verified is it possible to believe that one man could have painted so much in such a short time.

Villanueva was stunned by his friend's activity, which he described at length. Goya, he said, worked in frenzied bursts that lasted for hours at a time. Sealed off from the outside world by his deafness, he concentrated exclusively on his work, and he painted so rapidly that a section of bare wall would come to life in hours. His speed and the sureness of his touch were difficult for an onlooker to comprehend. His face was contorted and he appeared to be engaged in a great struggle against time, as though he feared each hour would be his last on earth.

Goya soon discovered that an ordinary brush would take far too long to cover the white plaster walls. He first tried a rag tied to the end of a long stick. Finding that an improvement over the brush, he then devised a new brush of his own, made of large pig's bristles. This was another improvement, but the colors would not blend to his satisfaction, and after further experimentation he finally settled on sponges, though some have denied that he could have used them for painting.

The dome and vault of the church are breathtaking. The colors, mainly shades of silver and pastels, blend together in a dazzling harmony that inspired the church's poor parishioners to think of Heaven. This very personal celestial world was crowded with lovely, gracious handmaidens and more angels and cherubim than the dazed viewer could possibly count.

Beneath the dome was a balcony encircling the entire interior of the church, and behind it Goya placed his earthly scene, which was a marvelous blend of realism and his increasingly sure-handed Impressionism, a marriage that he alone could achieve. His saint was painted with such subtlety that at first glance he does not stand out, but his power is so great, his expression such a blend of self-assurance, piety, compassion and humility that ultimately he takes command of the scene. Although the real St. Anthony was an Italian from Padua, Goya's saint was a poor Spanish monk whose real-life counterpart could be seen anywhere in the country and would be recognized instantly by those who came to the church to worship. He was shown performing the miracle, surrounded by a huge crowd of *Madrileños*.

These larger-than-life figures were the real people of Madrid whom Goya had known for so many years. In the vast throng, scores of individuals stood out. There were thrill-seeking old women, children who were too busy

playing to pay any attention to what was happening, strutting *Majos* and poor bricklayers. There were visitors from the country, conspicuous in their threadbare attire. There were street girls, provocative and eager to catch the eye of a potential client, even while a miracle was being performed in their presence. There was the aristocrat jarred out of his boredom and the half-wit who was impressed in spite of himself.

Goya's portrayal of these characters was one of the most significant aspects of his genius. A lesser artist would have shown the crowd awed by what was happening in their presence, and it is true that here and there individuals could be seen on their knees, praying. But Goya's beloved crowd of the bullfight and street pageant was brash rather than pious. Most of those watching the saint perform a miracle were excited rather than awed. The viewer is captured by this excitement; then, as he, too, gradually falls under the spell of the saint, he is overcome by the miraculous event he is witnessing.

While Goya was still at work on the great enterprise, word began to circulate in Madrid that he was painting a marvelous picture, and ladies and gentlemen began to drive out to San Antonio de la Florida to watch him at work. For more than two weeks he tolerated the growing crowds of uninvited guests and actually appeared to be unaware of them. Then, one day, the inevitable happened. A young dandy, a nephew of the Count de Fuentes, had the temerity to interrupt him. Goya's temper flared, perhaps because he felt that someone from Aragon should know better, and before the two men could be separated, blows were exchanged. The young grandee promptly demanded satisfaction, and Goya, of course, was willing.

Faced with the possibility that the nation's greatest artist might be killed, King Charles intervened. That same day both principals were served with a written order

bearing the royal seal: the duel was forbidden on pain of immediate expulsion from the country. And the next morning a full company of royal household troops was on guard duty at San Antonio de la Florida to prevent anyone other than Goya and Villanueva from entering the church. The crowds dissipated and the unpleasant incident was forgotten.

A few days after Goya completed his work at San Antonio de la Florida, a large royal party drove out to the church. At the head of the procession were the King and Queen, with the First Minister and two cardinals in attendance. According to one account, the entire company applauded spontaneously at the sight of Goya's work. Another story had it that no one spoke until the King expressed his hearty approval.

Whatever the group's reaction may have been, Goya's reward was princely. Charles IV gave him a purse of one hundred thousand reales, and the bishop of Madrid felt compelled to give him another fifty thousand, though the the Inquisition was already doing everything in its power to prevent the publication of the *Caprichos*.

The artist's prestige was now so great that he could command any fee for his commissions. It was said that the Ambassador of the French Republic, Ferdinand Guille-mardet, paid the staggering sum of forty thousand reales for his portrait, a painting that holds a high place among Goya's masterpieces. Not everyone was required to pay so much, however. The Duchess of Osuna, upon whom the *Caprichos* made a deep impression, asked Goya to paint several pictures of demons and witches to hang in her Madrid palace. He created an entire series for her, and although she would have given him any price he demanded, he charged her only a nominal sum.

Was the Duchess of Alba still a part of Goya's turbulent life? One of her many palaces was located only a short

distance from San Antonio de la Florida, and according to one persistent story the artist accepted the task of painting the church because it was convenient for him to pay Maria Cayetana a visit after he completed his day's work. Perhaps he did see her frequently, but their tempestuous affair may already have come to an end. The truth of the matter has never been unearthed, although numerous attempts have been made.

By early 1799 Goya and the Duchess of Alba undoubtedly were in different parts of Spain. Maria Cayetana had gone off to her estate in Sanlucar to avoid the cold Madrid January, and Goya was in Toledo, where he painted a *Betrayal of Judas* for the sacristy of the great Cathedral. Perhaps the proximity of so much of El Greco's work disturbed him; their styles and approaches were totally dissimilar, and Goya had struggled in vain to establish a bond with the earlier titan of Spanish painting. Whatever the reason, his *Betrayal of Judas* was an inferior, strangely flaccid work. It was judged at the time as less than a masterpiece, and when Goya presented it to the Academy, it was accepted by his colleagues without enthusiasm. The best they could muster was a politely worded letter of thanks. Not even Francisco de Goya was inspired every time he picked up his brush.

The year 1799 marked a major turning point in Goya's career. So much praise was heaped on him after the publication of the *Caprichos* that for a time his restlessness disappeared. His work at San Antonio de la Florida won international acclaim. A Paris newspaper printed an article, which he saved for the rest of his life, in which he was called "Spain's most precious asset."

He was receiving enormous sums for his paintings, and his financial comfort isolated him from the problems of the world. General Napoleon Bonaparte had made himself First Consul of France, assuming dictatorial powers,

but no evidence suggests that Goya had ever heard his name. The war engulfing Europe did not touch him. He was fifty-three years of age, he had more than recovered his skills after his illness, and in spite of his loss of hearing, life was sweet.

In 1799 he solidified one of the lasting friendships of his life, with Leandro Fernandez de Moratin, a highly successful young playwright who had traveled extensively for a decade and more. Goya painted the portrait of his dashing friend, and the two grew closer. Moratin is generally credited with drawing the painter out of his isolation and arousing his curiosity about the world outside the borders of Spain. He regaled Goya with stories about London and Paris, the world's two liveliest cities, and Goya, who had never traveled anywhere other than Italy, began for the first time to broaden his horizons. Thanks to Moratin he developed an interest in the contemporary art of England and France, and it was the dramatist, in all probability, who obtained copies of various Rembrandt paintings for him. He had seen engravings made from Rembrandt but wanted to study the actual work of his great predecessor, and there were remarkably few Rembrandt paintings anywhere in Spain.

His own collection of art works was growing. According to a later inventory, Goya owned two portraits by Velasquez, a dozen Rembrandt prints, one painting by Correggio and four by Wouvermans. When there was a bare wall in his house, he filled the space. Six of his own still lifes decorated his dining room. He was also acquiring a handsome library, but how much he actually read is questionable. Many years later his son Javier remarked that the pages of many of the books in his father's splendid library were still uncut.

By the turn of the nineteenth century Goya had become one of the mainstays of Madrid society. The great, the

wealthy and the talented came to his studio to have their portraits painted, and for the first time some were invited to his home, including many attractive women—noble ladies, prominent actresses, pretty models. It was said that the most handsome women in Madrid could be found under his roof.

How Josefa reacted to her new and unexpected role as a hostess can only be imagined. Her husband at last felt sufficiently secure to invite people to their house, but it is unlikely that Josefa shared his feelings. Exhausted by decades of childbearing, bowed by the sorrow of losing one child after another, she had lived her entire life in the shadows. Now, with almost no preparation for her new role, she was being asked to entertain authors, poets and philosophers, grandees, bankers and diplomats, the most handsome and talented and flirtatious women.

Sliding doors in the Goya house could be opened to make one large chamber of the drawing room, the family sitting room, the library and the dining room. Goya had finally filled the house with handsome furniture; according to an inventory, forty-six chairs were available for the use of guests. So some of the gatherings under his roof must have been large.

The diaries and journals of many prominent persons indicate that they frequently attended Goya's salon and dined at his parties. Any foreigner of consequence visiting Madrid was sure to be there, along with government ministers and members of the twelve leading families. The Duchess of Osuna did not feel she was lowering herself by accepting Goya's hospitality, but there is no record of any visit paid by the Duchess of Alba.

Goya was often mentioned in these accounts. He told jokes, he was pleased to show visitors his art collection and he was an attentive host, making certain that his guests had enough to eat and drink. No mention of Josefa

appeared in the diaries and journals of the guests. Perhaps she stayed in her own quarters and took no part in the festivities, or she could have been in attendance, but chose to remain in the background.

Probably no one was surprised at her lack of participation in her husband's new social life. Madrid society was dominated by men, and the only ladies present at most events were nobles—or actresses, models and mistresses. By now, Goya had outgrown his own middle-class ways as well as his wife.

Only Goya knew the extent of his wealth. Over the years Martin Zapater had invested more than three hundred thousand reales in real estate for him, most of it in Aragon. Moratin's correspondence mentions two valuable properties that Goya owned in Madrid, and Javier de Goya inherited a large house and garden in Cadiz. But Goya was still too much the peasant to put all of his money in land. He kept a large iron strongbox in his library, apparently filled with diamonds and gold, which he regarded as his real security. Much of Goya's gold is known to have been in French gold *louis*. When the Bourbon dynasty in France had fallen and noble refugees had fled the country, they took their *louis d'or* with them, and this money eventually found its way into foreign hands. How extensive his diamond collection may have been is difficult to estimate. According to some accounts his gems were worth only fifty thousand reales, but others insist they would have brought.a quarter of a million in the open market. The man who had spent his childhood in a dwelling little better than a hut had no reason to fear poverty.

As First Painter Goya received an annual salary of fifty thousand reales, plus an additional five hundred for the upkeep of his official carriage, which bore his seal on one door and that of King Charles IV on the other. He was

summoned so frequently by Queen Maria Luisa to paint her portrait that she put him on a separate payroll of her own and paid him an additional thirty thousand reales annually. Since he charged others that much for a single painting, the Queen was hiring him at bargain rates.

The King and Queen were insatiable, and so was Manuel de Godoy. After Charles and Maria Luisa had been painted on horseback, Godoy also commissioned an equestrian portrait. Nothing better illustrates Goya's growing eminence than his developing friendship with the First Minister. Madrid society was treated to the extraordinary spectacle of the most powerful man in the kingdom actively courting the First Painter. Godoy corresponded with him, Godoy confided in him, Godoy even learned the sign language of the deaf so they could converse more easily. Goya was frequently invited to dine at Godoy's principal palace, but he was not impressed. The food was so rich it gave him heartburn, he wrote to Zapater, and the dining room was so chilly he had to keep his cloak around his shoulders when he sat down at the table.

The First Minister was not as foolish as some people thought. Inordinately vain, he was not content to be the most important and powerful man in Spain; he was also concerned with the opinion succeeding generations would have of him. That rested in the talented hands of the First Painter, and Godoy went to great lengths to win Goya's favor.

He succeeded admirably, and Goya was flattered, even sending along to Zapater an occasional note written by Godoy to prove he was telling the truth.

But Goya's eye and brush could not lie. His many portraits of Godoy reveal the man's vanity, greed and shallowness of character. He was handsome, the poses he struck were heroic and his uniforms glittering, but the man himself was revealed to be grasping, ambitious to a

fault and lacking in the intellect that his position required. Goya the courtier could be flattering and obsequious, but Goya the painter could only speak the truth.

So great was the demand for Goya's portraits, with visitors coming from France, Italy and Austria to sit for him, that Charles IV and Maria Luisa felt compelled to utilize even more of his services. He was ordered to paint various portraits of their children, and these pictures of the young princes and princesses again illustrate his rapport with the young. Only with the young Prince of the Asturias were his relations less than harmonious. The future Ferdinand VII, now in his mid-teens, was a sullen, brooding boy who had inherited the worst traits of both the Bourbons and the house of Parma. He disliked the candor of Goya's portraits, which seemed to emphasize his least attractive qualities, and he regarded the First Painter with a suspicion that subsequently grew into active hatred.

For the present, however, Goya could do no wrong, and in the summer of 1800 he began work on what he regarded as one of his most important projects, the family portrait of Charles IV, Maria Luisa and their children. Rarely had he worked with such painstaking care. First he made a detailed sketch, in color, of each member of the royal family, actually individual portraits in themselves. He insisted that each wear the costume that would appear in the group painting, and he spent countless hours making certain that a crease or fold of cloth was precisely right. During the summer he made four trips to the royal estate in the country, and he continued the work at the Royal Palace in Madrid after autumn came.

The large family portrait, which today occupies a place of honor in the Prado, is so forceful that it is nearly caricature. Charles and Maria Luisa would be laughable if they were not so pathetic. The Infantes and Infantas are appropriately vapid, listless and innocent, and the Prince of

143

the Asturias would appear to be a sly fellow if he reflected greater intelligence. Rarely has any modern camera portrayed a family group in such depth or with such delicate accuracy, rarely has any painter penetrated so far into the souls of his subjects. The portrait of Charles IV and his family deserves its reputation as a great masterpiece.

One curious aspect of this painting is that the artist himself appears in it, working on his canvas, his face concealed in shadows. Some critics have assumed that Goya was vain and wanted the world to see he was close to the royal family. But the facts are simpler. Thirteen members of the royal family were shown, and Queen Maria Luisa, being superstitious, wanted a fourteenth figure added, so the painter obligingly included himself.

Spain was going through a political crisis at this period, but nothing in Goya's work suggests that he was aware of it. Charles and Maria Luisa professed to be admirers of French First Consul Bonaparte and had entered into a complex deal with him. Under its terms Spain would cede the vast colony of Louisiana in the New World to France, and in return the Infanta Maria Luisa and her husband would be given crowns of their own, with Napoleon obligingly carving a new kingdom for the young couple out of the northern Italian states he had conquered. The arrangement was so cynical that it aroused bitter resentment in Spain. Goya appears to have been unmoved. Having made a deal of his own with the royal family, he could not have been too surprised to learn that the Bourbons once again were attempting to improve their own lot.

In any event, the artist had other matters on his mind. He resumed his affair with the Duchess of Alba in 1800—or it may be that they had never broken off, but had arranged their meetings with greater discretion. This was not Maria Cayetana's way, however. She still delighted in thumbing her nose at the conventions of society, so it is

possible that Goya decided they had to be more careful. Too obvious a scandal might have harmed him. He had enemies now, men who were envious of his success, and if they stirred up a scandal, some of his wealthy clients might have been reluctant to have him paint their portraits. The Duchess of Alba was a law unto herself, but she was plainly in disfavor at the Court, and Queen Maria Luisa would have pounced, making Goya the victim, had the lovers been too open.

In a letter to Martin Zapater, Goya revealed that the Duchess had come to his studio the previous day and that he had painted her face. This, he declared, "certainly pleases me far more than painting on canvas." The brief glimpse of the couple's private life is titillating, but Goya closed the door again as rapidly as he opened it, and Maria Cayetana maintained her usual silence. She and the painter were no longer seen together in the working-class taverns that both liked to frequent, nor was Goya a visitor to the Alba palace in Madrid. Apparently Maria Cayetana came privately to the painter's studio, where they could be completely alone.

A small portrait of the Duchess may come from this period. She looks somewhat older now, her face showing signs of maturation, even though it was still unwrinkled. Her voluptuousness and the erotic desire in her eyes are unmistakable, and it is difficult to avoid the conclusion that Goya was intent on portraying her to the world as he so often saw her in private. Painting one or more portraits of her took very little of their time together. Goya worked so rapidly that he usually completed a portrait in no more than three sittings.

Some of his early biographers, writing before 1850, claimed that he actually left Josefa and moved out of his own house to live with the Duchess in her Madrid palace. But no evidence can be found to substantiate this. Neither

would have been so foolish. The Crown would not have tolerated such blatantly immoral conduct so near the royal court, and the Inquisition, smarting from the defeat Goya had inflicted on a hitherto invincible institution, would have been quick to challenge him.

It was enough that the couple met regularly at Goya's studio. Whether their love was genuine, whether they were still infatuated, can only be surmised. Therein lies the enduring fascination of their romance.

XI
Mystery of the Majas

In 1800, the Duchess of Alba was not the only woman in the life of the fifty-four-year-old Francisco de Goya. His other paramour is known only as "B———." Goya made no reference to her in his correspondence with Zapater or anyone else, and she has never been positively identified in any of his works.

Don Manuel de Godoy, in a note to the painter, invited him to dinner and urged him to bring "B———" with him. Moratin commented rather waspishly in a letter to a friend in Paris that it had become impossible to see Goya alone. "B———" was spending uncounted hours in the artist's studio, often eating simple meals of bread, cheese, fruit and watered wine with him there. "He cannot bear to be out of her sight," Moratin observed.

This relationship apparently flourished at the same time that Goya was seeing the Duchess of Alba privately in his studio. Who could be faulted for thinking that Maria Caye-tana was not the great love of Goya's life, at least during this particular period?

It would be futile to list the ladies who have been iden-

tified at one time or another as "B———." Perhaps she was a Spanish noblewoman, or the wife of a foreign ambassador to the Spanish court. All that has emerged is the conviction—based on logic rather than evidence—that the lady was married, and that her husband could have caused trouble for Goya. It is difficult to imagine any other reason for the strict secrecy that the principals maintained.

Some authorities suggest that Goya wanted to keep word of this second affair from the Duchess of Alba, but in view of the Duchess' moral attitudes, this seems unlikely. He had enjoyed a fling with a younger woman while living at Sanlucar. Jealousy at this time would have made little sense. Affairs were informally conducted in Maria Cayetana's circle, and there was always a handsome officer, a rugged bullfighter, a polished nobleman ready to take the place of his immediate predecessor. Reason dictates that "B———" and Goya were protecting themselves from a husband's wrath.

Goya also had other, more political matters to think about. Napoleon had sent his brother Lucien to negotiate with King Charles—actually, to deal with Queen Maria Luisa and Godoy, the pair who ruled the country. Lucien Bonaparte was the only member of his large clan who shared even a portion of Napoleon's genius, but he could not curb his sibling rivalry, and the brothers soon would part company, with Lucien going into exile and remaining there through Napoleon's years of glory.

The visitor was given a large suite at the Royal Palace, state banquets were held in his honor and he was treated with all of the pomp and ceremony due a prince. An intelligent, affable man who had something of his brother's charm, he made an exceptionally strong impression on the entire court.

Goya met him, and when the two men retired for a

private discussion it was assumed that the artist would paint Lucien Bonaparte's portrait. Everyone was astonished to discover a few days later that it was Napoleon himself who wanted his portrait painted. Goya, however, flatly refused to leave Spain. If the French First Consul, the man whom all Europe feared, wanted a Goya portrait, he would have to come to Madrid for sittings.

Don Manuel de Godoy, anxious to keep Napoleon's good will, tried to persuade Goya to go to Paris, and Charles IV and Queen Maria Luisa added their pleas. But Goya was adamant, thereby winning a new reputation as one man of consequence who openly refused to do Napoleon's bidding. Contrary to the belief of his contemporaries, he was not being temperamental, nor was he taking a stand because he opposed Napoleon's policies. His reasons were personal. His deafness made him uneasy and shy in strange surroundings, Paris was far distant and he would have to spend at least a week on the road. Lucien Bonaparte must have understood his motives, even if others did not, and Napoleon himself was not offended, in spite of the fact that people in many lands snickered when they learned of the supposed rebuff.

During his sojourn in Madrid Lucien Bonaparte accomplished far more than the supposed mission for Napoleon's portrait. Portugal was England's active ally in the war, and Napoleon wanted Lisbon closed to the British navy. Although the Regent of Portugal was the son-in-law of Charles IV and Maria Luisa, Lucien convinced them to go to war against Portugal. Napoleon, after all, had powerful means of persuasion—those who were not his active allies became his enemies. Perhaps a hint was enough. Whatever happened, Spain promptly declared war on Portugal. Don Manuel de Godoy, who had never won a military victory, was named commander-in-chief of King Charles' armies.

Instead of organizing for war, Godoy found time to sit for a new portrait by Goya, who painted him in the most gorgeous of uniforms. The picture also shows his simpering expression, and forcefully brings out his blind vanity.

It was probably in early 1801 (some say as late as 1811) that Goya painted another masterpiece, *Majas on the Balcony*. Done for his own pleasure and then sold to the Duchess of Osuna, it well may have been the most popular of his works throughout his own lifetime. Many of his contemporaries considered it his greatest achievement, and the picture enhanced his reputation abroad as well as at home. It was so popular that Goya produced a number of versions of the same scene, several of them virtual duplicates of the original.

Some authorities have insisted that one of these *Majas* was the woman who posed for *The Maja Clothed* and *The Naked Maja*, and that all three paintings were done together. According to these sources, the model was not the Duchess of Alba but a young, unsophisticated girl in her late teens or early twenties who was also Goya's mistress at this time.

If such a person existed, she may have been the girl in *Majas on the Balcony*, but there is no basis for theorizing that she also posed for the other paintings. Since the face in *Majas on the Balcony* looks remarkably like the Duchess of Alba, it is more likely that Goya created a young, somewhat callow version of Maria Cayetana in this painting for his own amusement. In any event, it is futile to persist in trying to identify someone about whom nothing substantial is known.

In the summer of 1802 the Duchess of Alba died very suddenly at the age of forty. It was suspected that she had been poisoned by the Queen and Godoy, and rumors of foul play were so persistent that the government under-

took a formal investigation. Nothing came of this effort, but the rumors continued to circulate. The Duchess' physician was imprisoned, but nothing could be proved against him, so he was set free again and within twenty-four hours whisked off into exile.

Even in death Maria Cayetana was the source of unending gossip. The grandees were disturbed by her generosity to her servants, to whom she left large sums of money. Her little jester received enough to be kept in comfort for the rest of his days, and other members of the household were also handsomely treated. Goya's name was involved in the gossip because the Duchess left his son Javier a bequest of twenty thousand reales. Her will specified no reason for this gift.

Javier de Goya received his money, as did several others, but the government withheld the gifts to the servants pending a formal investigation. Royal troops immediately occupied the principal Alba palaces and estates, and it was announced that the Crown intended to make its own inventory of the Duchess' property and belongings.

Soon the scandal became even worse. Queen Maria Luisa was seen at court wearing several pieces of the late Duchess' most valuable jewelry. *The Naked Maja* and *The Maja Clothed* vanished and were not found until the death of Don Manuel de Godoy in 1808, when they were removed from his palace. The first Minister had also taken Velasquez' *Venus and Cupid*. Despite the theft of the latter from the Duchess of Alba, some modern critics theorize that the famous *Maja* paintings were executed for Godoy, a highly unlikely notion under all these circumstances.

No one dared to say aloud that the Queen and her favorite had stolen property that had belonged to Maria Cayetana de Alba. Francisco de Goya wisely kept his own

counsel, too. Zapater, his good friend, had died a few months earlier, and there was now no one to whom he confided his innermost secrets.

According to one popular account, *The Naked Maja* later fell into the hands of Napoleon's brother Joseph, who occupied the throne of Spain for a short time. He allegedly took it back to Paris and presented it to his brother, the all-powerful Emperor. After the fall of Napoleon, the story goes, the painting was returned to Madrid and was presented to the reactionary King Ferdinand VII, the eldest son of Charles IV. The powerful Alba family tried to buy the work but failed, and it remained hidden for many years.

In the final decades of the nineteenth century *The Naked Maja* appeared in the open and was placed on exhibition in the Prado, adjacent to *The Maja Clothed*. There it remains to be seen by all who visit Madrid.

No other painting, not even the *Mona Lisa*, has inspired as much continuing comment as *The Naked Maja*. It has made Goya's name familiar to millions who are totally ignorant of art. At least thirty books of nonfiction, most of them untrustworthy and repetitive, have been written on the subject, along with a dozen novels that have appeared in seventeen languages. Goya and his Duchess have been depicted in several plays and a popular motion picture. Only two people, however, knew the truth about the twin paintings, and neither ever mentioned the subject in public or in writing.

After the Duchess of Alba's death, Goya planned an ambitious project in her honor. After his own death, many years later, a sketch was found among his belongings for a large mural he intended to paint on the wall of the crypt above her tomb. She was the central figure in the study. No one knows why he did not follow through, though various stories abound. According to the most persistent

legend, the new Duke of Alba, trying to live down his predecessor's notoriety and restore the dignity of his great family name, refused the painter admission to the crypt.

A significant change in Goya's life followed the Duchess' death. In a few months he reverted to the habits of younger days, once again taking street girls, *Majas* and models to bed after sitting with them in the taverns until the early hours of the morning.

By the latter part of 1802 he was acquiring a reputation as the sourest, most hot-tempered man in Madrid. A courtier who inadvertently jostled him on a staircase in the Royal Palace was challenged to a duel. Clients who arrived late at his studio for sittings were refunded the money they had already paid and were told to find another artist. Goya still entertained guests at his house on occasion, but he was inclined to be glum and silent, and sometimes stamped off to bed before they departed.

He was so irascible that some people, afraid of his acid tongue, began to avoid him. And his temper may have cost him dearly. In the summer of 1804 the Director General of the entire Academy of San Fernando died, and as he had been a poet, custom dictated that a painter be elected as his successor. Goya was wealthy and famous beyond his dreams, but he had long wanted the position, which he regarded as an honor that would cap his career.

He submitted an application with almost seventy pages of documents substantiating his claim, and he scoffed when Gregorio Ferro also applied for the post. The election took place on October 30, 1802, with members of both the Painting and Poetry Divisions participating. Ferro, whose talent and reputation were far inferior, won by the overwhelming vote of thirty-seven to eight.

This blow, coming so soon after the death of the Duchess of Alba, made Goya's temper even worse. He threatened to cane servants who did not carry out his orders

quickly enough. On many occasions he became involved in fistfights. Only his reputation and his position as First Painter to the Chamber kept him out of trouble with the constabulary. It was said he always shouted now, no longer speaking in a normal tone of voice.

Early in 1803 Goya painted another self-portrait. The change in his appearance was startling. His lips were thin and compressed in a straight line and his eyes were hostile and cold. His balding head was still massive, but he looked very old now, and strangely vulnerable.

Few people, however, felt sorry for him. One celebrated incident that took place at the Academy revealed the hazard of contesting the angry painter. Goya confronted a poet who had referred to a portrait in casual, slighting terms in a Madrid newspaper. Goya deliberately blocked the man's path and stood for a time, glaring at him.

The poet, who was very slender, tried in vain to brush past the burlier man. Suddenly Goya pulled his broad-brimmed hat from his head and jammed it down over the unfortunate poet's ears. "There, Señor Poet," the artist shouted, "learn to respect a head large enough to wear this hat!"

Ungentlemanly conduct was strictly forbidden at the Academy, and members were subject to immediate expulsion if they broke this unwritten rule. But Goya was no ordinary member, and taking his membership from him would have made the Academy the joke of Europe. The poet solved the dilemma by apologizing to Goya in print, thus making it appear that he, not Goya, had been in the wrong. Goya said nothing. Thereafter, fellow members who had reason to suspect that he nursed a grudge against them took pains to avoid him. This did not necessarily save them from reprimands. Goya, who now walked with the aid of a sword-cane, sometimes pointed his stick

154

at a person who supposedly had offended him, and let everyone within earshot know his candid opinion of the culprit.

For a year following the death of the Duchess of Alba, Goya did no painting, though he regularly attended the Academy and sometimes was seen at court. He turned down all commissions, offering no explanation for his brusqueness. He entertained no more often than once or twice a month, and continued to frequent taverns with young women of the streets.

In the summer of 1803, when Goya resumed his portrait work, his clients discovered that he had become even more difficult. In addition to his exorbitant fees, he charged extra for special poses, and if a client bored him, he might be dismissed without preamble or excuse. Rank and wealth were no guarantee of civility, but Goya was in greater demand than ever, his eccentricity apparently convincing many aristocrats of his genius.

How Josefa adjusted to her husband's changing temperament is not known. Javier, by now their one surviving child, was the only possible witness to what transpired under the Goya roof, and at no time did he ever mention his parents' relations.

Goya was untouched by the many catastrophes that struck Spain in 1803. An epidemic of yellow fever broke out in Andalusia, the plague appeared in Barcelonia, and both dreaded diseases spread rapidly through the country. A violent earthquake caused severe damage in Malaga, convincing the superstitious that Spain had offended God, and Madrid, where the annual rainfall usually was very light, was tormented by heavy deluges.

When the fear of infection spread, most grandees hurried off to their country estates to isolate themselves until conditions improved. The royal court functioned for a while longer, but after a few weeks Charles IV gave in to

155

the demands of his physicians and ended all audiences.

Francisco de Goya, who had once been so near death, paid no attention to the epidemics. He was accepting commissions again, and those who came to his studio for sittings said he displayed a magnificent disdain. Madrid's taverns were half-empty now, but Goya still frequented them, showing no fear of disease.

Conditions became worse in the winter of 1803–4. Due to the heavy rains, the wheat crop failed; in the ensuing famine, bread riots broke out in the country's major cities. The war with Great Britain still dragged on, and one day late in 1803 Don Manuel de Godoy's carriage was surrounded by a mob demanding bread and peace. The First Minister was rescued by the royal household troops, and several demonstrators suffered cracked heads. Charles IV, adept at reading omens, quietly left Madrid with his family to take up residence behind the barricaded walls of a country fort miles away from the capital.

Goya seemed oblivious. He raised his prices again and tyrannized his subjects, forcing them to remain motionless throughout a sitting and putting on great displays of rage if they moved even slightly. At times he threw his brushes and paints to the floor and stalked out of the room. He painted only enough now to live in style. Although his genius made it impossible for him to turn out an inferior work, many of his portraits were uninspired. Moratin expressed a widely held view when he remarked, in a letter to a friend in Paris, that Goya's career seemed to be drawing to a close.

A few romantic late-nineteenth-century critics believed that Goya continued to grieve for the loss of the Duchess of Alba, but it is difficult to believe that a man now nearing sixty years of age could have been that dependent on any one woman. He had had affairs with more women than he could remember.

It is more likely that he felt he had no more worlds to conquer. He had won recognition as the greatest portrait artist of his time. The *Caprichos* were unique, and every type of painting and drawing he had attempted had won him a secure place in the history of art.

In the years ahead, Goya would do some of his most significant work. For the moment he was coasting, but he was far from blind to what he saw around him. The starvation of Madrid's poor made an indelible impression on his soul, and he would later record that suffering in a series of magnificent etchings.

Now, however, he turned out only a few portraits, perhaps no more than six annually, working an average of only eighteen days in a year. He filled his days by reverting to the habits of his youth and wandering aimlessly, endlessly through the streets of Madrid. He saw haggard war veterans, men who had lost arms or legs, reduced to begging in the streets. He observed old crones sifting through the garbage of the wealthy, and little children with pinched faces and swollen bellies. And he watched the sleek and arrogant ignore the suffering so near to them. Unconsciously a great force was building within him that one day would explode in a devastating indictment of all who made war.

In 1805 his gloom lifted somewhat when his son made a brilliant marriage with the daughter of one of Saragossa's first citizens, Don Juan Martin de Goicoechea. The pleased father of the groom painted separate portraits of Javier and his bride, Gumersinda. These works show what the painter could still do when he cared to make the effort; both rank among his best and most delicate portraits.

Doña Gumersinda was a catch, but Javier's fortune was worth the attention of any aristocratic family. The *Caprichos* had brought so much wealth into the royal treasury that Goya quietly renegotiated his contract with the

Crown, and his son was guaranteed an annual income of fifteen thousand reales for life. In some inexplicable manner Javier's bequest from the Duchess of Alba was changed from an outright sum to four thousand reales per year, to be received until the end of his days. So without lifting a hand, he had a comfortable guaranteed income.

The proud father made doubly certain that Javier and his bride would never lack for anything. He wrote a clause into Javier's marriage contract promising to take care of the couple if they should ever be in need. And shortly before the marriage, in July, 1805, he bought a large, new house, giving the newlyweds one wing for their own use.

This arrangement lasted only a few weeks, however. Javier was accustomed to his father's eccentricities and crustiness but Gumersinda was not, and apparently she found him too difficult to tolerate under the same roof. Goya permitted only the plainest food to be served and, unable to hear anyone else, he delivered long tirades at the table, criticizing the many aspects of contemporary life that displeased or irritated him. Javier and Gumersinda moved to a small house of their own, although they took great pains to remain on the best of terms with the elder Goya. The family experiment had failed, but Goya apparently was not offended: his portrait of his daughter-in-law was painted after she and Javier set up housekeeping on their own.

There were many more rooms in the new house than Goya and Josefa needed, but although they could have lived in separate suites, they remained faithful to the habits of a lifetime and continued to sleep in the same double bed. Even now Josefa remained a shadowy figure. She somehow filled her days and evenings after her one surviving child moved away by supervising her husband's

household, as always, and Goya took her for granted, just as he had always done.

Spain, meanwhile, was racing toward disaster. To avoid active military participation in the French war, she was paying a huge annual sum to Napoleon, who had now crowned himself Emperor and was devising limitless ways to bleed the countries under his domination. The royal treasury of Spain was almost empty, her meager industries had come to a standstill, food prices were soaring and the nation was nearly in chaos.

Godoy balked when Napoleon asked for an increased annual tribute, and the Emperor, who could be brutal when the occasion rose, threatened to send his legions into Spain. The wiley Godoy was no match for the most powerful man of modern Europe, but he was an expert in evasions, and for months he stalled the inevitable crisis.

In the interim, to soothe himself, he accumulated more titles and more gaudy uniforms, weighted by medals that he issued to himself, and, wanting to preserve his brave face for posterity, had more and more portraits painted by Francisco de Goya. Those works are a terrible revelation of the step-by-step disintegration of an arrogant, proud man. The Godoy of 1804–5 was crafty and weak, corrupted by greed with an insatiable lust for power. Goya's portraits showed that the artist felt contempt and compassion, cruelty and sympathy for his subject. Perhaps only the painter realized that the First Minister of Spain was a broken man.

Such paintings were of no real interest to Goya. His professional expertise made it impossible for him to do an inferior portrait, though he did not try to excel. In his studio he filled his notebooks with drawings of the beggars, the prostitutes, the ordinary *Madrileños* he encountered on the streets. His sketches were reminiscent of

the *Caprichos,* as were the biting captions he sometimes scribbled beneath them, but he did not want to repeat what he had done in the *Caprichos.* He seemed to be marking time, waiting for inspiration, perhaps, or for an explosion of outside forces that would compel him to make another major effort.

XII
The Madrileño

Collapse finally struck Spain in the spring of 1806, and the country fell into ruin. Famine had not been alleviated, new natural disasters weakened the nation, and bands of armed men roamed through the cities, searching for food. No home was safe, no ordinary citizen could walk through the streets without fear. The burglary rate rose alarmingly, armed robberies became commonplace, and every wise man carried a sword, a knife and a pistol.

Don Manuel de Godoy met the emergency in the only way he could think of—by doubling the national constabulary, then doubling it again. But the robbers, who were desperate, hungry men, simply moved to the highways leading to the major cities. Most of the highwaymen achieved great popularity by becoming early nineteenth-century Robin Hoods. They robbed the wealthy and gave their purses to the poor; they kidnapped men of means, then distributed the ransom money to the needy. Almost overnight the highwayman became a national hero.

Some brigands, however, were hardened professional criminals who took advantage of the highwaymen's popu-

larity to murder as well as rob, hoping that the people would help them escape from the constables. Most of this breed were similar in temperament: they were uneducated and none too bright, with exceptionally hot tempers, and they were merciless to their victims when aroused. Their viciousness quickly gave the new breed of highwaymen a bad name and dampened public enthusiasm for their cause.

Early in June, 1806, an incident in the wine-growing region of Oropena created vast excitement on a national scale. A brigand who called himself El Maragato had been terrorizing the district for weeks, and on several occasions had beaten his victims senseless after robbing them. He sometimes operated alone, but more often was accompanied by several associates whose sadistic cruelty matched that of their leader.

The unlikely hero of the story was a quiet, frail monk of aristocratic birth, Brother Pedro de Zaldivia. He was accosted one day by El Maragato outside the walls of his monastery, and as he carried no money on his person, he offered the brigand his slippers, the only objects of value he had with him. But El Maragato was convinced he was hiding his purse and tried to knock him down with the butt of his menacing rifle.

Brother Pedro succeeded in evading the blow and was so outraged he forgot his own safety and tried to wrest the weapon from the heavier, burlier man. Other monks hurried out of the monastery to help Brother Pedro, and a shout from El Maragato summoned the rest of his band—attired, as he was, in Moorish dress. A full-scale battle took place, and the monks were in grave danger.

The incensed Brother Pedro astonishingly proved equal to the occasion. Gaining possession of El Maragato's carbine, he fired it at the brigand chief, wounding him so severely that when his comrades fled he was captured.

Overnight Brother Pedro became Spain's newest national hero.

No one in the country was more pleased by the incident than Francisco de Goya, who finally roused himself from his lethargy. Working from a sudden inspiration, he painted a series of six pictures on wood, which he deemed appropriate to this unusual tale, depicting the story of Brother Pedro's heroism and the fall of El Maragato. The theme, so Spanish in essence, was perfect for his rekindled talents, and the series was a new masterpiece.

Awakened at last, Goya took a new interest in his portrait work, too, and began painting people who interested him, not only those who paid him a commission. Almost overnight, or so it seemed, he was turning out great portraits again.

One pair of portraits created talk that has persisted down to the present day. First Goya painted an aristocrat, Don Antonio Cobos de Porcel, who was one of his good friends, and then he painted Don Antonio's exceptionally handsome wife, Doña Isabel. This latter work has an erotic candor suggesting that Doña Isabel could have been one of Goya's mistresses. But there is no evidence for such an affair, and it must be assumed he merely painted her as he saw her. Above his signature on Don Antonio's portrait Goya wrote, "To my friend," and a Spaniard regarded the friendship of men as near sacred. For Goya to break the code and have an affair with Doña Isabel would have been unthinkable, no matter how great the temptation.

Late in 1806 or early in 1807 another mysterious female appears to have entered his life. In her portrait, now known as *Woman in a Yellow Scarf*, she is revealed as provocative and somewhat sullen. Although many years his junior, her face reveals a familiarity with the world and its vicissitudes.

Nothing other than the superb portrait is known about this woman, who could not have been painted by Goya except for good reason. He was sixty years of age now, but he still had an eye for beauty, and his desire seems to have been undimmed. It has been suggested that this renewed love of excitement and adventure kept him young.

In the autumn of 1807, a new political crisis exploded. Don Manuel de Godoy, in spite of his failures abroad, had become so omnipotent at home that he managed to persuade Charles IV and Maria Luisa to set aside the order of succession, disinherit Ferdinand, the Prince of the Asturias, whom they despised, and set up a Regent after the death of the King. Public opinion was outraged by the King's act, yet the friends of the Infante Ferdinand were cast into prison.

Napoleon observed this tragicomedy from Paris and decided the time had come to act. Soon his eagle-bearing legions were marching south across the Pyrenees under the command of one of his most competent generals, Andoche Junot. Accompanying the expedition as the Emperor's personal representative was his brother-in-law, Joachim Murat, probably the most accomplished cavalry commander on the Continent, already a duke and soon to become a king in his own right.

French units entered Spain in small battalions, rather than by divisions and separate brigades. The troops gathered at predetermined rendezvous points and, gathering strength as they marched, they were greeted everywhere as liberators and friends. The conquest of Spain was accomplished without firing a single shot.

As the columns drew nearer to Madrid Godoy professed to be delighted, saying the French were his good friends and that he would welcome them as comrades. But at that point the *Madrileños*, hungry and disillusioned, took matters into their own hands. Huge mobs formed in the

streets, and the Spanish troops made no attempt to halt them as they ransacked Godoy's palaces. The First Minister hid in an attic for two days and a night. When he was driven into the open by hunger and thirst he was seized, stripped naked, taken before Ferdinand and forced to apologize.

The hectic pace of events was too much for the aging, increasingly befuddled Charles IV, who promptly abdicated and fled to one of his country estates. The introverted and cynical Prince of the Asturias mounted the throne as Ferdinand VII on the eve of the French arrival. Then Murat entered Madrid at the head of his cavalry and was greeted as a deliverer by hysterical crowds. He was pleased because he carried private instructions from his brother-in-law ordering him to avoid hostilities, if at all possible. Meanwhile Godoy, all but forgotten for the moment, languished in prison.

Members of the Academy of San Fernando stood above politics, or liked to think they did, and in a meeting held only twenty-four hours after the accession of Ferdinand VII they commissioned Francisco de Goya, who still held the title of First Painter to the Chamber, to paint the new monarch's official portrait.

Goya had already painted the Prince of the Asturias several times, usually showing him in a baldly candid, unflattering light, and was thoroughly familiar with his subject. Yet the new commission demanded great dignity of presentation, and he immediately requested sittings.

Ferdinand sent word to his First Painter that he was too busy, which was quite true. To the astonishment of those who thought the young man even more inept than his father, he went to great pains to insure his popularity with the *Madrileños* and, in what little spare time remained, to ingratiate himself with the French.

Goya, unimpressed, petitioned again for a sitting, and

165

the new King grudgingly gave him an hour. A second sitting was necessary, and this time Ferdinand could spare less than an hour. The painter complained bitterly in writing: "That is insufficient for the painting of a good picture, and not merely a portrait for a special occasion."

Ferdinand remained adamant, however, so Goya had to do his best under the circumstances. He painted the usual equestrian figure that custom demanded, but the stallion rather than the man dominates the picture. Perhaps his greatest mistake was in attempting to paint a flattering portrait. Ferdinand VII could not, even with an inventive painter's imagination, be made to look heroic. This painting was not one of Goya's more inspired works.

Ferdinand VII lost his crown before the painting was even completed. Napoleon decided to make his own move and summoned all the members of the Bourbon family to Bayonne, France. The former Charles IV and Maria Luisa went willingly enough, and even Godoy, who had been released from prison, attended the conference. The many children of Charles and Maria Luisa arrived one by one, with Ferdinand the last to appear.

He had been warned by his advisers that he was walking into a Bonaparte trap, but Ferdinand lacked the perspicacity to believe them. He was pleased to meet a brother monarch, he announced, as he reached the border.

The incisive Napoleon was disgusted by most of his Bourbon guests. Maria Luisa, he said in private, looked like a scarecrow who would be vicious if she regained the use of her claws. Godoy was a pathetic shell, a broken man who had no future. Only Charles IV seemed to be an honorable, good man, and the Emperor was impressed by his dignity.

Ferdinand was subjected to "special" treatment. Napoleon's own honor guard surrounded his quarters, and then the Emperor refused to receive him personally.

Napoleon made his wishes emphatically clear. Ferdinand was to abdicate without delay and publicly acknowledge his fealty to his father. Then Charles IV, in turn, was to abdicate for a second time.

Charles, who longed for a quiet retirement, readily agreed to the plan. But Ferdinand resisted, and his parents and Godoy were called in to urge him to change his mind. Napoleon finally sent word that Ferdinand would do as he had been instructed, regardless of his own desires.

Attempts were made to keep the so-called negotiations secret, but strange rumors began to filter into Spain, and the Spanish people grew restless. After living for generations in a repressive political atmosphere they were totally unprepared for the Bonaparte coup. The rights of man were as alien to the average Spaniard as the slogan of the French Revolution, "Liberty, Equality and Fraternity." Freedom of the press and of assembly were beyond the ken of poets and other intellectuals, and with the Inquisition still in power, the concept of freedom of religion could not be grasped even by the sophisticated.

Madrid was more advanced than other Spanish cities, but still a hundred years behind the times, and the theories espoused by political philosophers in other nations were mere words. No matter what their differences of opinion all Spaniards, *Madrileños* included, were unswervingly loyal to the Crown, in part because they had known no form of government other than absolute monarchy.

Although the Spaniard had been an indifferent soldier when sent abroad, he had always fought valiantly and well in defense of his homeland. Now, for the first time, large numbers of foreign troops were in Madrid, and it was whispered that the house of Bourbon was being deposed. Even worse, stories circulated that Napoleon

167

planned to replace the King with a puppet of his own creation.

Had the French troops in Madrid remained circumspect they might have avoided trouble, with so disorganized a Spanish populace. But Murat and other French generals drank champagne in the royal palace, and the French troops made themselves at home. There were fights over girls, fights in taverns, fights on the streets, and gradually a spirit of unrest spread and grew.

A riot was inevitable, and it was equally inevitable that the constabulary, fully sympathizing with their fathers, brothers and friends, should have looked the other way without loading their rifles. There were other, even more sinister warnings: a French officer was attacked without provocation by a group of men carrying knives; a French soldier leaving a brothel late at night was beaten to death by unknown assailants.

Joachim Murat, an exceptionally able soldier though an incompetent administrator, became deeply concerned and wrote a confidential letter to Napoleon, urging him to end the farce. Unless the Emperor acted soon, he said, the people of Madrid would get completely out of control and he would be forced to spill blood to keep order.

Napoleon, who ignored Murat's views outside of a council of war, replied contemptuously that the rabble of Madrid was harmless.

Murat knew better and had the temerity to stand up to the Emperor. In a longer, more urgent letter he warned that the slightest incident could set uncontrollable forces in motion and begged for permission to make a display of force.

The Emperor, who had no divisions to spare for a campaign in Spain, curtly refused. The peace, he said, would be maintained at all costs.

If Francisco de Goya knew of any of these develop-

ments, he paid no attention to them. He continued to work for an hour or two each day on his large painting of Ferdinand and took his usual strolls through the city, but he was becoming keenly aware of the change in the atmosphere. The sketches in his notebook, with great force and clarity, portray French infantrymen, their bearing arrogant, swaggering through the streets, flirting with pretty girls and behaving like great lords in the taverns. He also drew the *Madrileños*, the *Majos* in particular, withdrawing from the strangers in a typically Spanish manner, becoming more sullen, more resentful.

On May 2, 1808, the last members of the house of Bourbon departed for France, and this was the spark that provoked the disturbances Murat had feared. A crowd of more than twenty-five thousand, men of every class and a surprisingly large number of women, gathered in the Plaza Mayor and roared for the expulsion of the French.

French sentries standing duty outside various government buildings were stoned and knifed, and small squads of French troops were killed by the screaming mobs. The insurrection was underway, although the mob had no plan, no precise goal.

Forced to act, Murat sent two regiments of infantry to disperse the crowds. Shots rang out from the windows of buildings on the line of march, and the French infantry, who boasted that they had never suffered a defeat, were forced to retreat in disarray. Murat, who no longer had a choice, called out his cavalry. As the superbly trained horsemen thundered through the cobbled streets, the mob was forced to retreat to the Puerta del Sol in the center of the city.

Spanish regulars had been ordered to remain in their barracks, but when the news of the rioting and the slaughter by the French cavalry reached them, officers and men alike refused to stand aside. Hundreds raced to

169

form battle lines; a fullscale surprise attack was launched on the French rear. The fight lasted all day, but the Spaniards were no match for the finest professional soldiers on earth, and by sundown the French were in complete control. Several captured civilians found bearing arms were taken to the Puerta del Sol, and there, as a lesson to the people of the city, they were hanged, shot or bayoneted. No one was allowed to approach the bodies, which were left there for forty-eight hours.

All through the long, grueling day an elderly man, carrying a walking stick and wearing the high, stiff hat of the aristocracy, wandered alone through the streets of his beloved Madrid. He could not hear the shouts of the mob, the rifle fire or the roar of horses' hooves on the cobblestones, but his instinct preserved him from danger. What he saw chilled his blood, and at sundown he came to the Puerta del Sol, where he watched the savage executions conducted by the French. He seemed harmless enough; it was obvious that he was deaf, so French officers paid no attention to him. Everyone in Madrid was mad, or so it seemed, and the old man was no worse than anyone else. Certainly he could not damage the French cause.

The firing squads went to work again at dawn and again Goya was on hand to watch, absorbing every grisly detail. Some of the stories subsequently told about him are romantic rubbish: he did not sketch the dead and dying by moonlight, nor did he surreptitiously make his drawings under the noses of the French executioners. It was enough that he witnessed these scenes. He would never forget them, and he was resolved that the world would know and remember them, too.

Murat's vicious reprisals on May 2 and 3 were among the worst errors he ever made in his long, uneven career. Murat unwittingly offended the Spaniards in the worst

possible way, by destroying their dignity. For each Spaniard he killed, a thousand others swore to avenge that death. Tens of thousands went into hiding to wage an equally ruthless guerilla war that would continue for years.

Francisco de Goya stood second to no Spaniard in his patriotism. He despised the weak Bourbons for permitting the conquest of the nation, and he hated the French as vehemently as did any *Madrileño*. While others took weapons and left the city to attack French supply trains in the mountains, Goya remained behind and waged the war in his own way.

No one knows precisely when he painted the two large canvases that depicted the events of May 2 and 3, but he received a grant from the government for them in 1814. According to some sources he did the work immediately, while the horrors were still fresh in his mind, and then hid the completed canvases until the French occupation came to an end. Other authorities insist that several years passed before Goya produced these great masterpieces. But the dispute is not important. What matters is the paintings themselves.

One shows the Puerta del Sol at the critical moment of the French attack. Many of the Spanish civilians are armed only with paving blocks they ripped out of the road. The second scene shows the great square at night, with the French executioners at work. Rarely, if ever, has any artist portrayed the horrors of war with so much emotion. Certainly Goya was the first in history to depict such gruesome scenes, or to deliver such a searing indictment of the futility of war.

His touch was deft, more certain than ever, and many experts believe that these two paintings are his greatest masterpieces. Few artists have ever painted with greater

171

zeal or sense of mission. Like all Spaniards, Goya did his most effective work when he felt a deep commitment to his subject.

The Repression of the Uprising of the Third of May has had an impact lasting far beyond Goya's own time. The paintings have been called the distilled spirit of Spanish patriotism and have become a symbol to all men everywhere who hate war and its horrors.

Art critics have hailed the two paintings as the first true works of the Romantic Age. They burned into the consciousness of Delacroix, who carried the banner of Romanticism far down the road toward Impressionism in the twentieth century; they also inspired Manet, who, consciously or otherwise, used Goya's scene again in his renowned *Execution of the Emperor Maximilian.* Most painters of the Impressionist school have studied these paintings and been influenced by them.

At the end of May Napoleon gave the illiterate people of Spain a constitution they could neither read nor understand, and implemented this document by placing his elder brother, Joseph, on the Spanish throne. Joseph Bonaparte, bumbling, good-natured, but one of the more inept members of the clan, was totally unsuited to the role he was called upon to play. Napoleon did not care, for he regarded Joseph as a mere figurehead.

But Joseph did have common sense, and he grasped the mood of Madrid. On the day of his arrival he drove through deserted streets, passing houses with closed shutters. In a gloomy letter to his brother he said there were "no neutrals" in the land.

Some of the grandees and higher-ranking members of the Spanish clergy rallied to King Joseph, though they secretly despised him. But no one followed their example. Only a month after his arrival in Madrid the new monarch wrote again to his brother, saying that in a nation of

twelve million people he had twelve million enemies. And in a prophetic statement he added, "your glory will be destroyed in Spain."

Napoleon and his brilliant advisers had no real understanding of the Spanish character or of the type of warfare that would soon develop in that country. At the turn of the nineteenth century wars were still waged by standing armies, and civilians, who comprised the overwhelming bulk of the population, accepted victories or defeats with docility.

But not in Spain. Insurrections broke out spontaneously, first in one city, then in another. Young men left Madrid and other French-occupied centers by the thousands, sneaking past the enemy sentry lines at night to join bands of irregulars in the mountains crisscrossing the land. Modern guerilla warfare was first fought on a large scale in Spain during the brief reign of King Joseph Bonaparte: French arsenals, military depots, supply trains and barracks were subjected to constant harassing attacks. French officials were murdered in the night by unseen assassins. French laws, regulations and orders were circumvented. Ultimately the Spanish resistance became a national crusade, with poor monks and priests often leading entire parishes in this new type of warfare. It was relatively easy, the priests discovered, to arouse ignorant peasants by telling them that Napoleon was Satan incarnate, and that they had to wage a holy war in order to drive his devil's disciples from the land.

Annoyed and increasingly angry, Napoleon sent regiments needed elsewhere to Spain. But he soon found the drain never ending. No matter how many of his divisions entered Spain, they were opposed by forces a hundred times stronger, then a thousand times stronger, armies that swooped down out of the mountains at night, then vanished by daybreak.

The first open battle took place early in the summer of 1808 in Cordoba, where the Spaniards inflicted such losses on the French that the supposedly invincible legions were compelled to surrender. With Madrid now indefensible, King Joseph hastily left the city on July 30 to await reinforcements.

The *Madrileños* went wild with joy, proclaimed Ferdinand VII their King-in-exile and celebrated for seventy-two frenzied hours. And no one played a more significant role in those festivities than Francisco de Goya.

XIII
The Liberal

On the very day that Joseph Bonaparte left Madrid, Francisco de Goya went to the Academy of San Fernando and presented his formal portrait of Ferdinand VII to his colleagues. It was customary for a painter to name his own price on such an occasion, but in a time of such great national trial the patriotic Goya refused, saying he would accept any compensation his fellow artists and the poets thought fitting. He made a point of urging them not to give him too much. They replied by presenting him with a token one hundred and fifty doubloons, a tiny fraction of the price he would have commanded in normal times.

Hundreds of copies of the painting were printed, and within a few days they were distributed to every part of Spain not under French control. Many were smuggled into cities where French garrisons were stationed, and were exhibited in defiance of French orders. Many more people saw this picture than any of his other works during his lifetime.

The presentation of the painting to the Academy was only the first of Goya's activities during the celebration.

Many prominent *Madrileños* vied with each other in decorating their houses for the festivities, and according to the newspapers, Goya was everywhere, supervising the decorations outside the homes of his wealthy and prominent friends.

He still painted the portraits of many patriots, military men and civilians alike, but he regarded such work as his least important activity. By now he had amassed a large fortune, and he dispersed funds freely, giving considerable sums to help raise patriot armies in Madrid and in Aragon.

Saragossa, Goya's boyhood home, was under siege by the French armies, and no city in Spain suffered greater damage or worse hardships. Early in August, after a particularly ferocious bombardment, the French entered the city, only to find the people of Aragon lying in wait for them. Men, women and children attacked the advancing troops with knives, and the slaughter of the French was the worst Napoleon's regiments had ever endured. The French commander retreated, and all Spain rejoiced.

Goya received a formal invitation from the commander of the Saragossa defenders to visit the city, and he left Madrid without delay. For two months he went everywhere in Saragossa and its vicinity, drawing furiously to record the ruins of churches, convents, schools, hospitals and private homes. He painted a portrait of a local heroine, a young woman named Maria Augustina, and several scenes depicting the valor of the people of Aragon, which was described to him in glowing detail. He felt branded by the horrors of war, and made scores of drawings of its victims, of carnage that caused other men to avert their faces.

What had happened in Saragossa could happen anywhere, and Goya was inspired by a new sense of mission. He would portray the misery and reality of war rather than the pomp and ceremony of handsome generals

mounted on their stallions. He would force the world to recognize war for what it was. Much of what he did was too strong for his contemporaries to stomach, and he showed few of the drawings to anyone. As yet he had developed no overall theme, no method of presenting his work to the world, but he was obsessed by the nightmarish destruction and brutality he witnessed.

Goya remained in Saragossa for two months. His mother had died several years earlier—the date of her death is unknown—but both of his brothers were still alive, and they spent a great deal of time with him. All three made a sentimental journey to Fuendetodos, and Francisco was relieved to find that the war had not touched the village, which was still much as he remembered it.

Some of his work did not survive the second siege of Saragossa, which took place after Goya returned to Madrid in the autumn of 1808. Again the French broke through the walls of the city, and this time they entered the quarters of the Spanish commandant, where they found Goya's paintings proudly displayed. Some were slashed by French swords and bayonets; others were burned.

Goya alone did not grieve for the loss of these works. So great was his patriotism, so boundless the energy of this rejuvenated man of sixty-two that he promised to reproduce them, to do more and yet more. He was totally committed to the cause of Spanish freedom. And this experience would impel him to produce a body of art that was unique and startling.

Napoleon could not tolerate the Spanish victories, and late in the autumn of 1808 he took personal command of his armies on the Iberian Peninsula. In a lightning campaign, he forced the capitulation of Madrid early in December, drove a British expeditionary force out of Spain and returned to Paris in time for Christmas. As far as the

Emperor was concerned, the fate of Spain was settled, and Joseph Bonaparte returned to Madrid to resume his reign.

According to some accounts, Goya spent most of this critical autumn and early winter in Fuendetodos, as Saragossa was under siege. Others said he went to Madrid, saw what was coming and went into hiding with his wife, son and daughter-in-law somewhere in the countryside, presumably at the estate of a wealthy friend.

He did not return to Madrid until the latter part of March, 1809, a short time before General Arthur Wellesley, who would be made the Duke of Wellington in 1814, took command of British and allied troops in Portugal and began his long campaign to oust the French from the entire Iberian Peninsula.

Goya's personal dilemma was similar to that of many other artists. His posts as First Painter to the Chamber and Honorary Director of Painting at the Academy were official positions, and under a degree signed by King Joseph in January, only those officials who took an oath of allegiance to him continued to hold their offices. Goya, displaying the cunning of the Spanish peasant, managed to straddle the issue by avoiding the oath, yet keeping his positions without accepting a salary. He was able to walk this tightrope because he had no duties to perform.

The French officials administering Spain undoubtedly were embarrassingly, aware of Goya's position. France liked to regard herself as the final judge of all literature, music and art, and Napoleon posed as the great benefactor of the humanities. The French could hardly get rid of Francisco de Goya, the greatest living painter, without abandoning the principles that they trumpeted. So they took no action against him. Nominally he remained as First Painter to the Chamber and Honorary Director of Painting at the Academy, and the issue lay unresolved.

Goya's hatred of French rule had not diminished, but

they were in control for the moment, so, like the majority of guerilla fighters hiding in the mountains, he forced himself to wait for a change in Spain's fortunes.

Then circumstances appeared to conspire against him. The French quietly let it be known to the Municipal Council of Madrid, a body of local citizens, that the time had come for an official portrait of King Joseph. The Council stalled for time by appointing a commission of distinguished grandees and art experts to recommend an appropriate artist. Everyone knew who should receive the appointment, but the Spaniards stalled for time, and the French were helpless.

In December, 1809, the commission made its report; to the surprise of no one, they recommended Francisco de Goya. The Municipal Council, still taking its time, waited until the end of February before offering the appointment to Goya. He accepted because rejection would have been a futile gesture. In any event, he and his friends on the commission and the Municipal Council knew what they were doing, and once again they outsmarted the French.

It was no accident that the appointment came when King Joseph was absent from Madrid and had no intention of returning in the foreseeable future. He had accompanied the French armies into the field and presumably was inspiring them to greater efforts as they defeated the resistance in Andalusia. Joseph Bonaparte felt ill at ease in Madrid, where Spaniards of every rank avoided his court, found excuses not to accept invitations to the royal palace and, in general, made him feel like a pariah. Only when surrounded by French regiments was he comfortable.

Goya quietly let it be known that it would be difficult, perhaps impossible, for him to paint the portrait of a stranger who was not available for sittings. Not even the most severe and pedantic of French bureaucrats could argue the point with him, and the best they could produce

for him was a print that had been made in Italy, showing Joseph Bonaparte in profile.

Goya had all the ammunition he needed. He went to work on a large painting, now known as *Allegory of the City of Madrid*. The central figure is a symbol of the capital, a handsome *Maja*, and beside her rests a shield bearing Madrid's coat of arms. King Joseph's portrait occupied only a small portion of the work, and Goya apparently had a private understanding with his friends: when Joseph was driven off the Spanish throne, which all believed would happen sooner or later, it would be possible to paint him out and replace him with someone else without destroying the integrity of the work itself.

Ultimately this was done, although not by Goya, and the subsequent vicissitudes the painting suffered is something of a history of Spain of those times. At the end of the war, when hopes for a new type of government were high, Joseph Bonaparte's portrait was replaced by the single word *Constitution*. But Ferdinand VII, who returned as a tyrant, loathed the very mention of this word, and had his portrait painted in its place. The artist who was given this task did an inferior piece of work, and still another artist was called in to repaint the authoritarian King.

In the twentieth century, officials of the Spanish government, advised by art experts at the Prado, decided to restore the painting to its original state. The Bonapartes were at best a dim memory and no valid reason remained to keep Goya's work covered. Layer after layer of paint was removed by some of the most talented men in the field—until they found only a bare canvas. King Joseph's portrait had been carefully eradicated by a subsequent artist. It was decided to fill in the blank space with a commemorative scroll saying *"Dos de Mayo"* (The Second of May), and that is how the painting appears today.

180

Goya and his contemporaries, struggling to establish a principle, had struck the last blow against the Bonapartes.

But King Joseph, in spite of his subjects' hatred, made sincere efforts to win their goodwill, trying his best to become a true Spanish monarch. In Madrid he attended church services regularly, permitted the resumption of bullfighting, attending a number of such spectacles himself, and launched a much-needed campaign to improve and beautify the city. Obviously he intended to spend the rest of his life on the throne.

No matter how much the Bonapartes were despised, Joseph—and to a far greater extent, Napoleon himself— deserve credit for trying to take Spain out of the Middle Ages. One of the first Bonaparte decrees abolished the Inquisition. No single act was more important to the modernization of the nation. The Holy Office was reinstituted later under Ferdinand VII and flourished again for a short time, but its basic power had been broken and nothing could restore the institution to the eminent position it had enjoyed for centuries.

Napoleon forced the Church to turn over enormous parcels of land to the people, and he abolished the many feudal rights that made the grandees little monarchs, responsible to no one but themselves. The old courts of justice, under which the ordinary citizen had virtually no rights, were replaced by the Napoleonic Code, which has remained the basis of law in France and elsewhere down to the present day. For the first time in history the Spanish people were granted freedom of religion, speech, the press and assembly. Only political activities inimical to the Bonaparte regime were forbidden, and although the censors and administrators were strict in the application of this rule, they were unprecedentedly lenient in granting other freedoms.

A very small group of Spanish intellectuals welcomed

the new regime, being far-seeing enough to recognize that backward Spain was making a major leap forward. Moratin, for example, was pleased to accept the position of Royal Librarian. Francisco de Goya, sixty-four years old in 1810, was still too much the stubborn peasant to accept change gracefully, and he remained adamantly opposed to the Bonapartes. But even he could not stay the same, as one of the close friendships he formed at this time amply illustrates.

The Canon Juan Antonio Llorente, only a few years younger than Goya, had been one of the most feared men in the country under the old regime. His position as Secretary General of the Inquisition had made him all-powerful, and even Charles IV had been forced to treat him with great respect. Infinitely clever and resilient, the Canon had done an abrupt about-face after King Joseph came to the throne and was now writing a book called *A Critical History of the Inquisition*, filled with secret material known only to a very few men in very high places. This work would become essential reading for students of Spanish history and the Holy Office for the better part of two centuries.

Goya, who had been attacked by the Inquisition, could scarcely realize that he had become friendly with one of the highest-ranking leaders of that dreaded tribunal. The Canon became a frequent guest at the artist's home and they sometimes were seen strolling together through the streets—no doubt commenting to each other with disfavor as they watched boulevards being widened and new plazas being created.

In 1810 or 1811 Goya painted Canon Llorente's portrait, and the artist's eye did not err, though he had accepted the friendship of this crafty, cunning opportunist who would have sent him off to the dungeons overnight if the Inquisition had been restored to power. The portrait is

one of Goya's most powerful and compelling character studies.

He also saw Moratin frequently but managed to avoid either endorsing the regime of King Joseph or surreptitiously attacking it. His patriotism was in no way diminished, though, and he continued to make generous contributions to the partisans in the mountains, taking great pains to conceal these gestures from the French.

On the surface he was blandly apolitical. Only on one occasion was he forced into a position of seeming to favor the Bonaparte king. In June, 1810, members of the Academy were commanded to attend a program at their headquarters in honor of King Joseph, who was being commended as a great patron of the arts. Had Goya not appeared he would have singled himself out for criticism by the French—and instant retribution, for French officials could tolerate no insult to a Bonaparte.

Moratin and some of Goya's other friends were afraid he might choose to make a political martyr of himself, and they were relieved when he meekly appeared, sat through an afternoon of speeches praising King Joseph and just as quietly returned home. Not until later did Moratin appreciate the painter's private joke. In a letter to a friend in Paris the new Royal Librarian remarked that Goya, of all those present, was the only man who had not even tacitly committed himself to the Bonaparte cause—as he did not hear a single word of the speeches that hailed King Joseph.

Far too old to go off into the mountains to become a guerilla fighter, which he might have done in his younger days, Goya launched his own, more subtle campaign in 1809–10. His activities made his patriotism plain to all who cared to see, yet he did nothing to which the strictest French censor could object.

Following a tradition initiated by Velasquez, Goya de-

voted himself to a series of paintings on the vocational activities of the Spanish working man and woman. He worked diligently for long hours with a fervor he had shown recently only in his war drawings. His reply to the French usurpers was to show them and the world the essence of the real Spain, the Spain that was alien to foreigners, even one who sat on the throne—and he succeeded brilliantly. All of these works were completed by 1812, though some authorities have wondered whether a few might have been painted during the final years of his life.

Displaying a dazzling virtuosity of technique that was one of his trademarks, Goya painted the common people of Spain as though he were one of them. Perhaps he succeeded in these works because in spite of the wealth he had accumulated and the fame he had achieved, he still regarded himself as a simple artisan, a man who labored with his hands, one of the ordinary people. His warmth and sympathy for his subjects is overwhelming.

In *Knife-Grinder* he shows a man hard at work, oblivious of the fascinated gaze of a spectator. His expression is sullen, withdrawn and distrustful, the face of a typical lower-class Spaniard.

His *Water-Carrier* is a robust, healthy woman who has spent most of her life in the outdoors, and at first glance she seems happy. But a closer study reveals that she is tormented by her poverty, by her inability to change her lot in life. Her face haunts the viewer, suggesting that Goya was haunted by it, too.

Inevitably, some of the Frenchmen in Madrid turned to the most famous of artists to have their portraits painted, and Goya obliged them, displaying no overt signs of his hatred. On the surface his approach was businesslike, but he had his own way of making his feelings subtly clear. No client was likely to protest that his own portrait was

deliberately ordinary, uninspired or dull. After all, not even the greatest artist produced a masterpiece every time he faced a canvas, and besides, who was the amateur —even if he was the subject of a work—to say that the great Goya's efforts were below his usual standard?

The portrait of the personal equerry to King Joseph, General Nicolas Guye, given the title of the Marquis of Rio Milano, illustrates Goya's method. From a purely technical standpoint the portrait is above reproach, but it is flat and reveals little of the inner man. Goya was doing what was requested of him, taking French gold and doing no more than was necessary.

Occasionally, however, the subject excited him, making it impossible for him to contain his enthusiasm. Always understanding children and sympathizing with them, he came to life when he painted the portrait of the Marquis of Milano's little nephew, Victor, who wears the uniform of a page of King Joseph's court. Boyhood, Goya was saying, was universal, and no child was his enemy, regardless of his nationality.

In the autumn of 1810 Napoleon visited Madrid briefly, causing Goya one of the greatest problems that confronted him during the French occupation. Before hurrying back to France the Emperor issued an explicit order. Vast fortunes in art works were hanging in palaces confiscated from the foes of France and in the convents and monasteries closed by Imperial command. Napoleon demanded that a commission composed of the three most distinguished painters in Spain select "the fifty finest masterpieces" and ship them to him in Paris. In a transparent effort to hide his theft of Spain's art treasures, the Emperor announced his intention of building a museum in Paris that would be dedicated to the art of Spain.

Goya may have been flattered to learn that Napoleon, in spite of everything on his mind, considered him Spain's

185

greatest living artist, but he was not pleased when he discovered that the Emperor had requested him to serve as the chairman of the commission. Its other members were Mariano Salvador Maella and an artist named Manuel Napoli, whose work has been virtually forgotten.

The three painters faced a cruel dilemma. Napoleon expected his orders to be obeyed promptly and without question; a refusal would have guaranteed a long prison term. It was impossible to delay, as Manuel Romero, the Minister of the Interior and Commissioner of Police, made emphatically clear. The commission was told to complete its task within three months.

Goya and his colleagues did what they could to save Spanish art for Spain. They showed great cunning in the way they obeyed the order, selecting only three paintings by Velasquez, none of them his more important masterpieces, two by Murillo, and making up the overwhelming majority of the collection with inferior works by artists of lesser stature. Goya drew on his experience with laymen, realizing that they knew little about art and could not distinguish a masterpiece from the banal. He was relying on Napoleon's ignorance to preserve Spain's art treasures.

As it happened, none of the paintings ever reached France and some never left Madrid. French convoys were being attacked by guerillas with increasing frequency and success, and the dispatch of the paintings was delayed until the war returned to Madrid, when some were stolen or destroyed.

The Ministry of the Interior and other officials felt that Goya had performed his task with distinction, and the French were grateful. They awarded him the special crimson cravat, their symbol of honor, which such men as Canon Llorente and Moratin wore with pride. Later, when Spanish rule was restored and wearing the cravat was regarded as high treason, an investigation was made

of all men who had been given the award. It was established that Francisco de Goya never wore his cravat, and, in fact, had burned it in his fireplace on the day the French evacuated Madrid.

Joseph Bonaparte obviously had a touch of the peasant, too. Although less vain by far than Napoleon, he nevertheless enjoyed flattery, and on several occasions he discussed having an official portrait painted. Knowing that the world loved to laugh at Bonaparte blunders, he would not have considered having any artist other than Goya. But after hesitating for a long time, he decided against the plan, and Goya was never summoned.

King Joseph undoubtedly knew he would not be rebuffed, but he had undoubtedly seen some of the near-caricatures Goya had painted in the past, and he had no desire to be preserved for posterity as a buffoon—or worse. Goya may have lived in dread of a summons to the Royal Palace, as Moratin hinted in his correspondence, but Joseph Bonaparte was not so much the fool as his many enemies claimed. He and Goya never met face to face. Inasmuch as Goya was the most widely known man in the country, it would have been natural for him to receive an invitation to a royal audience. But he was not invited, for Joseph and his French staff understood that the painter had no liking for him or for what he represented.

But although Goya was quiet for now, the time was approaching when he would be hailed as a hero by every liberal in Europe. It is ironic that Goya's compassion for humanity and zealous defense of personal freedom flowered in opposition to the French, who first set these ideas in motion in the French Revolution and spread them throughout Europe under the powerful sponsorship of Napoleon.

XIV
The Disasters of War

Many people, viewing a series of satiric drawings that Goya made when in his sixties, have mistakenly assumed that he abandoned the faith of his youth as he grew older. Nothing could be less true. He was as devout a Roman Catholic in his old age as he had been as a boy.

But, as noted earlier, he despised men who abused the power of the Church. No intelligent Spaniard of his era could have felt otherwise, and he deeply resented the activities of men who had grown wealthy, supposedly in the service of God, while the poor suffered.

The French occupation changed the situation of the Spanish Church overnight. Cardinals and bishops lost vast estates, the Inquisition was abolished and approximately two thirds of the convents and monasteries in the country were closed, forcing nuns and monks to give up their calling and return to the mainstream of Spanish society.

Goya satirized them in a series of brilliant drawings. He portrayed former nuns clumsily trying to accustom themselves to fashionable gowns and eagerly searching

for husbands, and former monks behaving with the crudeness of stable boys. Yet even while making jokes at the expense of human frailties, he did not lose his feeling of compassion. It is obvious that he sympathized with those who were finding it so difficult to adjust to life in the world beyond the cloister.

Other drawings may have been inspired by Canon Llorente, with whom Goya had so many long discussions, and it may be that the painter read the *History of the Inquisition*. He had no reason to sympathize with the Inquisition, and under the freedom of expression the French brought to Spain Goya attacked the viciousness of the Inquisition and other abuses perpetrated by men in the Church. Some of his Inquisition scenes, from which numerous prints were made, are stunning in their impact. Here is the terror brought to life; the viewer feels as overwhelmed as the victims. Few men have ever been portrayed to be so cruel, callous and stupid as Goya's version of the Grand Inquisitor Zapata.

Several of his drawings are completely lacking in humor, their strength emanating from their somber tone. Such is his portrayal of Galileo, his body twisted out of shape by torture, subjected to an endless interrogation. The scientist, one of the true giants of the Renaissance, is a shadow of what he had been, but he still has greater dignity than his tormentors. It is generally assumed that Goya learned the story of Galileo from Canon Llorente. No word of the astronomer's ordeal had ever been published in Spain, and anything printed on the subject elsewhere had been banned from the country. Goya could have learned of the Galileo story only from a man like Llorente.

It is noteworthy that Goya usually carefully avoided contemporary events in his paintings and drawings. He had expressed himself fully in the early days of the

French occupation, and now he seemed to be waiting for a change in Spain's fortunes before he returned to his earlier theme. In the meantime he kept himself busy, never falling back into the lethargy he had suffered after the death of the Duchess of Alba.

The violence that lay so close to the surface in Spanish life continued to fascinate him and he did many paintings and drawings that showed ordinary people killing and being killed, raping and being raped. He emphasized the cruelty of human nature, and there were strong echoes of the *Caprichos* in the greed, lust and jealousy he portrayed.

The human suffering caused by epidemics was also a subject that was close to him, perhaps because of his own critical illness more than a decade and a half earlier. No drawing illustrates this more emphatically than *Pest House*: a strong light shining down from a high window reveals a grisly scene of the dead and dying. Lifeless bodies, emaciated and twisted, are clad in rags. Here and there a victim of one of the recent epidemics still lives and feebly raises a hand or tries to struggle to a sitting position. But death has marked them, too, and soon will claim them.

Now, in 1810, the situation everywhere in Spain was deteriorating more than ever. Napoleon, determined to bring the entire Continent under his banner, was already overextending himself, and by 1812 would come to the brink of ruin. Troops were needed for his invasion of Russia, now in the planning stages.

Spain remained the thorn in Napoleon's side as he tried to concentrate his energies and resources elsewhere. He could spare few men and little war materiel for Spain, but the partisans who lived in the mountains gave his garrisons no rest. When the troops left a city to attack guerillas, the metropolitan dwellers rose up in revolt. The

Emperor had tried to maintain a conciliatory policy, but now he became increasingly harsh, in spite of Joseph's attempts to persuade him otherwise. Joseph knew what his brother did not, that the Spanish opposition would become more virulent under repression.

Ironically the people of Spain had no idea that King Joseph was their champion and defender. He himself carried bread from the palace to the poorest sections of Madrid during the famine of 1811. To them he was solely the symbol of French rule. By the last days of 1811 rocks were thrown through the windows of the royal palace late at night, slogans were painted on the palace walls under the noses of French sentries. Joseph risked his life every time he went abroad in his carriage, though a French cavalry platoon always accompanied him.

The French tightened their regulations. Any Spaniard found carrying firearms would be hanged. When a French citizen was killed, a special tax would be levied on the entire community, and ten hostages would be sent to prison, where they would be subject to the death penalty. Precisely as Joseph Bonparte had predicted, these measures sent thousands of men fleeing into the mountains to join partisan bands. The British, operating from their bases in Portugal under Lord Wellington, obligingly sent the guerillas large supplies of arms, ammunition and gunpowder.

Wellington had kept a close watch on the situation as he obtained additional reinforcements and subjected his troops to a rigorous training program. Now he sent a confidential message to the War Office in London that Spain would soon be set free.

"Every Spaniard is our enemy," Joseph lamented in a sad letter to his brother.

The French generals in Spain were competent veterans who had distinguished themselves as strategists and tac-

ticians, but Spanish warfare was unlike any they had ever known. They tried to treat the guerillas as bandits but discovered they were dealing with patriots whose tactics were unorthodox and who would never admit defeat. The bewildered generals wrote to Paris for advice, and Napoleon replied in two words: "Smash them!"

But the Spaniards refused to be smashed. The guerilla slogan, "*Muera Napoleon,*" appeared on walls everywhere. Joseph Bonaparte realized that the end was approaching and commented to some of his aides that his brother could succeed in Spain only by killing every man, woman and child in the country.

As the struggle became more intense the natural ferocity of the Spaniards asserted itself. The guerillas took no prisoners: captured Frenchmen, even those who surrendered without a fight, were put to death and frequently they were tortured before they expired. The French, to whom such "uncivilized" warfare was shocking, soon retaliated in kind. Men were hanged, shot, bayoneted, stoned to death, even drowned. Atrocities committed by one side inspired even worse acts by the other.

"Our beloved homeland," Moratin mourned, "has become one great slaughterhouse, and I fear the worst is yet to come. Has God forsaken us all?"

There were no formal battles, no sharp lines separating the two sides. The guerillas attacked at will in the cities and the open countryside, wherever they found the enemy. The French struck back wherever they thought the partisans might be gathering. Refugees whose homes had been destroyed, the wounded and the sick, wandered from one place to another, sometimes moving aimlessly simply because motion of any kind seemed preferable to collapse. No part of the country was spared, and all of Spain became one vast theater of military operations.

Goya had released no paintings or drawings that used

the war as a theme since his visit to Saragossa in 1808, but he remained fully conscious of the conflict, continuing to fill his notebooks with sketches. He was groping toward his theme, but his thoughts had not yet gathered. He drew one aspect of the war, its horrors. Gradually, as the struggle progressed with no end in sight, he refined these works, and by early 1811 he was translating his original rough sketches into precise, detailed etchings.

He had no plans in mind for publication of this work. In fact, he must have known that he would be forced to destroy the drawings if the French came to search his house. Nearly every drawing would be regarded as subversive and inflammatory by the forces of occupation.

A nationwide famine compounded Spain's suffering in 1811, and no one, not even the wealthy, had enough to eat. Even basic staples were difficult to procure, no matter how much money one was willing to pay. Joseph Bonparte begged his brother for supplies, but Napoleon was supporting the largest armies in the history of Europe and could spare no food for Spain. The famine spread alarmingly, and although no trustworthy statistics have ever been compiled, it has been estimated that at least twenty-five thousand persons died in Madrid and fifteen thousand in Barcelona. Money was worthless, and bread became the only viable currency.

Late in 1810 Goya's friends urged the old man to take Josefa and leave the city permanently. When his son added his voice to the clamor, the painter finally gave in, buying a modest house a short distance from San Antonio de Florida. He could easily have afforded a handsome villa, even a small palace, but he had lost whatever taste for magnificence he had ever possessed. His attire now was sober and his home was small and unpretentious, a dwelling of an elderly man of the middle class and his shy, retiring wife.

Unwilling to sever all of his ties with the Madrid he had loved for so long, Goya maintained his studio there. But he rarely went into town and seemed content to spend most of his time in the open country. There he tried painting landscapes for the first time in many years and was pleased to discover how much his skills had improved. He did portraits of his son and daughter-in-law and of his daughter-in-law's parents, though he did no more paintings of Josefa.

During his forced sojourn in the country Goya painted one of his most inspired portraits, that of his grandson, Mariano. The proud grandfather's love for the little boy shone through the work, and the expression on the child's face indicates that he fully returned the old man's love. This portrait has been called the most tender of Goya's many masterpieces.

Even in the country the old man found it impossible to escape from the horrors. He saw the dying on the roads, in the churches, in the gutters of Madrid when he visited the city. His drawings became sharper, more intense, and he became increasingly aware of his own vulnerability. One day late in the year he made a special trip into Madrid, accompanied by Josefa, and in the presence of a notary he signed his will. No man was immune from the famine, not even a great artist.

He may have felt his own end was near, and he began to engrave etchings, most of them scenes he had witnessed, although some were of incidents that had taken place in other parts of the country. The fury of the young Goya reappeared in these works, which breathe his all-consuming hatred of war's savage and senseless destruction. He drew because he felt compelled to record the insane world in which he lived, and he nurtured a faint hope that the day might come when others could see these drawings.

It was man's inalienable right to live and to seek happiness in his own way, Goya cried, and the senselessness of man's inhumanity to man was a crime against every law of Nature. His rage was directed primarily at the French, whom he despised with a frenzy far beyond reason. At the same time he knew that his fellow countrymen were committing atrocities too, and he did not spare them. In the broadest sense he was indicting all mankind, and he shouted to the world that homo sapiens was the most cruel, ruthless, vindictive and callous of all God's creatures.

He called the series *The Fatal Consequences of Spain's Bloody War with Bonaparte, and Other Emphatic Caprichos.* The operative word, in his approach, was *consequences*. He was not as concerned with the war itself as he was with the results of the fighting. His one desire was to hold up a mirror and show mankind its cruelties.

It required a strong stomach to study these etchings. Javier de Goya saw them, and wrote that he was shaken. Moratin looked at them and declared that they made him ill. Jovellanos, who had been released from prison during the short time Ferdinand VII had been on the throne and who had taken an active part in the war against the French, paid a secret visit to his old friend Goya and was shown the etchings. Deeply impressed, this genuine Spanish liberal, who would die of natural causes within a few months, inspected the etchings with great deliberation and said they were too strong for the world to see.

Goya kept the etchings hidden, and only a few of his intimates knew of their existence. When he died, he left the plates to his son. Finally, in 1820, the artist's friend Cean Bermudez put together a collection of the prints. The full set was not published until 1863, thirty-five years after Goya's death. At that time the Academy of San Fernando, which had obtained possession of the original

plates, published the collection, omitting three etchings that seemed unrelated to the series.

At that time the Academy gave the work a new title, *Los Desastres de la Guerra,* or *The Disasters of War,* and it is under this name that the world still knows the superb, blood-chilling series. No other indictment of the insanity of war is as well known or has had an impact on civilization equal to that of *The Disasters.* Goya the humanitarian had done his finest work.

One of the early drawings sets the tone for the series. Several brutal French soldiers, bayonets attached to their rifles, are pointing their weapons at two Spanish peasants, one of whom carries an ancient pike, while the other holds a small knife in his hand. In the eyes of the peasants one sees pride, resignation and sullen, resentful hatred. Goya's caption, scribbled in his almost illegible hand, is blunt and to the point: "With reason—and without."

The artist condemns his fellow Spaniards with the same objectivity he shows toward the French. In one drawing several wounded French soldiers are scattered on the ground. A burly Spanish peasant screams with frenzied hatred as he raises an ax above the head of one of the soldiers. A second peasant is about to thrust a knife deep into the back of another fallen soldier. Goya's captain further emphasizes his hatred of all senseless brutality: "In just this way."

The artist is full of compassion for the women of Spain, and in several drawings he shows them performing deeds of valor against the French. They, too, are capable of behaving with unreasoning cruelty, but he excuses them on the ground that they have ample cause to hate the enemy. Several of the more gruesome drawings show Spanish women being raped by beastlike French soldiers.

Some of the most telling drawings are indictments of pillage. In one, soldiers are stripping clothing from the

bodies of dead and dying Spanish guerillas. In another, troops are leaving a church, their arms filled with crucifixes and other objects, while a monk who has been severely beaten lies in a stupor, near death.

Occasionally Goya abandons realism for symbolism or the fancies of his imagination that were so striking in the *Caprichos*. In one drawing a number of terror-stricken dogs flee from the advancing hordes of the enemy, and horses give in to the same panic. In another, wild dogs attack a woman who is running from the enemy, and the caption is scornful: "What does this mean?"

In one of the most famous drawings of the series, *The Ravages of War*, Goya draws a kaleidescope of horrors: houses are falling apart, bodies are scattered everywhere, a poor mother tries in vain to protect her infant and the living and dead are jumbled together in a terrified and terrifying mass. Thousands of copies of this print have been distributed in every civilized land on earth.

Another of the more celebrated drawings is *Were You Born for That?* A vast arena is littered with the corpses of war's victims, and signs of destruction are everywhere. A single survivor, mortally wounded, is trying in vain to stand on his feet; in a moment, he, too, will collapse and die.

Goya never forgot the executions that had taken place on May 2 and 3, and some of the more impressive drawings show innocents being slaughtered by uniformed executioners whose faces are sometimes impassively bland, sometimes filled with blood lust.

Perhaps no drawing better expresses the artist's theme than one in which a man is being hung by French soldiers from a lone tree located in a desolate countryside. The caption is abrupt: "Why?"

The mutilated as well as the dead and dying appear throughout *The Disasters of War*. The consequences of

197

famine and pestilence are portrayed graphically, along with sadistic cruelties inflicted by the strong on the weak. Goya suffered inner tortures of his own during the years of the war, and he deliberately forces the viewer to share his torment. His cries of indignation and pain compel his audience to feel his sense of outrage.

In January, 1812, the war began to move toward its climax. Wellington marched toward Spain from Portugal, and King Joseph Bonaparte was the nominal leader of the legions that went to meet him. In the weeks that followed, approximately ten thousand Frenchmen and about half that many British troops were killed. Casualties on both sides soared to more than one hundred and fifty thousand by the time the Peninsular War came to an end in 1813. The climax of the campaign of 1812 came in August, when a triumphant Wellington entered Madrid. After this he moved methodically, driving the harassed French from city after city. Finally Napoleon, whose losses in his Russian invasion had been catastrophic, was forced to withdraw the bulk of his divisions from Spain.

Goya survived the war unharmed, but the famine apparently claimed Josefa as a victim. According to a brief reference made later by Javier, his mother's constitution was fatally weakened by the hunger she suffered in the last months of 1811. She died in June, 1812, though neither the exact date nor her place of burial was recorded.

How did Goya react to the death of the plodding, faithful woman who had lived with him through the long decades? No friend commented, and the artist himself was silent, as was Javier. Josefa left no will, but her husband took it upon himself to give their son many of the paintings and drawings that had decorated their house. These were the works, as Javier later commented, that he had painted "in complete freedom, as his genius willed."

Among these works were the six wood panels depicting

the fate of the bandit El Maragato, a dozen paintings developing the themes in *The Disasters of War* and the renowned *Majas on the Balcony*. There were fifteen landscapes, and at the bottom of the inventory drawn up by father and son was a painting that Goya linked with *The Disasters*. He called it *Colossus, or Panic*, and it was part of the nightmare that obsessed him.

In an eerie, frightening light a huge, monsterlike giant emerges from smoke and flames with clawlike hands half-curled, ready to destroy the world. Below are masses of humans and animals, fleeing in hysterical, blind terror from this dreadful creature. They mangle and kill each other as they run, but the survivors race on, even though it is evident that the monster will devour them.

The precise date of this painting, which has become one of the most widely reproduced of Goya's works, is unknown. But it is believed he painted it in 1810–11, when he did most of his work on *The Disasters*.

Generous to the point of denuding himself of most of the paintings he had done for his own satisfaction, Goya handed over almost all of his private collection to his son. He kept only two portraits for himself. One was of his friend Pedro Romero, the most popular bullfighter of the period. The other was of the Duchess of Alba, the portrait in which she wore the rings marked "Goya" and "Alba." For the moment, at least, most of the walls in the painter's house were bare.

Regardless of how he may have reacted to his wife's death, Goya had no time to brood. One of Lord Wellington's first acts after entering Madrid was to ask him for a portrait. Goya went to work at once, displaying his customary, frenzied impatience, and the painting was finished a scant three weeks later. A notice in the newspapers on September 1 invited the public to the Academy to view "the equestrian portrait of the generalissimo Lord

Wellington, Duke of Ciudad Rodrigo, executed by the First Painter to the King and Director of the Academy, Don Francisco de Goya."

Those who believed that Goya had executed the painting between Lord Wellington's arrival in the city on August 12 and the end of the month were mistaken. The artist had a head start on the work under circumstances that are still shrouded in mystery. At some time in July, when the future of Madrid was still in doubt, Goya left the city, somehow made his way through the French lines and reached British headquarters. There he was received with great ceremony, and the allied general invited him to dinner.

One night in the British camp, after the commander had spent a day in the field, Goya drew a sketch of him, and it was this that laid the foundation for his formal painting. Ironically, the sketch was the better work, perhaps because it showed a very human Wellington who was slumped in exhaustion after the decisive battle of Arapiles. One of the most impassive members of a people who hated to show emotion, Wellington donned his habitual mask in Madrid, and Goya did not penetrate it. The formal painting is, in spite of its great subject, one of Goya's less impressive works.

Regardless of the artist's motive for joining the British-Portugese expedition in the field, the story that he and Wellington became good friends is untrue. On the contrary, there is reason to believe their brief relationship was thoroughly unpleasant. Both had tempers; Goya's was hot and the Iron Duke's chilly. The future Duke of Wellington had an acid tongue and was noted for speaking nastily to those he regarded as inferiors.

According to a story that may be based on truth, Wellington became impatient during a sitting in Madrid and said something insulting to the painter. Goya, reacting

unthinkingly, reached for one of the general's pistols, which was lying on a table. The professional soldier also reacted instinctively, and drew his sword. Horrified and embarrassed aides were forced to intervene and tempers were soothed, at least on the surface. The painting was completed in a strained silence that neither of the principals chose to break. No matter whether the tale is true; Goya and Wellington did not meet again. Wellington withdrew from Madrid and Joseph Bonaparte returned.

The war went on, and Goya recorded the activities of unsung Spaniards in two memorable paintings done on wood. Both scenes were set deep in the forest: in one men were making gunpowder by primitive means, and in the other they were fashioning bullets in an equally crude manner. In both of these works we see the bold juxtaposition of the serenity of nature and the activities of men whose aim was destruction. These paintings are a cry from the depth of the soul of a man sickened by slaughter and suffering.

XV
Forces of Reaction

The withdrawal of the last French troops from Spanish soil late in 1813 marked the end of active hostilities, but it did not mean the end of the war for Francisco de Goya. Still immersed in *The Disasters*, Goya refined some of his drawings and made several new ones. These last works in the portfolio owe a debt to his earlier *Caprichos* series. They were allegorical in nature: some showed men with the heads of animals and birds, or beasts with the heads of men. The meaning of many of these drawings is obscure, and experts have been debating them since the mid-1860s without reaching definitive conclusions. That may have been Goya's intention. As he grew older he seemed to delight in allowing others to interpret his work as they chose. It is also possible that as old age approached and he withdrew increasingly into a world of his own, he thought in terms of symbols and concepts beyond the grasp of others.

He did not show his increasing age, and his physical condition remained sound. A self-portrait painted in 1815

reveals a few more lines in his face and a little less hair, but otherwise he was unchanged. Even now there was little of the intellectual in his face. He resembled the elderly, beret-clad men who may be seen dozing on Spanish stoops today.

The French invasion had wrenched Spain from the Middle Ages into the nineteenth century. The Spanish people had learned the worth of personal freedoms, and Spain was free of the Inquisition. With high hopes for the future, Spain was now preparing to take its place in a modern Europe.

But Ferdinand VII, who returned to Madrid from exile late in March, 1814, had ideas of his own. He had been isolated from the mainstream of modern thought, from the principles of the French Revolution, but he would hardly have understood them had they been explained to him. With Napoleon's defeat at Waterloo, a new age of reaction was setting in throughout Europe, and no national leader was more suited to usher it in than this Bourbon who trusted no one and nursed a private grudge against all society.

A new constitution had been drawn up before Ferdinand's arrival, embodying the highest hopes of the nation's most profound thinkers. It is said that a copy was presented to the King as he stepped onto Spanish soil. He supposedly gave his thanks, stuffed the paper into his pocket and promptly forgot it—but that story is an exaggeration. For the moment, the document was very much on his mind.

A forced smile touched the corners of Ferdinand's mouth as he entered Madrid in an open carriage and acknowledged the cheers of the people with a stiff wave of a partly raised hand. He went straight to the royal palace and closeted himself with men he believed loyal to him. No word of their discussions leaked out, but it was ru-

mored that the King did most of the talking. Early in April he began to issue proclamations and orders.

His first decree nullified the new constitution and directed that any man who continued to support it be subjected to the penalty of death.

His second decree reestablished the Inquisition.

His third decree restored all property that had been confiscated from the Church and grandees.

His fourth decree reestablished the feudal powers of the nobility.

His fifth decree reestablished the system of justice that had been in force under Bourbon rule.

His sixth decree ordered that any man who had cooperated in any way with the Bonapartes be put to death, imprisoned or exiled, depending upon the severity of his offence.

In all, Ferdinand issued sixty decrees during the first week of his return to Madrid, and he forcibly turned back the clock by centuries. The common people, who knew no better and were dazed by their long years of suffering, cheered mindlessly. Men of intelligence were in despair, and many immediately left the country, voluntarily going into exile.

A special royal commission was formed to examine the case of every man who had dealt with the French. Francisco de Goya, who had been awarded the red cravat of the Order of Spain by order of King Joseph Bonaparte, was summoned for a long interrogation, and all of his activities under French rule were subjected to a close scrutiny.

Goya encountered no real difficulties. He showed the commission his recently completed portrait of the hero of the siege of Saragossa, Don José Palafox, and Don José testified on his behalf. He unveiled, for the first time, his magnificent portrayals of the events of May 2 and 3. A

dozen patriot leaders appeared to testify on his behalf, and a score of others volunteered to do the same. He was exonerated and restored to all of the posts he had held under the Bourbons.

The suspicion still exists that the commission subjected Goya to a show trial for very good reason. The outcome of his case was never in doubt, and since he was the most internationally celebrated of Spaniards, the whole world awaited the outcome. By promptly clearing Goya's name of suspicion, Ferdinand enhanced his own reputation.

Yet the new King disliked his First Painter and confided to his few intimates that he distrusted him, though he made no serious accusations against Goya. Ferdinand felt uneasy with any man whose spirit was independent.

Regardless of his personal feelings toward Ferdinand, Goya threw himself into a frenzy of work in preparation for the festivities celebrating the King's restoration. No one has ever been able to make an accurate count of the number of portraits of the King that Goya painted in the next few months. According to some accounts the total may have been as high as twenty, and one story has it that he painted a large equestrian figure in a single afternoon.

At first glance it appears that Goya was as ecstatically idolatrous as the ignorant citizens who ignored Ferdinand's repressive decrees and cheered him whenever he made a public appearance. It is inconceivable, however, that the artist who had drawn the *Caprichos* and *The Disasters of War* could have been that empty-headed or lighthearted. Men who were dismayed by Ferdinand's autocratic attitudes looked hard at Goya's paintings, and suddenly they understood.

The great painter knew his sovereign well. The portraits he painted were as terrifying as any of the monsters he had drawn, but at the same time so cleverly realistic that not even the most zealous of Bourbon supporters

could claim that the King was being ridiculed. Ferdinand appeared stupid, domineering, cruel and weak, those same qualities that any visitor could see in him. There was no need for Goya to speak his opinion; his paintings enunciated his views loudly and succinctly.

With the restoration, Goya was once again inundated with requests for portraits. Unwilling to slight great grandees or bishops who might become his dangerous enemies, Goya raised his prices, then raised them again. No matter how much he charged, the clamor increased, and he could not resist. Every Spaniard of importance wanted to be painted by the artist who had achieved such international recognition. So, at the age of sixty-nine, then seventy, Goya forced himself to work with the same concentrated fury he had demonstrated at half that age.

He did not leave his studio for days at a time, and only on weekends could he return to his house near San Antonio de la Florida. He was again earning vast sums of money, a fortune he did not need, but his way of life remained spartan. He slept on a cot in one corner of the studio, and most of his meals consisted of cold meats, bread and watered wine brought in to him by a charwoman. He had no interest in the social life of the mighty under the restoration; sickened by hypocrisy, deception and man's continuing inhumanity to his fellow beings, he refused almost all dinner invitations. Under no circumstances would he go to the new restaurants patronized by the wealthy, but he sometimes went alone to the workmen's taverns he had frequented when he was younger, and there he ate a solitary, simple meal. Only when old friends coaxed and pleaded would he consent to dine at their homes.

On weekends he spent his time with his son and daughter-in-law, and his most constant companion was his

grandson. He took Mariano on long walks, carefully pointing out the glories of nature to the child, who was now eight or nine years of age. He painted many portraits of the child, each luminous and tender. The world was foul, he seemed to be saying, but hope for the future rested in Mariano and others of his generation.

Goya's grandchild was not his only escape from venality, cruelty and corruption. In 1815 he conceived an idea for a series of etchings on the bullfight, a subject that had always fascinated him, and he began making preliminary sketches. In the finished work, which he called the *Tauromaquia*, there is a surprising academic quality missing in all of his other drawings. He was teaching the uninstructed layman the delicate balances and technicalities of the bullfighter's art.

He filled many notebooks with his sketches, and from them he made fifty drawings, thirty-three of which appeared in the completed portfolio. The others, apparently, he deemed inferior, although posterity disagreed with him. These works are extraordinary in their technical detail; but the color of the arena, the exciting atmosphere, are strangely missing.

The *Tauromaquia* was undertaken and completed by a man in his seventieth year. Etching is a precise, exacting art, requiring an exceptionally sharp eye and steady hand as well as talent, and Goya was not the most patient of men. Yet the series was amazing in its precision.

He did not need the money, although any work put out under his name would earn a fortune. As nearly as can be determined, the idea of teaching and the art of bullfighting obsessed him, as so many other projects had in the past.

The *Tauromaquia* was published in 1816; Goya followed custom by presenting King Ferdinand with the first

set of prints. He was not received in person by the monarch, however, and no record of Ferdinand's gratitude exists.

By 1816 it was becoming obvious that the King was the one man of standing in Madrid who wanted nothing to do with his First Painter. Others offered Goya ridiculously large sums for their portraits and were willing to wait months for the privilege of sitting for him. Ferdinand could have summoned him to the palace immediately and ordered a portrait, but that call never came. Other than the portraits done at the time of the restoration, Goya never painted Ferdinand again, nor did he do portraits of any other member of the new royal family.

Too stupid to recognize the element of caricature in the coronation paintings of 1814, Ferdinand avoided Goya for a far different reason. The king was possessed by a private demon, a compulsive hatred of his parents. Though Charles IV and Maria Luisa were living in Rome in harmless exile, resigned to their lot, their eldest son was convinced they were conspiring against him to snatch his crown at any moment. This delusion persisted until the death of Charles in 1819, but even then Ferdinand was convinced that some follower of Charles might depose him.

Goya had been First Painter at the court of his parents and a good friend of Charles. A painter might obtain information of value to a conspiring ex-monarch if he were allowed into the royal palace for sittings, to wander at will through its chambers. Convinced that Goya was a spy in the pay of Charles IV, Ferdinand unofficially but firmly closed his doors to the painter.

Had Goya been a man of less reputation, he would have been cast into prison, like scores of others who had been loyal to Charles IV. Not even the half-demented Ferdinand dared to prosecute Francisco de Goya on such flimsy

grounds. The restored Bourbons of France, the royal family of England, even the Tsar of Russia informed the Spanish monarch in letters and through their ambassadors that Spain was fortunate in having Goya still producing his masterworks. Ferdinand cared little about what most men thought of him, but was sensitive to the opinions of fellow kings and princes.

Goya felt no embarrassment, no sense of humiliation that Ferdinand wanted nothing to do with him. He had known too many great personages through the course of long, eventful decades. He kept his counsel, knowing that Madrid was overflowing with informers who would report any slight to the dignity of the Crown.

But the creative artist always has the last word, and Goya made his views of Ferdinand VII scornfully clear in a series of remarkable drawings, *The Prisoners*. It was impossible to publish them in Spain, so Goya concealed them in the drawings for *The Disasters of War*. This led to some confusion after his death, and not until the Academy published *The Disasters* in 1863 was it finally understood that *The Prisoners* comprised a smaller series separate from the larger work.

It is impossible to determine whether the poor wretches of *The Prisoners* were political victims or common criminals. It was enough that they were human beings, subjected to indignities and torments beyond the comprehension of civilized man. The same sense of outrage that inspired *The Disasters* appeared in *The Prisoners*; in that sense the two series were related.

For centuries, the prisons of Spain had been the most primitive and barbarous in Europe. In other lands, the practice of treating prisoners like beasts had gradually been abolished; although prisons everywhere were far from ideal, none were as appalling as those in Spain. How Goya came by the details of these drawings is uncertain,

but men sometimes endured such ordeals, and were later released. Presumably some of these survivors told the painter their stories and described the prison conditions to him. Goya himself never saw the inside of a Spanish prison cell, but his picture of the prisons as well as his portrayal of the punishments accorded captives during the reign of Ferdinand VII was accurate.

Goya sets the tone of the series in the first caption, "The security is as cruel as the crime." His scene is a loathsome dungeon cell in which the viewer sees a lone figure, a captive who is bowed down by the weight of his chains. He begs for mercy, for an alleviation of his suffering, but his plea is unheeded.

"Security does not require the torture of a criminal," states the caption on the second picture. A prisoner being tortured is suffering intolerable pain. What gives this drawing special significance is the indication—no more than a hint—that the prisoner is being raised from the ground on a cross. Here, although Goya is being ambiguous, no doubt deliberately, one sees a veiled criticism of the Inquisition, whose prisons and torture chambers were operated separately from those under direct government supervision and control.

"If he is guilty, may he die without delay," says the caption on the third engraving. In this picture Goya portrays another man under torture, held against a stone wall by means of a cruel iron collar around his neck. He, too, is suffering indescribable torment.

"Do not open your eyes. It is better to die," he comments, to a girl being tortured. In another drawing, interrogators are shouting to a woman under torture, "Do you retract?"

In yet another, his anger at the penal system overflows in a long caption: "What cruelty is this attempt to break

apart a human body that has already become a skeleton! Who would have believed that such a savagery of oppression could unleash human beings like ferocious beasts!"

His own political stand becomes very clear in another drawing that portrays a woman in chains in a dungeon cell. "Because she was liberal," he states, and with that declaration the painter for the first time casts his own lot with the authors and other intellectuals who were struggling to prevent the reaction that threatened to engulf all Europe in the aftermath of Napoleon's fall from power.

None of Goya's prison drawings was sold in Spain during his own lifetime. No man, not even Goya, could have castigated the regime of King Ferdinand so savagely and escaped punishment. But in some mysterious way the prints of many of these engravings found their way to Paris, London, Stockholm and ultimately to Switzerland. There Goya was hailed as a champion of freedom, and no doubt the Spanish embassies sent home word regarding his critical drawings. Perhaps the ambassadors sent no copies, and the government lacked evidence; in any event, Ferdinand took no action against the old man who had dared to speak the truth.

In November, 1817, Goya made a trip to Seville, and there he delivered an altar piece for the enormous cathedral, a painting of the city's patron saints martyred in Roman times. Although it does not rank with his greatest masterpieces, it was unmistakably a work by Francisco de Goya, demonstrating that at the age of seventy-one, he was still capable of competing with men half his age and defeating them with ease. In his work he appeared to have discovered the secret of eternal youth.

In 1819, he further isolated himself from Madrid, giving up his studio in the city, selling his house and buying another, not far from the Segovia Bridge across the Man-

zanares. This old place, situated on a large plot of ground and surrounded by handsome trees, soon became known as *La Quinta del Sordo*, the House of the Deaf Man.

With him went the last woman who was important to him in his life, a distant relative who was many years his junior. Doña Leocadia Weiss was the widow of a Bavarian merchant. She had lived in Spain for many years and had two children of her own, Maria del Rosario and Guillermo. According to some accounts, Doña Leocadia was not a widow, but had been deserted by her husband, and Goya first took her under his roof as an act of charity when she was penniless.

She acted as Goya's housekeeper and, to whatever extent he still enjoyed an active sex life, was also his mistress. Much to the surprise of the few who were still his intimates, he enjoyed a very pleasant and calm relationship with a woman no one else could tolerate. Moratin wrote to friends that she never stopped complaining about the sad life she had lived, and Javier, who may have seen more of her than anyone, related that she had a temper as violent and unpredictable as his father's.

Goya's deafness apparently was a decided advantage in his relations with Doña Leocadia. When she launched one of her tirades he needed only to avert his gaze or close his eyes. Others, Javier said, were forced to leave the room, but his father, unaware of what she was saying, remained tranquil.

If he found Doña Leocadia only a convenience, he was delighted with her young daughter, still a small child when he gave refuge to the family. Maria, called Rosario or Rosarito, was his constant companion, and he painted several portraits of the child and also did allegorical drawings for her amusement. Since she was born two years after her father deserted the family, many writers believe she may have been Goya's child.

Perhaps the most remarkable of Goya's activities at his new house was a project he undertook strictly for his own pleasure. The interior walls of the dwelling were bare, so he filled them with a variety of paintings, the most famous of them located in the large chamber on the ground floor that was used both for dining and sitting.

The most important of these is a large portrait, done in oils, of a woman wearing the costom of a *Maja*. No longer young but still showing distinct traces of youth, she is handsome and the expression in her eyes is fiery. Inasmuch as Goya did no portraits of Doña Leocadia on canvas, it has long been assumed that she was the model for this *Maja*.

The largest of the wall paintings, seventeen feet long, is known as *The Vision of the Romeria of San Isidro*. In this work some ordinary Spaniards are returning home from a night of drinking, perhaps from a tavern, perhaps at a festival. They are singing loudly, but there is no mirth in the scene. The technique takes on the fuzzy qualities of one of the drinkers, as though seen through his eyes—distorted, somber and almost frightening. The painting has been interpreted in various ways, and the debate continues. Goya was not trying to be explicit for anyone else's sake; he did the painting for his own house, where he entertained very few visitors, so it was enough that what he put on the wall satisfied him. Fiends and monsters, grinning skeletons and figures possessed by demons inhabit this painting, but the terror is muted, perhaps because the work has been placed on the dining room wall.

Oddly, none of the dining room paintings were finished. In one, however, a huge monster holds a helpless human in his enormous hands and is eating him. Here the terror that Goya could create with his brush is rampant.

A second room, the combination studio and bedchamber in which the artist worked, slept and spent most of his

213

time, was also filled with wall pictures. There are no separate and distinct paintings here. An all-encompassing mélange of figures spreads across four walls, making one continuous dream. Men talk and eat and argue against backgrounds of typically Spanish scenery; they go on pilgrimages, love and die; strange figures move across the sky, and on close examination their shapes are vaguely human. Three creatures with handsome wings soar high in a sky of deep, serene blue.

One section of the wall is no more than a fragment. Authorities have never been able to determine whether Goya deliberately left this portion undone or whether he lost interest in the project. There are splashes of color, bits of sky, occasional rocks and boulders, and from behind one of these is seen the head of a small dog. That is all. Was Goya trying to say that man ends in nothingness? Was he creating impressions strictly for their own sake, not trying to formulate a thought for the viewer? For he himself was the principal viewer, and he did not appear to care whether anyone else even saw, much less appreciated this work.

Goya may have tried to leave the world behind him when he retreated inside his new house. But the world would not permit him to withdraw, and his services as a painter were still sought by the great and the wealthy. When a subject interested him he could be persuaded to paint yet another portrait. Money no longer mattered to him, and he had labored for so many years that he literally could not call a halt to his production.

What makes these portraits of his old age fascinating is that his vigor and skills were undiminished. He could still penetrate deep into the soul of a subject; his hand was firm and his technique flawless.

XVI
Labors of Love

Goya had barely settled in his new house and started to work on his wall paintings when a new project, one that he himself called "a labor of love," brought him out of retirement. The result was one of his more inspired masterpieces, a work all the more remarkable because of his advanced age. As a boy, he had attended the school of the Scolope Fathers in Saragossa. Now, in the summer of 1819, the priests of the Madrid chapter of the order offered him a commission he found exciting.

The patron saint of the Scolope Fathers was San José de Calasanz of Aragon, and the priests, who had just built a new church and school in Madrid, wanted a portrait of him to place behind the altar. They had delayed until the last minute before going to Aragon's most distinguished son, as the dedication of the church would take place in only five weeks. Certainly they had thought of no one else for the task. The members of the chapter who called on the painter made it clear to him that he was their first and only choice.

Goya accepted the offer and the challenge. Attacking

the project with the same fury he had demonstrated throughout his younger days, he finished the great work in ample time. He elected to paint the saint in his old age. The concept was simple: San José is performing a miracle as a light from above shines down on him, and the scene is observed, in the presence of the congregation, by a priest who is offering him his last Communion.

The old man is one of the most extraordinary characters in Goya's gallery of paintings, an aged figure of power and purity. Some biographers have wondered whether the painter, himself growing old, identified with San José. Or perhaps he simply recalled his own youth in Aragon, when the Scolope Fathers filled his young mind with tales of the wonders performed by the old saint on behalf of children. Those memories inspired a great work.

Goya accepted the relatively small sum of eight thousand reales for the painting and was paid half of that sum in advance. On the day of the dedication, which he attended, he informed the priests that he did not want the second payment and refunded all but twelve hundred reales, for him a token sum. That was only the beginning of his generosity. A true professional, he had rarely made anyone a gift of a painting, but on this occasion he donated to the head of the Scolope Fathers' school, Father Pio Pena, another masterpiece he had done for the occasion. It was a sketch called *The Prayer of Jesus in the Garden of Olives*. His very Spanish Jesus is a figure of extraordinary beauty, and his use of dark and light set a stirring example for the painters of the Impressionist school who would follow him. It is unlikely that Goya was thinking about posterity when he painted these two works. Still a simple man of Aragon, he was expressing his thanks to the priests who had given him an education at their own expense.

In the next few years he painted several portraits of

saints. Notable among them are a Peter and a Paul, both executed with unerring skill. Religious figures became increasingly important to him as his life gradually drew to a close, and among the last he painted were striking portrayals of an old monk and a pious nun. Their identities are not known, but the elderly artist preserved their likenesses in paintings as simple as they are stunning. The skills Goya had acquired over a lifetime had not deserted him.

His vast body of work now spoke for itself. Spain had not yet learned of the existence of the two *Majas, The Disasters of War* or *The Prisoners*, but prints of various sketches for the latter series were circulating in other lands. He was regarded throughout Europe and in such growing American centers of culture as Boston, New York, Philadelphia and Baltimore as a symbol of nineteenth-century liberalism and humanitarianism. It did not matter that he lived in semiretirement, seeing only a few old friends and those whose portraits he consented to paint. Men of good will everywhere hailed him as one of their greatest champions.

Goya posed a grave problem for King Ferdinand, his administrators and the officials of the revived Inquisition. Lesser men had been sent to civilian jails or the Inquisition dungeons for far less serious affronts. But other nations, despite their reactionary regimes, had not regressed as far as Spain. The spirit that would spark the Revolutions of 1830 across the Continent was already very much in evidence, and leaders everywhere, including the men of power in the Vatican, were sensitive to public opinion.

This consciousness of the modern world was forced on Ferdinand VII and the Holy Office, no matter how often they closed their eyes and ears. The arrest of Goya would have created a furor everywhere, and the reputation of the Spanish Crown and the Spanish Church would suffer.

So the old man enjoyed relative freedom, though he respected the delicacy of his position and took care not to abuse his prerogatives. He could shrug off being ignored by the royal court, but he knew better than to issue an open challenge to the Inquisition. Never again would the Church allow itself to be shamed by a Galileo-like trial, but the Holy Office was still capable of reacting if pushed too far. A deaf man in his seventies could simply disappear; no one would know that the Inquisition was responsible.

Regardless of his awkward political position, the aged Goya refused to stagnate as an artist. While in his seventies he did a series of sardonic paintings whose cruel realism was reminiscent of the *Caprichos*. In one of the most famous of this group he showed a lovely but stupid young woman. In the background stand Time and a hideous, skeletonlike old hag, a representation of what the girl will become.

Even in his advanced years Goya continued to experiment. When Europe was stirred by the news that the Archbishop of Quebec had been captured by hostile Indians, tortured, put to death and dismembered, Goya recorded the event in the form of two small pictures that he painted on copper.

He also experimented on tin, in a painting called *Shipwreck*. This account of a horrendous catastrophe was inspired, in all probability, by the sinking of a frigate, the *Medusa*, a frightful accident in which all hands were lost in a boiling sea. Death and destruction continued to fascinate him.

In 1819 he began a new series of *Caprichos*, but only a few drawings for this portfolio were ever completed. Goya was too busy with a variety of projects; knowing that his time was short, he tried to make the most of it. In 1819, after making a number of experiments, he intro-

duced to Spain the process of lithography, which had been invented a quarter of a century earlier. Astonishingly, he was able to adapt his own techniques to this new form, using a razor and an unsharpened pencil. His first known lithograph, produced in 1819, was a picture of an old spinner, and it was a masterpiece.

In the portraits done in his seventies he sometimes used colors in new and striking ways, sometimes abandoning his brush completely and spreading the paint with his finger or thumb. He knew no failures in these latter days, and every work he completed was incisive, all of them showing his great understanding of human nature.

Not even the constitution of a peasant from Aragon could tolerate such frenzied activity at the age of seventy-three, and late in the year he suffered a physical collapse. The nature of his illness is unknown, but it may have been a heart attack. Gravely ill, he was saved by the skill of his physician, Eugenio Arrieta, and by the devotion of Doña Leocadia. The following year, when he was recovered, he presented the physician with a double painting, one side a portrait of Dr. Arrieta, the other showing a gasping, half-dead Goya leaning back in bed against the physician, who is raising a cup toward his lips.

After his recovery Goya returned to work with his usual vigor. His brush with death had caused him to worry about the future of little Maria del Rosario, and he named a good friend, Don Tiburcio Perez, guardian of the funds he intended to leave her. Although he had no actual legal rights with regard to Maria, he wrote a new clause into his will advocating that Perez, who was a noted Madrid architect, be made the little girl's guardian.

Demons and monsters had haunted Goya again during his illness, and while he was convalescing he found he could not remain idle. So he began to work on a new series of etchings, doing the original drawings in red ink

and calling the portfolio *Disparates*. Once again he struck hard at the stupidities, crassness and vices of mankind. This time he wrote no captions, allowing the works to speak for themselves.

The last of Goya's great works, the *Disparates* could not be published in the Spain of his own day and did not appear in print until 1864, when the Academy issued an edition. Even then they attracted little attention, for they seemed so abstruse that most critics dismissed them as hallucinations of an old man who was losing his sanity.

Goya was very much aware of what he was doing, and it is probable that he was playing a game with posterity, daring the viewers of the future to interpret his complex messages. As yet this challenge has not been met successfully, partly because the artist purposely filled the pictures with contemporary illusions that only he—and possibly a small group of intimates—understood. It is difficult to find any two authorities who interpret even one of the twenty-two drawings in precisely the same way.

One of the most outstanding of the *Disparates* shows a group of men and women dancing to a tune played by a music box. The women are dressed as *Majas*, the men as *Majos*, and at first glance their wild contortions look gay and abandoned. But a closer examination reveals that the women are no longer girls: some are middle-aged, others are elderly, and they are as desperate as they are ludicrous. The men are in even worse shape: their joints are stiff, they are bald and fat and flabby.

Another picture, sometimes called *The Circus Queen*, is a perfect example of the vague meanings that characterize this series. A huge crowd is gathered in what appears to be a coliseum, staring up at a tightrope that seems to stretch from infinity to infinity. Balancing on the rope is a magnificent white horse, and on the bare back of the horse stands a handsome woman dressed in white. Goya

may be saying that the act is absurd, as is the interest of the crowd. Or he may be saying that the lot of womanhood is exceptionally difficult, and that for a female to maintain her balance in the world Goya has known requires extraordinary skill and dexterity. If this is his intent, it may be that the crowd is fascinated by her performance because it applauds her—or, perhaps, because people are hoping she will fall. Every viewer is entitled to his own interpretation.

If any one theme can be said to dominate the *Disparates*, it is women. Goya, who surely qualified as an expert on the subject, apparently viewed women with great sympathy: according to some interpretations of the portfolio, he might even be regarded as an advocate of women's rights. If true, this would be extraordinary in a Spaniard who lived the better part of his life in the eighteenth century. On the other hand, perhaps in this series Goya was merely less critical of women than of men and their institutions, conduct and mores.

In most encounters between the sexes Goya may have regarded woman as the victor. In one perplexing picture a superb stallion has a firm grip on the white dress of a handsome woman and is about to leap through space, carrying her with him. The woman's arms and legs are flailing about and she appears to be protesting, although in vain. But a closer study of her face indicates that she is thoroughly enjoying the experience and that she, not the stallion, is in command. In the background one of Goya's loathsome monstrous beasts appears to be sinking into the ground, in contrast to the magnificent stallion who will soar into the air. This creature is eating, whole and alive, another woman, who may be his willing victim, as she seems to have jumped voluntarily into his mouth.

Whatever Goya intended to portray, every viewer of the drawing becomes his own expert, his own critic, his

own authority. A great artist in his mid-seventies, a man of extraordinary talents endowed with an imagination as unique as it was terrifying, had the final word and enjoyed the last laugh.

In yet another picture he showed a woman with two heads; one is attractive, set in the normal position, while the other, growing in a deformed way from her breasts, is hideous. This second head may be guiding her as she flees from two vaguely defined creatures—monsters, perhaps, or even the products of her own imagination. Awaiting her and trying to rescue her as she runs toward a place that may be a convent is a crowd of normal, healthy women. Behind them stand elderly women, some of them crippled, some blind, some deformed.

The series is filled with two-headed men, gentleman-and-brute, compassionate priest-and-hypocrite, happy-and-surly. These figures seem to tell their own stories, but Goya has complicated his meaning by adding other figures, some of them normal, others acting in strange, cryptic ways—some allegorical, some realistic, some deformed.

One of his most dreadful monsters seems to possess all of the physical characteristics of both man and woman. This figure, which is both human and nonhuman, defies description. Some critics have leapt to the conclusion that this drawing expressed Goya's opinion of marriage, a horrible, unworkable, forced mixture of man and woman from which there is no escape.

Not all of the *Disparates* portray terrifying creatures. Some are purely satiric, reminiscent of the lighter *Caprichos*, and reveal Goya's lively sense of humor. But even here, his intentions are obscure. These drawings, like all the others in the portfolio, may be interpreted in many ways.

Authorities agree only that Goya knew precisely what

he was doing, that he was as sane as he had been for many years, and that he was challenging all who would ever look at the *Disparates*. It may be—on this there can be no agreement—that he drew them as an artistic testament, portraying in allegorical and symbolic form his fundamental views of man and civilization.

After Goya finished the *Disparates*, perhaps in 1821, his output began to slacken. He still displayed consummate skills, but the effort took a great toll. His handwriting had become that of an aged man, and his hand was shaky, even erratic. The discipline he was forced to exert when he painted can only be imagined.

Then, in the last stage of his long life, he found himself embroiled once again in the political life of his country. He had become so much the symbol of the humanitarian, the liberal—even the rebel—that it may have been impossible for him to keep aloof.

In January, 1820, in the seaport of Cadiz, units of the Spanish army led by General Rafael de Riego mutinied, refusing to sail for South America to quell rebellions in the Spanish colonies. It is significant that the insurrection occurred in Cadiz, which had resisted Napoleon longer than any other Spanish city and had been the birthplace of the short-lived constitution. Riego had been a prisoner in France for six years, where he had been exposed to the principles of the French Revolution and the personal freedoms that Napoleon had espoused. Now, suddenly, he found brother officers and their troops rallying to him because they, too, could no longer tolerate Ferdinand's cruel and regressive rule.

Ferdinand discovered he could not put down the spreading revolt, for no troops remained loyal to him. After long months of evasion, he was finally compelled to make his peace with the insurgents.

Virtually a prisoner of the army and of the *Cortes*,

which now refused to remain a rubber stamp automatically ratifying royal decrees, Ferdinand was compelled in 1821 to restore the constitution, grant some personal freedoms, limit—although not completely suppress—the Inquisition and promise full amnesty for those who had opposed him. Spain appeared to be emerging from tyranny.

But the crafty Ferdinand was playing his usual double game. As early as 1820 he had issued secret appeals for help to the powers that had defeated Napoleon. Tsar Alexander of Russia was the only monarch who was willing to send immediate assistance, but by 1822 Austria and the restored Bourbon monarchy of France were ready to act.

They were delayed for a time by Great Britain, which feared that an invasion of Spain would permit the Bourbons of France to expand their influence. But Britain was not prepared to make war on the issue. Her people were prosperous after years of wartime deprivation, and she wanted peace at almost any price.

No nation objected too strenuously when, in April, 1823, a prominent member of the French branch of the Bourbon family, Prince Louis Antoine, the Duke of Angoulême, led a large and powerful army across the Pyrenees. Spanish liberalism proved to be paper-thin, and men who had waged ferocious guerilla warfare against Napoleon for years refused to take up arms again. Spanish defenses collapsed within a few weeks, and Ferdinand was restored in triumph to his full powers.

But the liberals had one last card to play, and the *Cortes,* or parliament, fled to Cadiz, taking the King with them as a prisoner. The French besieged the city and finally, in September, 1823, the last defenders of the new order surrendered.

Ferdinand promptly abolished the constitution again, returned the Inquisition its full powers and, completely ignoring his promise of an amnesty, subjected Spain to a bloodbath. So many men were shot, so many others imprisoned and tortured, that even the French troops of occupation were sickened by the slaughter and threatened to rebel. Instead they were evacuated, and Ferdinand kept his firing squads and hangmen busy.

Before the liberals' surrender, the great national hero of Spain had been General Rafael Riego, hailed everywhere as a liberator. A second man shared the honors with him —Francisco de Goya, regarded as a champion of the people and their liberties. He made only one public appearance, on April 4, 1822, when he attended a meeting of the Academy of San Fernando and was the first member of the Academy to march to the podium and take a solemn oath of allegiance to the constitution.

But he did much more. To commemorate the occasion he drew a picture, much in the style of the *Caprichos* or a twentieth-century political cartoon. He portrayed a handsome young woman, labeled Justice, armed with a whip called the constitution. With this weapon she mercilessly flailed a mass of bats representing the forces of reaction. The artist's caption was succinct: "Divine reason spares none of them."

Thousands of prints flooded Spain, and other copies were sent abroad, all of them a signal to the world that the seventy-six-year-old artist had taken a stand once again. This act required tremendous personal and moral courage. Goya could have remained silent, and because of his age and his infirmity, no one would have blamed him. He realized, as did his friends, that the hold of the liberals was tenuous and that the intervention of foreign troops, if it came, could restore Ferdinand to full power. But Goya

allowed himself to be counted and threw his full prestige behind the men who sought liberty and justice for all Spaniards.

The significance of the restoration in September was not lost on Goya, and he immediately took steps to protect his family, acting so promptly that he must have made his preparations well in advance. Within twenty-four hours of King Ferdinand's return he turned over his new house and its surrounding property to his grandson, Mariano, signing the deed in a shaking hand in the presence of two notaries.

He then sent Doña Leocadia and her children out of the country. Her son, Guillermo, had served as a militiaman with the constitutionalists, and Goya knew he would be executed if he fell into the hands of his enemies. So, using funds supplied by the old man, his housekeeper-mistress fled to exile in Bordeaux with Guillermo and Goya's beloved little Maria.

At the age of seventy-seven the painter stood alone. Fortunately he had many friends among those who had been loyal to Ferdinand, so he was probably in no immediate danger, but he knew the vengeance of the King would not be postponed indefinitely. The stand he had taken on behalf of the constitution was so firm that the monarch, to whom revenge was a way of life, would certainly take action against him.

Though he could not protect himself, Goya refused to leave the country. His son and grandson were in Spain, and so were his investments. He had traveled outside the country only in his youth, when he had lived in Italy. Urged to follow Doña Leocadia to Bordeaux, he replied that he no longer remembered what little French he had learned years before.

The old man was physically and emotionally incapable of living alone, however, so his son and daughter-in-law

offered him a home with them. He refused, saying they would be "tainted" by him and would be forced to share whatever suffering Ferdinand might cause him. Javier de Goya had remained apolitical through the recent years of turmoil, and as long as he remained neutral he would be safe. His father flatly refused to compromise him, and nothing would change the old man's mind.

His position as Court Painter had not been taken from him, Goya declared, and he still received his annual payment from the Crown. When he was removed from the post, he said, then would he know that personal danger was imminent.

A wealthy, powerful friend who had maintained good relations with both political camps came to Goya's rescue. Don José Duaso y Latre offered Goya shelter in his own house, and the painter accepted, realizing that Don José would be able to survive Ferdinand's anger. There were many servants on the Duaso household staff, and Goya was given the best of care. Under the circumstances the best of all possible solutions had been found, though everyone knew it was temporary.

But a much greater calamity struck the artist. In gratitude for his host's hospitality he tried to paint his portrait, but for the first time in his life he failed. His brush would no longer obey his will. He made four attempts to do the portrait and finally gave up in despair and disgust when he could not achieve an accurate likeness. Now he was truly bereft, and this fate was worse than any punishment King Ferdinand might inflict on him.

XVII
Twilight of a God

Goya's friends continued to intervene for him at Court, and the day of his confrontation with Ferdinand VII was postponed repeatedly. Many men in high places, including the Cardinal Bishop of Seville and the editor-in-chief of the official government newspaper, managed to persuade the King that his prestige abroad would suffer if he actively persecuted the revered painter. Ferdinand hesitated.

Old Goya had not lost his peasant's cunning, and he did not mind exploiting the weakness of the monarch. He had no desire to remain in a land of tyranny, he told his influential friends, but he would go into voluntary exile only on two conditions: first, he demanded a promise, in writing, that his property would not be confiscated if he left Spain; second, he demanded the right to return whenever he pleased for visits of any duration he deemed desirable. Nothing, he said, would deprive him of the right to see his son and grandson.

The spectacle of the aged artist negotiating with the cruel but confused King amused no one. Goya believed

from the outset that strength as well as right were on his side, and in his own mind the outcome of the battle was never in doubt. He was aware of his position and convinced that Ferdinand lacked the courage to take any drastic action against him. In fact, he felt certain the King would think he had won a victory if the man who represented a constant embarrassment to him should leave the country of his own free will.

Goya was in such high spirits that he suddenly recovered his ability to paint. He regarded this as a miracle and duly went to San Antonio de la Florida to offer his thanks to God.

In the first five months of 1824 he painted several portraits, and it was true that all of his old skills had returned. His eye was keen, he had not lost his extraordinary talent for dissecting the souls of his subjects and, most important of all, his hand was steady again.

Perhaps the most important of the portraits he painted during this period was one of Javier. The painter's son had aged in recent years and now looked almost as old as his father. Even when painting someone he loved, Goya could not lie.

Finally, on May 30, 1824, King Ferdinand quietly signed a decree permitting his loyal subject, Don Francisco de Goya, to go out of Spain for the purpose of taking the mineral waters at Plombières, France. The royal order mentioned nothing about exile, and Goya would be free to return whenever he wished.

The order also demonstrated that Ferdinand had lost none of his own cunning. He had balked at promising in writing not to confiscate the property of a subject, believing that such a document would be beneath the dignity of the Crown. The visa served the same purpose because Goya ostensibly was leaving the country only for the purpose of improving his health. The permit actually men-

tioned that the mineral waters might aid his rheumatism. Not even the King could take away the property of a prominent citizen without alarming every other substantial property owner, however, so Goya had the guarantee he sought.

Early in June Goya set out from Madrid for the French border, traveling in his own carriage. The trip was exhausting for a man of his age, and it took him a full week to reach Bordeaux. That city had become the unofficial capital of the intellectuals and other refugees from Spain, and several battalions of constitutionalist militiamen were stationed nearby. The well-organized refugees even had a screening committee that passed on the credentials of new arrivals and then voted whether or not they would be allowed to stay. That the France of the restored Bourbon monarchy should have permitted such activities on their soil appears surprising at first glance, but the French knew what they were doing. The concentration of anti-Ferdinand forces in one place made it easier for the secret police to keep watch over them.

Goya was hailed as a hero when he reached Bordeaux. The head of the welcoming committee was Moratin, who had settled permanently in the city after leaving Spain three years before. Doña Leocadia and her daughter were also living there, Guillermo having joined his fellow militiamen nearby. Goya did not move into the quarters occupied by his former housekeeper-mistress. She and her daughter were living in only two rooms, so there was no room under their roof for the most distinguished of Spanish refugees. It is also possible that their relations had cooled somewhat.

Moratin found quarters for him in a school for Spanish refugee boys operated by his friend Manuel Silvela, and for three days the youngsters were privileged to have the

great artist as their tablemate. Goya, ravenous after his travels, ate enormous meals.

He had also decided to do more traveling and insisted on going to Paris. It was absurd, he declared, to have come as far as Bordeaux without seeing the great works of art in the French capital.

His friends were horrified. He spoke no French, he was stone deaf and he moved with difficulty, due to his rheumatism. Moratin tried to tell him that Bonapartist veterans had become highwaymen and were the scourge of the provincial roads, that the newspapers were filled with stories of a crime wave in Paris. Doña Leocadia added her pleas to Moratin's, and other prominent members of the refugee community urged Goya to reconsider.

But the old man had made up his mind. He wanted to explore new trends in art, and he had always intended to see the sights of Paris.

His friends did the best they could, renting a carriage and driver for him, writing ahead to various friends, whom they asked to keep an eye on the old man, and arranging suitable quarters for him in Paris. A revitalized Goya bade his friends farewell. When he left Bordeaux, Moratin sent off a glum letter to a mutual acquaintance, saying he never expected to see Francisco de Goya again and requesting immediate notification if something untoward happened to him.

Goya proved he was tougher and more resilient than anyone imagined. He enjoyed himself on the long ride to Paris, and although he didn't care much for French food, he ate hearty meals at the inns along the road. On one occasion he dined with two handsome young women, sisters, whose paths crossed his. Obviously his infirmities did not prevent him from appreciating beauty.

Paris was the capital of the Bourbon regime that had

231

restored King Ferdinand VII to full power, and it would have been awkward to receive Goya as a symbol of Spanish liberalism. So his politics were forgotten, and men of every faction joined in greeting him as a great artist. Members of the Spanish community were the first to welcome him. He was given a suite in a comfortable house occupied by friends of Moratin, who immediately notified the poet that the "young traveler" had arrived safely.

According to a story that may be apocryphal, Goya met Delacroix in Paris, and during the next few months frequently received the younger man, who later would acknowledge his great debt to the Spanish master. It is true that Delacroix was in Paris while Goya was there, and since 1822 had been regarded as one of the most important younger artists. So it is possible that such meetings actually took place.

Paris had only a slight impact on Goya. Members of the French art community would have lionized him had he given them the opportunity, but he was too busy. He enjoyed himself thoroughly, had a splendid time sightseeing and spent hours sitting at sidewalk cafés, watching the world pass. Letters written by several people to Moratin indicate that he never failed to notice a pretty girl. His only complaint was the food, which he ate sparingly until his hosts began to prepare simple Spanish meals for him, and then his appetite returned. The balmy summer weather, the freedom from Ferdinand's reprisals and the comfortable living not only restored his equanimity but revitalized him. He began to paint again.

One of his subjects was Don Joaquin Maria Ferrer, later to become President of the Spanish Council, and another was Don Joaquin's wife, Doña Manuela. Both of these portraits could have been painted by Goya in his fifties. He also did a self-portrait portraying himself as an almost cherubic man with twinkling eyes, wearing a jaunty cap.

He also did a hearty study in oils, which he called *The Bulls*. If it was not a masterpiece, he did not miss the mark by much. But at no time was he inspired to paint any of the French scenes that brought other artists to Paris by the hundreds. His delight in life turned his mind toward the Spain he had left behind.

Moratin and Doña Leocadia were afraid that the raw Paris winter would mean the end for the old man, so their Paris friends followed instructions and bundled him off to Bordeaux late in September. He had spent three of the most carefree months of his long life in Paris, and they were all the more enjoyable because he had been productive as a painter.

When he arrived in Bordeaux, a new home was awaiting him. Moratin had found a snug house for him at 24, Cours de Tournay, and Doña Leocadia had already moved in with her daughter to make the place ready for him. Soon after Goya joined them, young Guillermo came from the military camp to spend weekends at home.

Goya and Doña Leocadia were closely observed by the Spanish refugee community, so a great deal is known about their life together. Both were moody and hot-tempered, and Doña Leocadia never hesitated to express an opinion on any subject, even on one about which she knew nothing. She and Goya tried to dominate each other —though he never lost an argument because he could resort to his old trick of looking away when she addressed him. Her frustrations made her even more of a shrew, and she was certainly not the most popular member of the refugee community. But she and Goya apparently enjoyed a tacit understanding, and their frequent quarrels in no way impaired their relationship.

In the early winter of 1825 Goya received an official communication from the Spanish government, a new visa permitting him to remain abroad and conveying the

Crown's "best wishes" for "the restoration of his health." His first visa had included no time limit, so its extension well may have been an effort by King Ferdinand to keep the old man away from Spain.

Ten-year-old Maria del Rosario remained the great joy of Goya's existence. She had already mastered French and when she showed an aptitude for painting, the old man rejoiced. He wrote to Ferrer in Paris that she had a talent for miniatures, that he was encouraging her and hoped to send her to Paris later to continue her studies.

Goya knew better than to make her his own pupil. None of his assistants had achieved anything on their own, and the great painter seems to have been incapable of communicating his thoughts about painting to others. Realizing his inadequacies, he preferred to let Maria study under others.

Years later Maria del Rosario Weiss was hired to copy masterpieces at the Prado and began to establish herself as an artist in her own right. But she contracted one of the many unidentified illnesses of the nineteenth century and died a short time later. She would have lived and died in total anonymity had it not been for Goya's great fondness for her.

Many Spanish refugees of stature had settled in Bordeaux, among them counts, generals, a mayor of Madrid, and a former Viceroy of Mexico, Don José Miguel de Azanza, Duke of Santa Fe. All wanted Goya to paint their portraits, and he happily obliged them; his hand was still remarkably steady, but he worked a trifle less rapidly, and this annoyed him.

His life in Bordeaux gave him a sense of contentment he had not known in a great many years, and he enjoyed the companionship of friends, the climate—everything but the food. At times he worried about his investments in

Spain and arranged through friends there to make certain that there was no interruption in his monthly payments. He also wrote occasionally to Javier, and late in the spring of 1825 he settled certain properties and their income on his son.

The coming of warmer weather also made him homesick, and he had to be dissuaded from returning to Spain. Moratin, who had assumed the obligation of supervising his affairs, wrote to a friend in Paris, "He . . . takes it into his head, at moments, that he has much of consequence to do in Madrid; if we leave him to himself, he will be off on an unmanageable mule, with his blanket, his cloak, his walnut stirrups, his leather bottle and his wallet."

In mid-June Goya fell ill, and on June 16 was on the verge of death. But two refugee physicians prescribed treatment that saved him, and Doña Leocadia nursed him back to health. The ailment vanished as swiftly as it had attacked him, and in early July, though still convalescing, he returned to work. No longer heeding Doña Leocadia's advice, he refused to rest for very long and spent most of his waking hours at his easel.

Goya's restlessness manifested itself in many ways. In the summer of 1825 he expressed dissatisfaction with life in a rented dwelling and bought himself a snug house with an enclosed garden in the rear. It was located at 10, Rue de la Croix Blanche, and the deed demonstrates that Goya was thinking of the future. He paid cash for the place, but listed it in Doña Leocadia's name. He was now in his eightieth year, and he wanted to make certain she and Maria had a permanent home of their own if he died before he could make other arrangements for them. His illness, it would seem, had frightened him.

The new house suited his purposes perfectly, he wrote to Javier. His studio was a small room with a north light,

and he slept in a chamber with a southern exposure, which gave him the warmth and sunlight he craved and enabled him to look each morning and evening in the direction of his beloved Spain.

In 1825 Goya's eyesight began to fail. He refused to wear glasses but consented to utilize a large magnifying glass when he worked. He kept almost frantically busy, as usual, and his impaired eyesight in no way interfered with his productivity. In fact, Maria del Rosario's interest in miniatures inspired him to try his hand at this exacting art.

He painted scenes from life, portraits, even some of his demons, monsters and witches. In all, he is known to have painted more than forty miniatures. Only a few have survived, and he may have destroyed the rest himself because he was dissatisfied with them. He painted them all on ivory, the surface of which could be used again after being scraped clean.

In the autumn of 1925 Goya began to produce lithographs, forming a partnership with two Frenchmen, which proved lucrative and gave the world more of the great artist's work. One of the men, Jacques Galos, a Bordeaux banker of Spanish descent, provided the funds for the venture; the other, Gaulon, was a local printer interested in lithography. Goya soon turned out profitable lithographs, and in the next year he enjoyed yet another resounding success with a series of four pictures called *The Bulls of Bordeaux*. The initial printing of one hundred each, done in Gaulon's shop, sold rapidly because of the magic Goya name, so a second printing was made, then a third and a fourth. The old man had lost none of his interest in the finances and kept a close watch on sales. More copies could have been sold, he wrote to Ferrer, if a lower price had been charged and his own name had not appeared on the lithographs. But he felt certain that his

profits would be greater in the long run, no matter how much was charged.

Late in the spring of 1826 Goya's yearning for Spain finally overcame him, and he decided to go home for a visit. The entire refugee colony in Bordeaux tried to dissuade him, but again he would listen to no one, and a scant four days after deciding to make the trip he set out on his journey. He would allow no one to accompany him, but consented to use a carriage instead of traveling on horseback.

Word of his coming preceded him, and Madrid greeted him like a conquering hero. Crowds lined the streets as he was driven to Javier's house, an impromptu procession was formed and hundreds stood outside the house for hours each day, waiting for a glimpse of the great man.

Ferdinand VII promptly utilized the situation for his own benefit. Every painter, dramatist and poet of stature had left the country and gone into exile, but now the greatest of all artists had voluntarily come home. The Crown graciously granted Don Francisco de Goya a "full pardon," though the official document, which was printed in full by every newspaper in Spain, made no mention of the supposed crimes the painter had committed.

In spite of this gesture, Goya and Ferdinand did not meet. According to a story that has persisted to today, the King sent his First Painter, whose annual salary was still being paid, a summons to an audience. Goya, who had been enjoying the best of health, felt suddenly and mysteriously indisposed that day, and the King, who was intelligent enough to take the hint, did not extend a second invitation.

Ferdinand, nonetheless, was determined to share in the great artist's glory, and commissioned Vicente Lopez, the best painter still residing in Spain, to paint Goya's "official" portrait, suggesting that it hang in the headquarters

of the Academy of San Fernando. Although Goya had never been painted by anyone other than himself, he consented to have the portrait done.

Lopez was overwhelmed by the reputation of his colleague and had his hands full. Goya could not sit still for more than short periods and constantly interrupted the sittings by assuming various bullfighters' positions and explaining them in detail. He also wandered to the canvas from time to time, to examine it with a magnifying glass and make technical suggestions. Ordinarily Lopez had his own approach, but he followed all of the great man's ideas to the letter.

In spite of these handicaps the painting was first rate, although somewhat idealized. By the time the official ceremony of presentation and hanging took place, however, Goya was no longer in Madrid. Perhaps he deliberately left for Bordeaux so he would not have to take part in any official function that might indicate his approval of Ferdinand.

Goya treasured his visit with his family during those eight weeks, and saw a few of his old friends, too. But Madrid in 1826 was not the city he had known and loved. Constables were everywhere, strong detachments of troops guarded every public building and official residence, and the presence of secret police discouraged people from attending bullfights, concerts, the theater, dining in public or even wandering through the streets. After Goya returned to France he refused to discuss the Spain he had just seen when his fellow refugees questioned him.

The old man's relatives had been horrified when he appeared in Madrid alone, and they proved that they, too, could be stubborn when he insisted on returning unaccompanied to Bordeaux. His son and daughter-in-law feared for his safety on the road and threatened to lock

him in the house unless he behaved sensibly. Goya was forced to capitulate, and Mariano went with him to Bordeaux. Secretly pleased, the old man made a holiday of the journey, which lasted for several weeks. In Bordeaux, Mariano remained as his grandfather's guest for another month.

Goya never went back to Spain again and no longer spoke of his homeland. The country had been so changed by Ferdinand that the greatest living Spaniard preferred to think of the past rather than the harsh reality of the present. Though he no longer required a visa and, thanks to his "pardon," was free to come and go as he pleased in Spain, he refused to exercise the dubious privilege.

Again he threw himself into his work. On several occasions he accompanied Doña Leocadia to her favorite entertainment in Bordeaux, a permanent circus. From these visits he drew two superb, delicately executed black and white sketches of elephants. For little Maria's amusement he also made sketches of tigers, camels, foxes and pet dogs. His pen and pencil were never still, and again he began to fill notebooks with drawings of people in all walks of life. Sometimes he abandoned realism for the demons, monsters and other creatures that had been bottled within him for so many years.

A significant change took place in the attitudes of the eighty-year-old Goya after he returned to Bordeaux. For the first time he truly made his home in France. Although he walked with difficulty, he resumed the practice of his earlier days, strolling through streets, observing the people, then committing them and their activities to paper.

He was interested in everyone—the wealthy merchant, the shopkeeper, the laborer, the children playing in the streets—and women of every kind. Although his eyesight had dimmed, Goya had not lost his ability to see and remember every detail of a pretty girl's face and figure.

Scores of attractive young women filled the pages of his notebooks.

The cruelty of mankind still fascinated and disgusted him, and sometimes he drew pictures reminiscent of the *Caprichos* and *The Disasters of War*. One such drawing, which he called *The French Punishment*, shows a condemned man slowly mounting a flight of steps to a waiting guillotine.

The last of Goya's finished paintings, which he did in 1826 or 1827, was a portrait of a young French woman, a near-masterpiece known to posterity as *The Bordeaux Milk Girl*. She expresses a charming, delicate sexuality and a joy of living that epitomize all that Goya ever found desirable in women. The painting might well be regarded as his artistic epitaph, although he continued to sketch and, at the time of his death, left several unfinished portraits.

In 1827 his correspondence with his son increased. Feeling that his end was drawing near, Goya completed the rearrangement of his financial affairs. The most important change guaranteed his grandson an annual income of twelve thousand reales. In his letters, written in an increasingly shaky hand, he frequently expressed the desire to see his family again. Javier agreed to come as soon as his own affairs permitted, and the old man was so anxious to see him that he offered to pay for the trip, even offering a free visit to Paris as a bonus.

In March, 1828, Goya was critically ill, but he astonished his doctors and friends by recovering enough to resume his normal activities. He was grateful to a friend, José Pío de Molina, for his improvement and tried to express his thanks by painting Molina's portrait, but the work was never completed.

His daughter-in-law and grandson arrived for the long-awaited visit on April 1, 1828; the old man's joy over-

whelmed him and he wept. He was overcome by his emotions and could not arise from his bed the following day, but he still had the strength to write a brief letter to Javier, in which he said: "I cannot tell you anything more, such great joy has made me a little ill, and I am in bed. Please God, you will come to join them, so that my happiness may be complete."

His hand shook so badly that a drop of ink splashed onto the paper. It was the last time he would ever hold a pen.

By the following day his condition was much worse, and apparently he had suffered a stroke. He temporarily lost the powers of speech, and one side of his body was completely paralyzed.

For the next two weeks his daughter-in-law and grandson maintained a vigil at his bedside, along with Doña Leocadia and her children. Goya was comfortable, cheerful and seemed to be suffering no pain, although he grew progressively weaker. He was resigned to the fact that his life was drawing to a close.

According to one story, Doña Leocadia was bending over him moments before the end and saw a completely lucid Goya staring at the hand that had painted so many pictures, drawn so many sketches. Then he closed his eyes, sighed gently and died.

He was buried the next day, April 17, 1828, in the Carthusian Cemetery in Bordeaux, sharing a tomb with his good friend Don Martin de Goicoechea, who had died three years earlier.

For decades Goya's tomb was nearly forgotten. Not until sixty years later did King Alfonso XII of Spain take the first steps to bring his body home. The tomb was opened, but by that time Goya's remains could no longer be distinguished from those of Don Martin, so nothing further was done for another eleven years.

In 1899 the bones of both men were placed in a single coffin and brought to Madrid for burial in the Church of San Isidro beneath a handsome monument. But the people of Madrid, the men and women Goya had immortalized, were not satisfied. They knew San Antonio de la Florida had been his favorite church, and public pressure forced a final transfer of the coffin to a place in front of the altar. There it remains to the present day, with Goya's angels and cherubim looking down on him from the ceiling, his *Majos* and *Majas* maintaining their vigil from the balcony walls.

Select Bibliography

Adhemar, Jean, *Goya*, Paris and New York, 1948.

Araujo, Sanchez Zeferino, *Francisco Goya*, Madrid, 1895.

Barbarrosa, M. C., *The Living Goya*, Boston, 1939.

Brieger, Lothar, *Francisco de Goya*, Berlin, 1922.

Feuchtwanger, Lion, *This Is the Hour*, New York, 1951.

Fleischmann, Benno, *Francisco de Goya*, Vienna, 1911.

Gassier, Pierre and Wilson, Juliet, *Life and Complete Works of Francisco Goya*, New York, 1971.

Godoy, Manuel, *Memoirs of the Prince of Peace*, Paris, 1836.

Grappe, Georges, *Goya*, Paris, 1937.

Gudiol, José, *Goya*, New York, 1945.

Iriarte, Charles, *Goya*, Paris, 1867.

Lafuente, Ferrari Enrique, *Goya*, Madrid, 1947.

Lopez-Rey, José, *A Cycle of Goya's Drawings*, London, 1956.

Malraux, André, *Saturn: An Essay on Goya*, London, 1957.

Mayer, August L., *Francisco de Goya*, translated by Robert West, London, 1924.

Mercadal, J. Garcia, *Goya*, Saragossa, 1955.

Oertal, Richard, *Francisco de Goya*, Berlin, 1907–8.

Paris, Pierre, *Goya*, Paris, 1928.

Perez y Gonzales, Felipe, *Goya*, Madrid, 1910.

Pillement, Georges, *Goya*, Paris, 1937.

Poore, Charles, *Goya*, New York, 1938.

Poza, Jenaro, *The Politics and Times of Goya*, Saragossa, 1935.

Sanchez-Canton, F. J., *Goya*, Paris, 1930.

———, *The Caprichos of Goya*, Barcelona, 1949.

Stokes, Hugh, *Francisco Goya*, London, 1914.

Vallentin, Antonina, *This I Saw: The Life & Times of Goya*, translated by Katherine Woods, New York, 1949.

Zapater, Francisco y Gomez, *Goya*, Saragossa, 1968.

List of Illustrations

Index